LIFE AND DEATH IN PICASSO

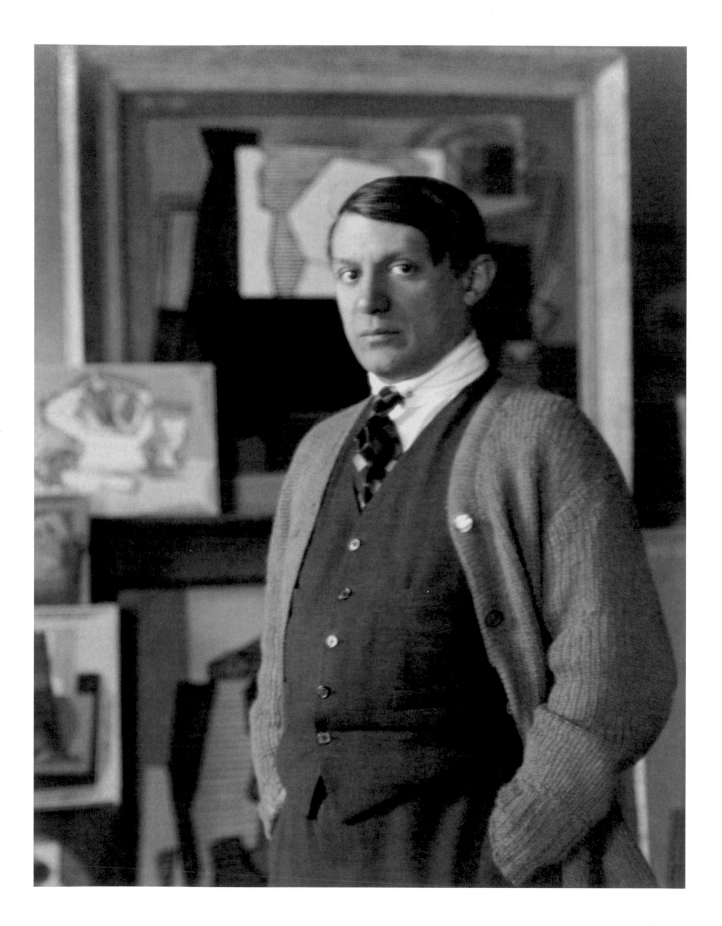

LIFE AND DEATH
IN PICASSO

STILL LIFE/FIGURE, c.1907–1933

CHRISTOPHER GREEN

WITH AN ESSAY BY J. F. YVARS

WITH 133 ILLUSTRATIONS, 124 IN COLOUR

Thames & Hudson

Museu Picasso

Cover illustration

Bottle and Mandolin on a Pedestal Table, Juan-les-Pins, [Summer] 1924
Pen, Indian ink and wash on Arches paper, 31.5 x 23.5 cm.
Sketchbook 30, MP 1869, f. 11 r. Musée National Picasso, Paris. Z V, 310

Frontispiece

Man Ray, *Picasso in his studio on rue de la Boétie*, Paris, 1922
© 2008 Man Ray Trust/VEGAP/Telimage

The exhibition 'Objetos vivos: Figura y naturaleza muerta en Picasso' was held
at the Museu Picasso, Barcelona, from 20 November 2008 to 1 March 2009

Ajuntament de Barcelona **Institut de
cultura.**

First published in Spain as *Objetos vivos: Figura y naturaleza muerta en Picasso* by the
Museu Picasso, Barcelona, 2008

First published in the United Kingdom in 2009 by Thames & Hudson Ltd,
181A High Holborn, London WC1V 7QX

www.thamesandhudson.com

British Library Cataloguing-in-Publication Data
A catalogue record for this book is available from the British Library

ISBN 978-0-500-09348-1

Printed and bound in China by C&C Offset Printing Co. Ltd

Contents

Foreword

Pablo Picasso has always been closely associated with the city of Barcelona, and it is fitting that the Museu Picasso de Barcelona continues to consolidate its position as a centre for the understanding, study and dissemination of his art. The exhibition 'Objetos vivos: Figura y naturaleza muerta en Picasso' marks a major step forward in this direction.

The Museum seeks to generate new insights into and discussion about the artist, and this show, organized by the Museu Picasso and curated by Professor Christopher Green of the Courtauld Institute in London, one of the world's foremost specialists in the field, does all of that and more. It features aspects of Picasso's work not previously studied in any depth, while at the same allowing us to enjoy a superb selection of works, many of which have never been shown in Barcelona.

This is, then, a great new opportunity for the people of Barcelona and visitors from all over the world to continue to rediscover the art of Picasso: an art that is now more vital and more powerful than ever.

Jordi Hereu
MAYOR OF BARCELONA

Preface

On 8 November 2006, just a week after taking up my new post at the Museu Picasso, I attended a lecture by Christopher Green, Professor of History of Art of the prestigious Courtauld Institute in London, part of a series of talks organized jointly by the museum and the Universitat de Barcelona.

'Under the Cloak of Harlequin: A Picasso Still Life of 1924' was the title of a brilliant and insightful talk that put forward thought-provoking new interpretations of certain aspects of Picasso's work. It seemed to me that the thesis Professor Green presented possessed all the elements necessary for the preparation of an exhibition that would, moreover, coincide with the line of work being pursued by the exhibitions programme here at the Museu Picasso. The fact that the fundamental research work had already been done has meant that just two years after the lecture we are able to open this show, which is of such great significance to the museum.

I particularly want to mention how valuable it has been to have Professor Green as curator, and to express to him our profound gratitude for accepting our invitation. For a young team like ours, involved in a process of growth, the experience of working closely and continuously over a two-year period with a specialist of such importance has been one of the exceptional added benefits of this project. Christopher Green is internationally renowned and unanimously respected for the rigorous and innovative character of his scholarly work, and for his years of teaching at the Courtauld, where many of today's directors and curators of major museums all over the world had the good fortune to be taught by him.

Without attempting an exhaustive list, I would like to mention some of his published works, such as *Cubism and Its Enemies* (1987), an indispensable reference for any in-depth study of the movement, or the monograph *Juan Gris* (1992), an essential guide to that painter's œuvre. On the subject of Picasso, Christopher Green edited and co-authored *Picasso's Les Demoiselles d'Avignon* (2001), in which he submitted a number of the established theses on that picture to critical review. Tremendously rich in implications, *Picasso: Architecture and Vertigo* (2006) – his last book before this one – is a thrilling engagement with Picasso's work in the light of some of the central features of the *architecture* of our society. The repercussions of this study and its outstanding contribution to the continuing effort to construct new approaches to the artist have still to be appraised.

In *Life and Death in Picasso,* starting from the well-known fact that metamorphosis is a constant in Picasso's creative evolution and a defining characteristic of his work, Green takes us forward and for the first time sets out to look at how, through the manipulation of signs and pictorial language, the artist moves between figures and objects, animating what is inanimate and vice versa. On an initial level this exhibition can be experienced as a journey through Picasso's imagination and his creative processes, while on a deeper level it helps us to understand – by way of references to Apollinaire, Freud and Surrealism, among other things – the dense cluster of ideas and reflections associated with the presence of death that underlie the artist's works.

This exhibition provides us with a model for one of the museum's primary objectives. Under the generic rubric 'Rethinking Picasso' we have grouped a series of programmes aimed at renewing current discourse about the artist and his work, going beyond biographical narratives and stylistic classifications in search of new perspectives that incorporate the terminology and arguments of the aesthetics and the theory of art of the late twentieth and early twenty-first century as an alternative to the commonplace and conventional. A special new postgraduate course in conjunction with the Universitat Autònoma de Barcelona, a new approach to the presentation of the collection, two forthcoming series of new publications and the temporary exhibitions programme itself form part, along with other projects, of this commitment to establishing the Museu Picasso as a centre of excellence in research and in furthering knowledge about the artist.

I would like to express once again my deep gratitude to Christopher Green for his work, his unflagging dedication and his unstinting involvement with the team here at the museum in the course of the project.

The exhibition would not have been possible without the indispensable help and cooperation of the many individuals and institutions who have loaned their works; on behalf of the museum I want to thank them once again for their support. Of particular value has been the generosity we have been shown by the artist's heirs, who have, as in the past, assisted us with the loan of essential works, some of them on public display here for the first time.

I also wish to express our indebtedness to Professor Yvars, who kindly accepted the invitation to write an essay for this publication. Finally, my sincere thanks to all the team at the museum, whose professionalism and dedication have made this project a reality.

Pepe Serra
DIRECTOR, MUSEU PICASSO

Acknowledgments

The Museu Picasso de Barcelona wishes to express its gratitude to all the people who have made the realization of this project possible, in particular and very especially to Catherine Hutin, Claude Picasso and Bernard Picasso, in recognition of their generous and invaluable contribution to this exhibition and their constant support of the museum.

We also wish to acknowledge the inestimable cooperation of María Jesús Albiñana Cilveti, María Alonso, Anne Baldassari, Anna Batiste, Graham W. J. Beal, Yve-Alain Bois, Eugenio Carmona, Josep Maria Català, Susan Davidson, Lisa Denison, Diane Deriaz, Lorna Dudley-Williams, Evelyne Ferlay, Anna González Batiste-Alentorn, Elizabeth Gorayeb, Paul Gray, Richard Gray, Florence Half-Wrobel, Anne d'Harnoncourt, Karin Hellandsjø, Pablo Jiménez Burillo, Raymond Keaveney, Sam Keller, Jan Krugier, Shelley R. Langdale, Bernardo Laniado-Romero, Brigitte Léal, Lucie Maguire, Jesús Martínez Torrente, Isabela Mora, Helly Nahmad, Karsten Ohrt, Alfred Pacquement, Christine Pinault, Esther Pujol, Paco Rebés, Guillermo Solana, Nancy Spector, Nicolas Surlapierre, Michael Taylor, Annabelle Ténèze, Graham Thomson, Gary Tinterow, Gijs van Tuyl, John Vick, Marta Volga Guezala and Ornella Volta.

Finally, we wish to express our most sincere thanks to all the museums, galleries and collectors, not forgetting those who have asked to remain anonymous, who generously agreed to loan their works:

DENMARK
Statens Museum for Kunst, Copenhagen
FRANCE
Centre Georges Pompidou, Paris. Musée National d'Art Moderne/Centre de Création Industrielle
D.A.F., Fonds Erik Satie on permanent loan to Imec
Musée d'Art Moderne Lille Métropole, Villeneuve d'Ascq
Musée National Picasso, Paris
IRELAND
National Gallery of Ireland
THE NETHERLANDS
Stedelijk Museum, Amsterdam
NORWAY
Henie Onstad Art Centre
SPAIN
Colección Fundación Mapfre
Fundación Almine y Bernard Ruiz-Picasso para el Arte
Museo Nacional Centro de Arte Reina Sofía, Madrid
Museo Picasso Málaga
Museo Thyssen-Bornemisza, Madrid
SWITZERLAND
Galerie Beyeler, Basle
Marina Picasso Collection. Courtesy of Galerie Jan Krugier & Cie., Geneva
UNITED KINGDOM
Nahmad Collection
UNITED STATES
Private collection. Courtesy of Richard Gray Gallery, Chicago
The Detroit Institute of Fine Arts
The Metropolitan Museum of Art, New York
Philadelphia Museum of Art
Solomon R. Guggenheim Museum, New York

Exhibition

Organization and production
Museu Picasso, Barcelona

Director
Pepe Serra

Curator
Christopher Green

Coordination
Montserrat Torras and Sònia Villegas

Research
Montserrat Torras

Conservation
Reyes Jiménez and Anna Vélez

Registry
Montserrat Torras and Anna Fàbregas

Press and communications
Manel Baena and Anna Bru de Sala

Design
Ana Alcubierre

Graphics
Alex Dobaño

Audiovisuals
Emblemma Espais audiovisuals

Catalogue

Consell d'Edicions, Barcelona City Council
Carles Martí, Enric Casas, Eduard Vicente, Jordi Martí,
Jordi Campillo, Glòria Figuerola, Víctor Gimeno, Màrius
Rubert, Joan A. Dalmau, Carme Gibert, José Pérez Freijo

Edited and produced by
Museu Picasso, Barcelona

Authors
Christopher Green, J. F. Yvars

Chronology
Montserrat Torras

Photographic documentation
Margarita Ferrer

Bibliography
Margarida Cortadella, Sònia Villegas

Editorial supervision
Marta Jové

Translation from Catalan and Castilian into English
Graham Thomson

Revision of English texts
Graham Thomson, Lucie Maguire

Design
Andrés Mengs, Madrid

The illustrations in the texts and the images identified
with the symbol [•] are not on show in the exhibition.

www.museupicasso.bcn.cat
www.bcn.cat/publicacions

The Content of the Form

Picasso's Biomorphic Motifs

J. F. YVARS

'The simple is nothing but the simplified.'

I The enigmatic epigraph above is an observation made by Klaus Mann in Paris in 1933, during his enforced exile from Germany.[1] Mann was a writer who understood, as few others have, the formal arguments brought into play by the artistic creativity in Europe between the wars. 'Make it new!' – Ezra Pound demanded. That said, a subtle distinction drawn by Bernard Berenson, always faithful to the original formalist core around which his critical activities revolved, strikes me as even more appropriate to this subject: in our appreciation of an artwork it is important to differentiate between what he called 'illustration' and 'decoration'; in other words, between those elements that correspond to the representation of both the external and the inner worlds and those that refer to the lines, shapes and colours that materially constitute the artwork. In other words, content and form. Nonetheless, in the last analysis, says Berenson, 'form and content, decoration and illustration are, in the pragmatic reality of the work of art, the same thing'.[2] Roger Fry talked about the aesthetic composition and the dynamic composition in the same terms.[3] A plane, a linear tangent or a luminous point can be the equivalent of an emotive action upon which the intentional signification of the work converges. Visual unity versus poetic unity. A useful distinction that may help us as we go along.

1 Klaus Mann, *Tagebücher 1931 bis 1935*.
Munich, Spangenberg Verlag, 1989, p. 74.
2 Bernard Berenson, *Aesthetics and History*.
London, Constable, 1950, p, 50 and ff.
3 Roger Fry, 'Sensibility versus Mechanism',
Art-History as an Academic Study. Cambridge,
Cambridge University Press, 1933.

Yet the contemporary historiographical narratives that aspire to the status of art are suspicious of and at times openly reject the canonical certainties of the formal tradition we call Western, or, more narrowly, European. This is to venture into the misty realms of sense perception and to opt for a phenomenology of the aesthetic experience that, whether we like it or not, conditions our formal response to stimuli. The seminal works of Gombrich and Wollheim[4] have broadened our critical perspective and elevated our analytical capacity to exponentially higher levels: a sort of artistic anthropology capable of universalizing the piercing truth that artistic phenomena can be seen primarily as ideograms of common sensory experiences.

Art was not always so, but the development and evolution of new worlds of art have opened the way for various systems of formal affinity. These have tinted with their own colours the stylistic trends and '-isms' that constitute the founding narrative of modern art. In Hegelian terms, each of these imaginative and constructive trends functioned as the thesis (assimilation) and antithesis (transcendence) resulting in the formal synthesis put forward by the proposed figurative precedent. Of course, this theory needs severe adjustments of a historical and sociological nature, demonstrated by the steeply rising and falling trajectory of the historic avant-gardes, and their temporal sequence, ever since the crisis of visual identity so evident in the spread of Impressionism as a universal artistic language at the end of the nineteenth century.

Picasso's elusive and versatile work perhaps lends itself to this interpretation of the modern aesthetic experience more readily than any other. This is because of the dialectical and alternative character of its own formal dynamic, but above all on account of the condition of uniqueness that the artist imposed on each of the detours that define his long career. For example, he shows a recurring tendency to figurative metamorphosis, mediated by irony or by the events of his own life, and to the construction of objects that disfigure and push to formal extremes the real and even banal physical nature of the models – figures and still lifes, to adopt the classical taxonomy. For Benedetto Croce, too (and the affinity is by no means coincidental), 'artistic objects' are not exactly artistic expressions 'which exist nowhere outside of the souls that create or re-create them'.[5] For the Neapolitan philosopher, it is more a case of objects constructed for the expression of emotions.

4 Ernst Gombrich, *Art and Illusion: A Study in the Psychology of Pictorial Representation*. London, Phaidon, 1960. Richard Wollheim, *Art and Its Objects. An Introduction to Aesthetics*. Cambridge, Cambridge University Press, 1968.
5 Benedetto Croce, *Estetica come scienza dell'espressione e linguistica generale: teoria e storia*. Bari, Laterza, 1958, p. 32 and ff.

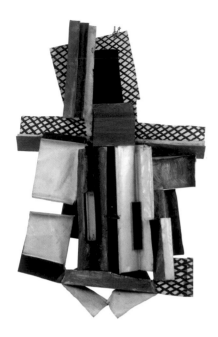

Fig. 1 *Violin*, Paris, 1915
Construction: cut, folded and painted
sheet metal and wire
100 x 63.7 x 18 cm
Musée National Picasso, Paris
MP 255. Z II 2, 580

From a purely descriptive point of view, Picasso's metamorphic period quite clearly starts with the early collages and *papiers collés* made between 1912 and 1914 – the years of Cubist plenitude, of course – (Fig. 1) and these return with force and complex distinctions around 1925. At that time André Breton, Georges Bataille and Michel Leiris were outstanding interlocutors in the artistic dialogue around Picasso. Surrealist anxiety, we might say. Picasso was always a gifted manipulator of signs, a skilful operator when it came to resurrecting dead objects in lively formal signs and vice versa. He transforms visual fantasy, which leaps teasingly from life to death, from Eros to Thanatos, into real presences. Their language is the product of a culturally aspirational post-Freudianism with a French intonation. Such a process of either imperceptible or explicit figurative eroticization ('violent eroticism' in the words of Christopher Green) coloured the drawings for the ballet *Mercure* (1924), together with such conventional settings as the bacchanal scene or the dance of the Three Graces with Cerberus (pp. 149–50), both in the Musée National Picasso in Paris. It also pervades a pastel sketch for the curtain (p. 143), which sets Harlequin against Pierrot in a linear synthetic caricature in the deformed manner of *Commedia dell'Arte* masks, and between 1924 and 1926 manifests itself most successfully in *The Dance* (p. 46). Some of the most remarkable works of the difficult following decade are saturated with suggestive biomorphic motifs, such as the uncompromising *Crucifixion* of 1930 (Musée National Picasso, Paris).

The arduousness of interpreting this is due, not by chance, to the sharply Fauvist chromatic treatment that tempers the expressive pathos of the images. It seems that on this occasion the malicious mimic Jean Cocteau, taking Massine into his confidence at Hyères, was right on target: 'Picasso, painter of crucifixions. His pictures are born of attacks of rage against painting – ripped canvas, nails, ropes and skin – in which the painter crucifies himself, crucifies painting, spits on it … but ends up submitting fatally, obliged to have all disaster of forms end in a guitar.'[6] Max Friedländer, a historian little given to formalist musings, speaking of the Picasso of those years, drew attention to the importance of photographic reproduction as a stimulus for figurative experimentation. He also observed how the artist intentionally distanced himself from mechanical verisimilitude and oriented towards a 'fashionably *recherché* artform'.[7] A perceptive observation, worth bearing in mind. But one thing at a time.

6 Cited in Léonide Massine, *My Life in Ballet*. London, Macmillan, 1968, p. 102 and ff. With regard to Picasso's aesthetic dramatizing, there is an interesting appraisal of this in Douglas Cooper, *Picasso: Theatre*. London, Weidenfeld & Nicolson, 1968.
7 Max Friedländer, *Landscape, Portrait, Still-Life: Their Origin and Development*. Oxford, Bruno Cassirer, 1949, p. 121 and ff.

II I trust the reader will excuse a personal note, which I feel is germane here. In the 1960s I had the opportunity to hear Daniel-Henry Kahnweiler speak in Barcelona. It was in the basement of the Sala Gaspar in calle Consell de Cent, where an intelligent selection of graphic works by Picasso was being shown. Kahnweiler addressed the value of objects in the construction of the artist's personal imagery: 'Le Sujet chez Picasso', announced thus in French, was misleading, because in fact we were treated to a brief exposition of the 1951 essay 'Der Gegenstand bei Picasso'. This was the second talk given in Barcelona by the legendary dealer. The first, somewhat disappointing (I have before me the typed transcript of the talk from the gallery's archives) was on the occasion of the exhibition of paintings by Picasso in the Sala Gaspar, in December 1960. Kahnweiler, who was expected to mount a defence of avant-garde art, repudiated abstraction as a dangerous formal gap that threatened the dissolution of art. This time he focused on the 'contents' of Picasso's art, not so much figurative (theme) as dimensional constructions (objects). Kahnweiler insisted once again on the emotional adjustments of the Malaga painter's art laboratory. In effect, Picasso had never allowed structural abstractions in his works, even in his Cubist interlude, except when these constituted elaborate formal variations on concrete figurative motifs carried to their expressive extreme. 'I have never painted an object without an unconfessed [*sic*] sentimental attachment, and never marked simply by an aesthetic imperative. It is out of place to paint a woman with a pipe in her mouth when everybody knows she is incapable of smoking.' This anecdote can be found in 'Der Gegenstand bei Picasso', which is included in a collection of texts by Kahnweiler.[8]

We should bear in mind, then, that we are talking about *objects* understood as fragments of real life, as the elements of a particular sense experience visualized. Norman Bryson[9] has contended that the technique used by Picasso for the construction of his plastic objects is a return to the old traditional procedure – an initial image on the canvas that arouses in the painter a certain sense of dissatisfaction – in a distinctly performative, interventional sequential process. The artist himself had confessed as much to Françoise Gilot, who recorded his words verbatim, however sceptical the reader might be about her merciless biographical indictment. For the artist, painting is a dramatic action in the course of which reality is perceived as divided: 'For me,' Picasso confessed, 'that dramatic action takes precedence over other considerations. As far as I am concerned the pure plastic is a secondary factor.'[10]

8 Daniel-Henry Kahnweiler, *Ästhetische Betrachtungen*. Cologne, DuMont Schauberg, 1968, p. 103 and ff.
9 Norman Bryson, *Vision and Painting: The Logic of the Gaze*. London, Macmillan, 1983.
10 Françoise Gilot, *Life with Picasso*. Harmondsworth, Penguin, 1966, p. 163.

But perhaps it was Jaume Sabartés, the artist's discreet confidant for almost fifty years, who has ultimately left us the most vivid image of Picasso's internal debate. It comes in an autobiographical fragment in which the artist interpreted his work as if it were a book in progress, like the disciplined list of chapters in which the basic data of a transforming aesthetic experience follows with impeccable formal logic. Early one morning in July 1939, Picasso gave Sabartés the text below. Perhaps the most complex encoded passage in his literary work, it situates us at the centre of a vivid Baroque creative dispute, the literary equivalent, according to the transcriber, of a painting, a drawing or a sculpture by Picasso – though there will be those who break off after a few lines, it rewards reading in full. The artist is in full surreal effervescence, anticipating the unvarying breathless drone of his play *Desire Caught by the Tail*, with no punctuation or intentional cadence of any kind:

'[…] the thread that works destiny that tinges the theft of crystal from the clay that shudders when huddled in memories toasted on the grill of azure and mint summer that hides its wing and puts tightrope omens in clusters of silence that cool in the shadow of words lightly said and cuts the oblivion of his life without salt on the shoulder of his friendship cast on thistles made soup of lamentations jumping in the frying pan made of spikenards splashing his body with the rain of peace putting in his pocket the time eaten by the sand and screws down the moment caught between the teeth of the white dove that beating the sky resounds in the drum that keeps away the bell and leaves her withered wet with pleasure and vibrant with fear caught in the heat eyes closed mouth open girl the bogeyman comes and takes the children who sleep too little sure I know you're the best there is in this world a suit of sequins a skin of wine a circular stair a ray of silence that passes through his hand and the reflection of a kiss in the apple a table of lime the hope that burns in a corner and the noise of the fish in the mouth of the jug ringing the cloud that waits in the picture the beak to wring the notebook of applause uncovering the affection of the prism that sings on the wall the profile of her face and hides from its light the sphere that smashes on falling to the ground the words that fly go back to the dovecote to make their nest in the bracelet made of copper and iron silk that the sun skein scratches from its kilometre thousands offensive weapon in equilibrium placed above his art that the gale stirs up order shirtless behind the gaze that pokes his desire through the

cane curtain that is never still laughing at everything while the summer passes
slice of melon the cicada lights and drags in its wounds the cape of the sword
from the bottom up the silence reveals the shadow of the angle that stretches his
voice that nails in the handkerchief the window of light that runs up little mouse
the rope of the well that is the abyss of the street and the cork that goes with its
wench to revels of sense sponges the stars off the bullfighters suit and throws
them on the beach on the net flavours the verse that falls and splits its forehead
in the void and spills its blood of violet red rays that cut the blue skirts that float
on the sky words that swing on swings of promises go back over the paintbrush
jumping with feet together its barrier of cries that the branches tear from the
ground that tosses and turns a hundred times in the bed before falling asleep
and passes back through the filter drip by drip illuminating them all colours each
one installs inside its workshop of illusions of the table of measurements that
balances the air of his reason with new suit seed of lily stallion mounts his will
and caracoles the bull placing *banderillas* of grace and wit wraps it in his
laughter and takes dove against his chest listening to the beating hands spurting
waves that fly from his swift race prisoner around the star chewing the bitter
prize of his virtue and making wine of his life the flea bites the heart of the cock
with a clean laugh and squeezes from the lemon the indifference that his black
destiny illuminates the table set at lunchtime the pieces of lobster and the lettuce
leaf the bread soft and the wine and the air that parades his wit playing the
castanets cabin in the baths raised by his spartans and they learn from him
suspicions that later they will tell in the shadow to their turtle dove those that
could hear behind the clusters of the more and the less said among the beads if
little grains of salt and of pepper dancing on the stage of oil and so long caramel
caramel that blazes caramel that burns caramel that cuts and breaks caramel that
stings pricks colour of red and green caramel of Sunday afternoon shut up in the
room without bulls and without anything wrapped in the paper that must be
made of every old cloth sheets that wrapped around efforts and romances of
science and of caresses flags in the port free of his way of creating silks that the
wind stirs cool strolling in the water his life of a little man waiting impatiently
for the time to see the sun and so happy that now whats good is beginning and
the curtain will rise of flames that are carried in its folds the past in dusty bottles
of the blue bull that drags the bluest of blues and thats enough for now you have

to go slowly and count 1. 1-2-3-4-5-6-7-8-9-10-11-12-13-14-15-16-17-18-19-20-21-22-23-25-26-27-28-29-30-31-32-33-34-45-36-37-38 - 40 - 50-21-32-17-34-60-70-80-110-120-0-0-0-0-0-0 and that the sun burn them and scorch them so they sing *soleares* at night alone in the solitude of the solitudes hoping to find a bit of coolness 1-2-3-4-5-6-1-2-3-4-5-6-7-1-2-3-4-5-6-7...'[11]

An extensive and perhaps excessive quotation, but this little-known text, disconcerting and hardly used in critical historiography of Picasso's work, conveys the tension between memory and model, experience and interpretation that is characteristic of his artistic process.

For Picasso, in the early and late metamorphic works, the very idea of transformation of signification and distortion of form, are articulated on the basis of specific figurative motifs. Bearing witness to this we have the clamorous examples of *The Dance* and *The Kiss*, works in which forms and figures in action co-exist, engaging in a play of anatomical transpositions with, as noted above, a markedly erotic charge. But these are also works that reveal the impression made by the discovery and assimilation, during those years, of Neolithic European and sub-Saharan cultures, and how the artist drew on them for virtual solutions to formal dysfunctions that had been beyond resolution within Cubism. He found the artistic information, and even its calm anthropological explanation, in Georges Bataille's magazine *Documents* and Christian Zervos's *Cahiers d'Art*. These were authentic repositories of unexpected images that dazzled the Surrealists and disturbed Miró, to cite one case, as John Golding has perceptively discerned. Here is a moment of emulation between the two – Picasso and Miró – in which the discovery of the graphic and expressive possibilities of the human figure and its reconstruction as a fantastical schema present to the contemporary eye a surprising synthesis – a synthesis made visible in Picasso's rough assemblages of 1926, such as *Guitar* [*and Knitting Needle*] and *Guitar* [*and Floor Cloth*], both in the Musée National Picasso in Paris. In contrast, *Bather and Cabin* (1928, Musée National Picasso, Paris) seems to bear out Sabartés and represent a detailed evocation of the artist's childhood in La Coruña: here is the daring child who discovers in the bathing cabin a mirror of equivocal images, a theme that recurs with *Bather and Cabin* (1929, Musée National Picasso, Paris), a small canvas that the artist kept jealously in his private collection. An indication, perhaps, that in the artist's mature work we are to see the symbolism of the female form and its ambivalent meanings once again in Freudian terms.

11 Jaime Sabartés, *Picasso: retratos y recuerdos*. Madrid, Afrodisio Aguado, 1953, pp. 184–87.

III The selection of works by Picasso that prompted these considerations was made by Christopher Green on the basis of criteria that are open to discussion. These are figurative objects converted into graphic signs, and these signs, over and above their value as pure genre categories – portrait, still life or stage sets – also show the radical transformation of meanings characteristic of certain moments in the creativity of the artist. Figures and landscapes, still lifes that range between experimentation – the organic active condition – and an air of desiccation, come to exist like mere three-dimensional objects formalized in two dimensions. In my judgment, they oscillate between constructed objects that conform to a greater or lesser extent to a normative formal layout and others that appear succinctly as biomorphic figurations in a sequence of ascending complexity. It is a process that spans almost a quarter century of Picasso's mould-breaking and always personalized iconography. Whether we start from the archaic masks of the Cubist period, sparse profiles in Indian ink or graphite, or the small landscapes in oils of 1908, we can perceive in all of them a sort of formal germ of what will later become an original and disquieting deployment of signs. These very assured sketches extend and branch out in a process of figurative expansion, and in so doing modulate between the morphological and the descriptive (like the primary schemas of some naturalist's herbarium) and what I would call the formally *fictive*, forced by the imagination.

A tentative work such as *Landscape* (Virginia Museum of Fine Arts) is perhaps a good example from which to start our inquiry. It is a painting contemporary with *Les Demoiselles d'Avignon* – both landscape and figuration at once – but above all a living construction on the basis of a vibrant chromatic range. However, the anthropomorphic or figurative derivations of late Cubism of the *papiers collés* period, with its formal perplexity – *Mandolin and Clarinet* (1913), *Guitar* (cut cardboard, 1912), *Head of a Girl, Still Life with Window and Bottle* (1916) – speak clearly of an instant of fantasy that uses the ductility of the sign and its infinite possibilities of interpretation and analysis. A superb *vanitas* in oil on canvas, *Musical Instruments, Skull* (p. 175), strikes me as an eloquent example of Picasso's new figurative range: the conceptual reality dissolves into colour signs, and the cranium – the skull, an ancestral image of the cultural fetish of death – looms out like a succinct paraphrase, the closed eyes and the decayed nose of Fate. Picasso affirms himself once and for all in the spectator's eyes as a compulsive inventor, obsessed with giving sensible form to his figurative insecurity

at a time of constant personal disquiet. This is the key, ultimately, to understanding the story of action and fantasy whose signs can be discerned in the narrative that articulates Green's succinct selection.

When Christian Zervos began seriously to put together the *catalogue raisonné* of Picasso's work in the 1930s, the sheer extent of the œuvre ended up unsettling the artist himself. It was as if he was disconcerted at the potent intensity and meaning of figurative nuclei grouped in successive sequences, marked, no doubt, by ambivalence – decoration or illustration? – in the terms of Berenson's aesthetic judgment. From any point of view, this narrative manner breaks with the placid conventions of chronological regularity, superficially seasoned with styles out of a scholastic manual, and plunges us into an abyss that is glimpsed between vertigo and architecture. Such a break inverts one of Green's astute propositions, the opposition between the difficult immensity of the work itself and the resolute cataloguer's commitment to a reductive, manipulative, schematic and, in short, fallacious ordering.

The 1930s was also the decade of the exhibitions – Galerie Georges Petit (Paris), Kunsthaus (Zurich) – that placed Picasso within the circle of the shapers of modern art. The shows held in these galleries exposed the artist's work to an unprecedented battery of theoretical interpretations and aesthetic judgments. The critics applied a whole array of forced contrivances – from heterodox psychoanalysis to cultural anthropology – in an attempt to transform this maelstrom of distinctive and disconnected images into a founding philosophy of the new art. These were the the roots of the Picasso myth: 'Pan, the great Pan!' Leiris exclaimed on one solemn occasion (Fig. 2, p. 26). Ultimately, it was the age of surprises. A photograph of Picasso's studio in *Cahiers d'Art* (no. 5, Paris, 1926) is a visual record of the crossroads where the artist found himself: an installation of artistic motifs. Its theatricality – in the centre is *Studio with Plaster Head* (1925, MoMA) – is a summons to active emotional involvement on the part of the spectator, making it a pioneer of the performance art to come.

In short, then, by tracing the increasing complexity of Picasso's images we can track the origin as well as the formal and figurative ramifications – there is rarely a narrative, except in the graphic series – of the worlds of alternative art inhabited by the artist's daydreams. Picasso was never a tortured fashioner of nightmares as Goya was, for

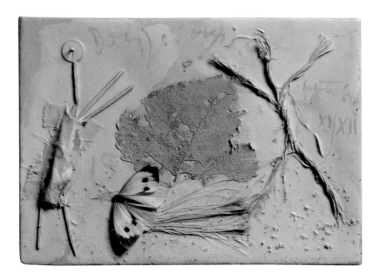

Fig. 2 *Composition with Butterfly*
Boisgeloup, 15 September 1932
Fabric, wood, plants, string, drawing pin,
butterfly and oil on canvas, 16 x 22 x 2.5 cm
Musée National Picasso, Paris
MP 1982–169

example, but more a bold transgressor of the representational conventions of the pictorial tradition, even in the extreme case of *Guernica*. His landscapes with a tentatively Cubist geometrization were not so much constructed as fantasized in Horta de Sant Joan in 1909, and were undoubtedly interpreted in a peculiar synchronous key that is informed by an emergent Catalan nationalism and a quest for geographical and sentimental identification. After these came the rectilinear constructions that culminate in *Guitar* (1912), when the quiet complicity of Braque provided the perfect counterpoint in a process of revolutionary plastic reading of the artistic consequences of the avant-gardes that were then starting – alas! – to be historical.

However, the 1920s seem to mark a new point in Picasso's creative trajectory, as the decade that witnessed the abundance of his much-debated Surrealist work. Its identification is highly controversial and its iconography hotly disputed, for all the proliferation of literary testimonies to Picasso's unquestionable affinity with certain leading luminaries of the Surrealist movement who erupted on the Paris scene at that time. Chief among them was André Breton, who tied up the loose ends in *Le Surréalisme et la peinture* (1928). His obsession with charting a *front rouge* culminated in the magazine *Minotaure*, for which Picasso designed the cover of the first issue. Then came the idyll of *Picasso poète* and the creation of the automatic or almost automatic poems. And perhaps also from this period is a still life as encompassing as *Guitar and Fruit Bowl on a Table in Front of a Window* (1924), or the so-called *carnets* from Juan-les-Pins, in which the drawings, in a unique formal ellipsis, insinuate flashes of abstraction that find

no continuity in the artist's subsequent work, but are always motivated, of course, by diaphanous figurative motifs, such as the divergent graphic variations on *Seated Nude* (1925, Musée National Picasso, Paris).

IV Nonetheless, unlike an artistic narrative based on formal variables whose origins are debatable, the new historiography of art is quite clearly centred on the analysis of artistic figurations and signs. Such an analysis defines and clarifies the artistic and intellectual project of some of the great names of twentieth-century art – Picasso, Miró, Dalí, to cite the Spanish Holy Trinity – who by their inventiveness defined the originality of modern art. Their work frequently conveys, by way of slanted or connotative procedures, the myths and archetypes that underlie the metaphors to which in one way or another they have given rise. In the case of the analysis and interpretation of Picasso's work, this methodological conversion has brought a radical change in the direction of research and has forcibly eclipsed, perhaps forever, recourse to a formally hackneyed and anachronistic collection of socio-biographical anecdotes. Previous explanations had included the private psychodramas of the artist – emotional encounters and differences, with their corresponding infidelities and fallings-out. The artist's work thus ceases to be the frantic testimony of a troubled moment in history to become the graphic symptom of a past time or the cultural indictment of an arrogantly autonomous art world that imposes its formal purity on the dramatization of the referential contents. In relation to *Guernica*, for example – a lacerating war poster converted by a fateful historical outcome into the fetish of a defeated Spain – the result has been greater analytical precision, a more fluid artistic story that extends the historical perspective into the shifting space of forms. In the case of Picasso's work, traditional academic methodologies are capable of revealing very little. The rigorous contributions made by John Golding, Elizabeth Cowling, Kirk Varnedoe, David Lomas and Christopher Green,[12] and of Eugenio Carmona, Paloma Alarcó, Jaime Brihuega and Rafael Jackson in Spain,[13] have restored to us the enriched images that are essential to understanding certain moments of truth in Picasso's art, in terms of the genesis of the structure of the work. Everything else is incidental.

To the contemporary eye, Picasso's Surrealist period would perhaps start with *The Dance*, but it is sharply differentiated above all because it draws together

12 John Golding, 'Picasso and Surrealism', Roland Penrose and John Golding (eds), *Picasso 1881–1973*. London, Elek, 1973. Elizabeth Cowling and John Golding, *Picasso: Sculptor/Painter*. London, Tate Gallery, 1994. Elizabeth Cowling, *Visiting Picasso*. London, Thames & Hudson, 2006. Kirk Varnedoe, *A Fine Disregard: What Makes Modern Art Modern*. New York, Abrams, 1990. Kirk Varnedoe, 'Contemporary Explorations', in William Rubin (ed.), *Primitivism in 20th Century Art: Affinity of the Tribal and the Modern* (3rd edn). New York, The Museum of Modern Art, 1985, vol. 2, pp. 661–85. David Lomas, *The Haunted Self: Surrealism, Psychoanalysis, Subjectivity*. New Haven and London, Yale University Press, 2000. Christopher Green, *Picasso: Architecture and Vertigo*. New Haven and London, Yale University Press, 2005.

13 Eugenio Carmona, *Picasso, Miró, Dalí y los orígenes del arte contemporáneo en España, 1900–1936* (exh. cat.). Madrid, Museo Nacional Centro de Arte Reina Sofía, 1991. Paloma Alarcó, Malcolm Warner (eds), *El espejo y la máscara: el retrato en el siglo de Picasso*. Madrid, Museo Thyssen-Bornemisza, 2007. Jaime Brihuega, *Las vanguardias artísticas en España: 1909–1936*. Madrid, Istmo, 1981. Rafael Jackson, *Picasso y las poéticas surrealistas*. Madrid, Alianza, 2003.

a complex bundle of imaginative traits and influences expressing the artist's notorious unpredictability. André Breton celebrates that unpredictability in the text that gave international artistic legitimacy to the movement: *Le Surréalisme et la peinture*. What were the artistic reasons for this unexpected triumph? They are unfathomable unless we can reduce them to the boom in publicizing culture. Nonetheless, I believe it is important to take into account the legibility of Picasso's graphic signs and figures. These are always, of course, far removed from the banal formalization of the Futurists, but also from the ethereal visual poetics of the pioneers of Surrealist art: Ernst, Tanguy, Masson and Miró himself – why not? – at the forefront. In *The Dance*, Picasso intuitively elaborated a closed image, a hermetic universe which in turn insinuates a metaphor for the dual character of modern art: in interpreting nature the artist reinvents it, turning it into a biomorphic analogue of art and giving plastic account of it. This is done by means of connected and linked signs, a doubling of faces and figures, in a process of modifications and elaborate visual paraphrases. These create living objects, the perception of which is diversified and complex. From the point of view of construction, and in the course of a process of conflicted reading, the artist thus proposes a succession of metaphors through images as signs – a cruel dance of death – imbued with the insights of Freud and Jung.

Perhaps this explains the fascination Breton felt for Picasso's early work, as a great fetishizer of ethnic objects and their disparate defining identities. The fact is that Breton was always a perceptive admirer of the enigmatic tracery and tricks of Picasso's Analytical Cubism, in, for example, *Ma Jolie* (1911–12). It should also be noted, however, that it was only in reflecting on the *révolution surréaliste* that Picasso fully discovered the explosive artistic possibilities of Analytical Cubism and collage, a discovery that advanced the figurative convulsion of the years 1924–30, with the great still lifes and the inanimate objects given life by formal transposition: *Mandolin and Guitar* (1924, p. 139) is an example, as are the organic drawings of this period, such as *Seated Woman with a Glass* (1924) or *Three Bathers* (1924, p. 52), reaching a height with the discovery of the virtual figurative flow in the *Bathers* of 1927 (Figs 3 and 4). The provocative still lifes of those years, *Musical Instruments on a Table* (1925; p. 163) or *Still Life* (1925, p. 167), similar in size to the linear hieroglyphic *The Artist and his Model* (1926, Musée National Picasso, Paris), manage to realize a figurative dream that started in the early 1920s. Uncertainty between a vertical or a horizontal organization in the structure of the picture was seriously affected by the dynamic of the composition

itself, in which plastic motifs and figures imposed what we might call their 'vitality' as objects – guitar and fruit bowl, woman and chair – and conditioned the exquisitely artistic balance of the whole, still without arriving at the metamorphoses and fantasies of the final years of the decade: *Guitar and Fruit Bowl*, for example, or the performative paraphrase *Guitar* (1926, both in the Musée National Picasso, Paris). Here the artist discovers relief, expressive energy and the formal ductility of the material, and definitively transforms works of art into plastic objects. The addition of sand and limestone compounds to the still lifes of that time – 1925 – is, of course, no accident; these still lifes emulate – though the association is curiously little noted – certain pared-down representations by Braque, *Fruit Bowl and Clarinet* (1920) or *The Marble Table* (1925). They anticipate the still lifes after 1939, where the expressive rigour of the plastic materials is conditioned by a firm, formal structure, subordinated to the contrasting colours with very little tonal mediation, as in the 1925 *Still Life* referred to above.

However, I think it is appropriate at this point to mention, even if only in passing, Àngel Ferrant's 'found objects' of the early 1930s. These plastic objects are dimensional and volumetric but closed, without that striking unfinishedness of Picasso's which leaves closure to the spectator. *Object* (1932) by Àngel Ferrant may perhaps embody a somewhat confused artistic proposal, close to the derivations of a Surrealist stamp being produced at that time by Ramon Marinel.lo, Eudald Serra and – even more simply, if

possible – Leandre Cristòfol. In the case of Ferrant, moreover – as Olga Fernández has pointed out[14] – the objects are the result of a significant artistic insight: the inability of traditional sculpture – carved, sculpted or moulded; monumental or expressive – to respond to the pressing formal imperatives of avant-garde art. It was, then, a question of engaging more deeply with the problem of what sculpure could actually do. But for Ferrant this experience resulted in a sense of 'vertigo' on account of the dual formal imperative it involved – on the one hand, a fully fledged assault on the collective imagination, the visual memory of a particular society that is defined by the sensitive recollection of the past; and on the other, close to the iconoclastic projects of *L'Amic de les Arts*, to confine ourselves to Catalan artistic culture. That option embraced a sort of 'anti-art', based on the reconstruction of certain random objects made of stray fragments and industrial waste subjected to the magical gaze of Surrealism. From any point of view, then, the certainties of the modern tradition disputed by Noucentisme were in danger of shattering. Surrealism's eruption on the scene as a totalizing artistic ideology, as an aggressive artistic front, was soon to subvert the strict boundaries of genre and style and to convert the worlds of art into active spaces of experience.

V In a letter written by Gertrude Stein to Picasso in February 1923,[15] the unclassifiable American activist assured him that she had received '*le tableau*'. This was none other than the *Calligraphic Still Life* now in the Art Institute of Chicago. It is a significant painting from any point of view because it reveals the linear and geometric tension that disturbed Picasso, working in an intellectual milieu characterized by a growing obsession with construction and structure. The works that Picasso made in Dinard in the summer of 1928 insistently dismantle the old compositional certainties of *les baigneuses*, which can to some extent be associated with the series of everyday objects that enabled Christian Zervos to argue for the presence of 'objects' in Picasso's work of those years, and to emphasize the metamorphic possibilities that so stimulated the artist. Peter Ludwig, in far distant 1950, devoted his doctoral thesis to the image of the male subject in the work of Picasso,[16] and put forward a very valuable and finely nuanced appreciation of the 'Dinard period': '[Picasso] commenced his experimentation with the figure by introducing grotesque effects in the linear disposition itself and in the resolutely plastic form of the bodies.' In effect, the 1928 painting *Dinard* depicts a parade of fictitious creatures supported on the line of the horizon

14 Olga Fernández, *Àngel Ferrant 1890–1962*. Madrid, Universidad Complutense, 2001. See, too, Rosa Maria Subirana, 'Àngel Ferrant y el surrealismo en Cataluña (1920–1936)', in *Surrealismo en Cataluña, 1924–1936* (exh. cat.). Barcelona, Generalitat de Catalunya, 1988. Elena Llorens (ed.), *El objeto catalán a la luz del surrealismo* (exh. cat.). Barcelona, Museu Nacional d'Art de Catalunya, 2007. As ever, of course, the best argument is put forward by the artist himself: Àngel Ferrant, *Todo se parece a algo. Escritos críticos y testimonios*. Madrid, Visor, 1997.
15 Gertrude Stein, *Correspondance* (Laurence Madeline, ed.). Paris, Gallimard, 2005, p. 93 and ff.
16 Peter Ludwig, *Das Menschenbild Picassos als Ausdruck eines generationsmässig bedingten Lebensgefühls*. Cologne, Mainz, 1950, pp. 69–70.

that separates the beach, the blue sea and a colossal mountain. The sea and the white clouds accentuate the expressiveness of sketchy arms that in outline strive to hold a green disk. On the surface, there are two powerful images in profile. In *Nude on a Beach* (1929), this ironic appropriation of human existence assumes iconic features and abandons any convention open to communication. Rough geometrizing outlines, edges sharply cut, evoke the old African iconographies in wood that fascinated Picasso in his years of Cubist inquiry and volumetric structural synchrony.

But perhaps the most striking example of this new constructive slant is *Head*, from 1928 (Musée National Picasso, Paris; Fig. 5) – '*mon petit blanc et noire*' in the words of Gertrude Stein, an early owner of this evocative sculpture/object. The geometrization in the form of an arrow with superposed eyes and a vertical mouth-vulva, in Pierre Daix's description, suggests the collaboration of Julio González in a dynamic of complicities, with the welding of the metal as a pretext. This is almost a definition of the way three dimensions were deployed in the early 1930s, in the wake of the monument to Apollinaire which was never definitively completed. *Head of a Woman* (1929–30, Musée National Picasso, Paris), in sheet iron with painted springs, where the involvement of González is evident, presents us with the dilemma of the independence of the plastic object as a virtual element of autonomous three-dimensional significance. It can even be seen as trivializing the variables of genre – landscape or still life – with a primordially pictorial and formalizing texture. Careful study of *Still Life with Palette* (1928) reveals the definitive motif to be undoubtedly structural, nuanced by strange biomorphic shapes that insinuate a figurative profile dissolved in a decidedly pictorial, plastic formal structure. This perception takes us back to another paradox, the simple planes of *Fruit Bowl and Guitar* (Fig. 6), in cut and painted cardboard, and the synthetic *Mask*, a graphic abbreviation of the Carnival mask, transformed and refined by the humanoid icons of sub-Saharan African sculpture.

In Picasso's case, biomorphic objects in metal represent something more than a happy moment in the creative output of an unpredictable artist. They are always motifs of ambiguous perception, halfway between two- and (tactile) three-dimensionality, presenting themselves to our gaze as striking challenges to interpretation, objects that

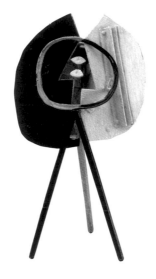

Fig. 5 *Head*
Paris, October 1928
Painted brass and iron
18 x 11 x 7.5 cm
Musée National Picasso, Paris
MP 263

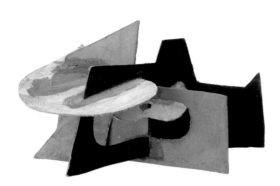

Fig. 6 *Fruit Bowl and Guitar*, Paris, 1919
Construction: cut and painted cardboard and fabric
21.5 x 35.5 x 19
Musée National Picasso, Paris
MP 257. Z III, 414

break with a stylistic tradition, as has been suggested from time to time. Those motifs found, in Julio González's technical mastery, the ideal field for their realization, free of the restrictive confines of genre and size, a fluid distillation of figurative suggestions that in their insistent graphic presence have still to be calibrated. Unfinished? Perhaps Picasso's immersion in Surrealism, so evident in the still lifes and 'live objects' of the 1920s, resulted – against the grain of the post-Freudian didactics of art – in ludic celebrations of Eros (*amor*), which prefigure the inexorable verdict of Thanatos (*mors*) and recover forgotten classical roots that are meaningful. We know that Picasso was impressed by Hesiod's *Works and Days* and its powerful images, and owned a splendid edition of his *Théogonie* printed by Flammarion in Paris in 1872. Hesiod's world is organized according to 'the mix of contraries and the mediation of opposites: a mixed universe in which the conflicting and harmonious powers are balanced'. This way of thinking was evidently congenial to Picasso, who always felt himself to be a classical, even a primitive man: Ortega y Gasset, a Malagan by adoption, remarked that 'Mediterranean man is the last of the ancients.'

For the artist this relationship of tension, of dialectic (if I may be permitted to speak in such terms) manifests itself through a series of acute polarizations – in Picasso's case, always extreme – that mark formal cadences on the landscape and define iconic features such as we find in the elusive figurations of those years. This is the necessary ambiguity characteristic of art. But Thanatos is the son of night and cunning: inexorable death or the death that 'any may cause through violence, annihilation or stratagem'. The abyss of art: that impasse that confounds the infinite forms of error and subjects the artist to the punishment of repetition, the eternal starting over and over again. The beginning, Hesiod concluded, is half of the whole. The artist laboriously rolls the stone to the top

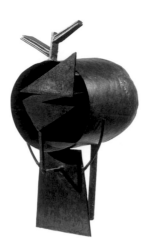

Fig. 7 Julio González
Head called *The Tunnel*
1933–34
Steel, 46.7 x 21.6 x 30.8 cm
Tate, London

of the hill then, once again, is struck by immobility, 'that infernal gesture' that brings about the return to the beginning, to nothing, to inaction. But let us leave Hesiod in peace. *Head of a Woman* (1928), a sculpture-assemblage in iron and welded metal, is the outcome of a fecund collaboration between Picasso and Julio González, a technical primitive fetish that suggests a certain formal and emotional complexity leading to the illusion of the finished work (Fig. 7). Is it tribal art, cultic art, cultural art? No, simply a figurative riddle hidden in a plastic object. Nothing more.

It should now be easy to perceive the substantial difference between images and figures, the morphological montages – matter and metaphor – of Picasso and the biomorphic objects of Julio González. For Picasso, it is all about daring exercises in dimensional experimentation based on a formal schema, either constructive or architectonic, within a primarily plastic register. For Julio González, I would say it was the opposite: the organic objects embody extreme tactile figurations with a realist stamp upon which the structural ordering of the space around them is based. Julio González's explorations of form in *Woman with a Mirror* (Figs 8 and 9) demonstrate this, and it finds its full realization in *Monsieur Cactus*, a lacerating three-dimensional symbol of violence created on the eve of the Second World War. But that is to broach a different subject.

In conclusion, let us return to the work of Picasso, to two paintings that in my view close the circle of the selection proposed here. What I think Christopher Green is insinuating is an audacious interpretation that approaches *The Kiss* in terms of the formal constructs of the still life. Strong lines that define the dramatic combat, the versatile figure of desire and the cannibal carnality of sex accentuate the metamorphic possibilities of the sign

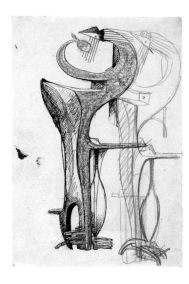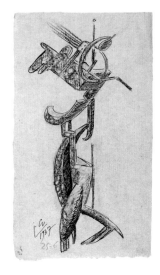

Fig. 8 Julio González
Studies for *Woman in Front
of the Mirror*, c. 1935–36
Indian ink, black pencil and red wax
crayon on ivory white paper, 30 x 20.2 cm
IVAM, Institut Valencià d'Art Modern
Gift of the Galerie de France

Fig. 9 Julio González
Woman in Front of the Mirror
25 June 1937
Indian ink and coloured wax crayons on
grey laid paper, 32.8 x 18.6 cm
IVAM, Institut Valencià d'Art Modern
Gift of C. Martínez and V. Grimminger

in a way that is close to the instinctive absence of inhibition of Surrealism. Here again
we have that interactive theatricality that demands the complicity of the spectator.

Seated Man with Glass (1914) is an early work dated by Picasso to Avignon in the
summer the First World War broke out. It is manifestly a sarcastic and even cruel settling
of scores with Synthetic Cubism, but at the same time a scramble of simultaneously
captured figures-cum-forms that dominate the plastic space, imposing on it their
variegated consistency as energetic motifs of art (Fig. 10). A work that takes us in
the direction of Miró? Perhaps; perhaps not. This vacillation simply defines art.

The magnetic and heterogeneous Surrealist movement intrigued and perhaps – why
deny it? – came to disconcert Picasso with its torrent of words and images, figures and
signs. Not only Freud and Jung, but also Georges Bataille and Michel Leiris, standing
in the long and sternly neo-Kantian shadow of Kahnweiler, opened Picasso's mind to
the deadly link between desire and form. It was a moment of crisis for painting as art,
when dissatisfaction with the means of expression led to powerful developments in
the material and the gestural. Picasso honed the figurative possibilities of objects,
accentuating their formalized dissolution, their conversion into plastic objects,
into the living presences of art. Miró, by contrast, in his use of an artistic counterpoint
close to the spirit of the 1920s, tempered the ancestral imagery of his native arcadia.
He gave a life of its own, invented or reinvented, to an unstoppable deluge of new

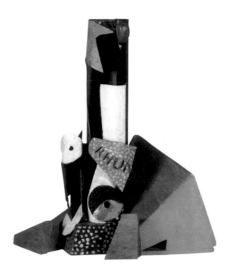

Fig. 10 Henri Laurens
Rum Bottle, 1916–17
Polychrome wood and sheet steel, 28.5 cm
Musée de Grenoble

signs, nuanced by an astringent surreal aesthetic. I interpret these two worlds of art as complementary and fused in that hard-to-define golden decade that preceded the dramatic polarization of the 1930s. In 'Amor y muerte en los dibujos de Picasso' (Love and Death in the Drawings of Picasso) María Zambrano grasped the heart of the matter: 'The whole of Picasso's art is the ultimate outcome of an erotic fury that immerses itself in its own object to discover its entrails. Picasso has exposed the entrails of art.'[17] Not a bad image with which to re-examine the artist from the perspective of the twenty-first century.

17 María Zambrano, *España, sueño y realidad.* Madrid, Fundación María Zambrano, 1965.

Study for a Guitar on a Table, Juan-les-Pins, [Summer] 1924
Pen and Indian ink on Arches paper, 31.5 x 23.5 cm
Sketchbook 30, MP 1869, f. 17 r. Musée National Picasso, Paris. Z V, 312 [●]

Life and Death in Picasso

Still Life / Figure, c. 1907–1933

CHRISTOPHER GREEN

'Toi le grand fleuve de feu nourricier et l'exterminateur'
(You, the great river of life-giving and murderous fire)
Balthus (Balthasar Klossowski) to Picasso, 22 October 1956[1]

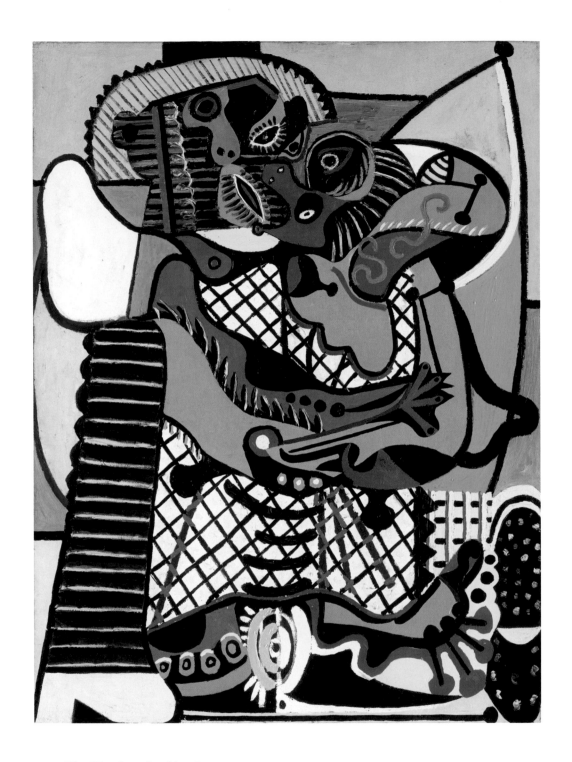

Fig. 1 *The Kiss*, Juan-les-Pins, Summer 1925
Oil on canvas, 130.5 x 97.7 cm
Musée National Picasso, Paris. MP 85. Z V, 460

1 Picasso's Sun

In 1907, Picasso made a hurried pencil drawing on a sketchbook page, where mask-like faces seem to have grown one after another on the paper like plants (p. 53). Dating from the period of his first encounter with African art, these faces are at once emblematically human and vegetable, their faces scored by angled striations like Kota reliquary figures from West Africa but also veined like leaves. At this moment, too, Picasso was making drawings of trees and drawings of nudes whose linear rhythms can seem almost interchangeable (pp. 54–57). This sketch and these drawings were made at a turning point for Picasso: at the point of release for his inventive powers in his unresolved masterpiece, *Les Demoiselles d'Avignon* (Fig. 2, p. 41), with its Cubist outcomes. The little sketch *Faces* freezes for us a moment of transformative invention, where beings can become plants and plants beings, and where both grow, as all things do, under the sun.

Nearly two decades later, on 23 July 1924, Picasso was more decisive and controlled when he used pen and violet ink to make a drawing, almost identical in size, of three sprawled sunbathers on the beach at Juan-les-Pins in the South of France (p. 52). This drawing too was made at a turning point in his work, at the point when his openness to the transformations that could take place as he drew and painted began to take him towards a newly forceful and sexualized imagery which has been aligned with Surrealism ever since. The sun plays a double role in this little drawing. Vibrating thick black stripes set it ablaze in the sky, while it seems to re-appear as a small disk with radiating rays on one of the bodies laid out below: the sun as navel or as female sex surrounded by pubic hair.

In this drawing, the starkly schematized signs fuse pattern-making and representation in a way that anticipates one of the two major paintings produced by Picasso in 1925 that announce unequivocally the new erotic direction of his work, *The Kiss* (Fig. 1,

1 Cited from Laurence Madeline, *'On est ce que l'on garde!', Les Archives de Picasso* (exh. cat.). Paris, Réunion des Musées Nationaux, 2003, p. 82.

p. 38). Here, on the scale of a grand portrait, Picasso translates a moment of violent sexual encounter into a brutally coloured crowd of signs, from which again the sun shines out. A massive head, upper right, probably male but possibly female, devours a smaller head. The mouth and one of the eyes of the larger head are ellipses that radiate rays. Set into the face are signs for the sun that are also signs for the female sex. At the base of the painting, between shod and unshod feet the female sex reappears, again ablaze as another brighter sun.

The other major painting of 1925 that announces Picasso's new direction is the Tate's monumental canvas, *The Dance* (or *The Three Dancers;* Fig. 4, p. 46). It combines the stripped-down planes of Picasso's late Cubism with the new fusion of pattern and erotically charged sign-making. The sun does not appear in this case, but its presence is announced behind the dancers, by the blue sky seen through the open terrace window which invites the imagination into a sun-drenched landscape.

This catalogue text is plotted between a beginning at the moment of the *Demoiselles d'Avignon*, around 1907, and an ending in the years just following 1925, when Picasso's semi-detached but crucial association with Surrealism was initiated. In between there is the adventure of Cubism and its post-war sequel in Picasso's work, its unexpected alliance with his so-called neo-classicism, a history that involves writers and other artists, including his close friends, the poet Guillaume Apollinaire and the young Spanish painter Juan Gris. I have chosen to introduce this beginning and this ending with images that give a role to the sun, either directly or indirectly, for a reason: because the exchange between the dead and the living, between things and human figures, which is the theme of this exhibition, is played out, it could be said, under the sign of the sun. In the plant/head sketch, the sun creates life and growth. In the sunbather drawing and the two paintings *The Kiss* and *The Dance*, the sun and Eros are brought together, explicitly so in *The Kiss* with Picasso's solar signs for the female sex. The sun and Eros are fused to form symbols of love as a creative, a vital force, and also as symbols associated with violence and even death. In *The Kiss*, the lovers' clinch could be murderous. In *The Dance*, Picasso himself identified the flat shadowy dancer on the right as the effigy of his friend Ramon Pichot, who died while Picasso was working on the painting.[2] On either side of a dancer with arms raised in emulation of the Crucifixion is a dancer emblematic of ecstatic sexual release – a figure

2 The first to analyse the picture iconographically, taking account of Picasso's identification of Pichot, was Alley. See Ronald Alley, *'The Three Dancers'*. Newcastle-upon-Tyne, Newcastle University, 1967 (The Charlton Lectures; 48).

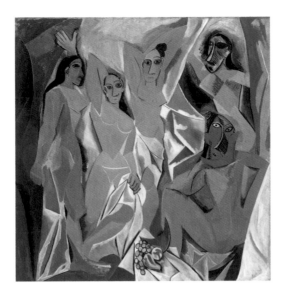

Fig. 2 *Les Demoiselles d'Avignon*
Paris, June–July 1907
Oil on canvas, 243.9 x 233.7 cm
The Museum of Modern Art, New York

whose rigidity and sombre restraint went hand in hand, for Picasso, with the ever-present reality of death.[3] In these images, the sun has a role that is at first simply life-giving, but ultimately, in fusing the solar and the sexual, brings life and death together.

Picasso's work was made in a small avant-garde world where painting and sculpture co-existed with poetry, and where visual art was given its first commentaries by poets. The poet closest to Picasso was Apollinaire, from the 1900s until his untimely death in 1918, a victim of the influenza epidemic that swept Europe. In the period of Picasso's introduction into the Surrealist milieu in Paris (1924–30), there is no poet or writer whose role in relation to Picasso can compare with Apollinaire's. However, in approaching his work of this period, over the last twenty years commentators and historians have singled out two writers above all others as intermediaries between that time and our own: the founder of Surrealism, André Breton, and more recently the so-called dissident Surrealist, Georges Bataille.[4] Apollinaire and Bataille both compulsively returned to solar imagery, and both, in diametrically opposed ways, placed Picasso under the sign of the sun, fully cognizant of the metaphorical force of the solar image as life-giving and life-consuming.

3 The first to make the crucifixion reference was Gowing. See Lawrence Gowing, 'Director's Report', *The Tate Gallery Report, 1964–1965*. London, Tate Gallery, 1966, pp. 7–12.
4 See, for instance, chapter 3, 'Uncanny Doubles', which centres on Picasso, in Lomas's important study of Surrealism, psychoanalysis and identity. David Lomas, *The Haunted Self: Surrealism, Psychoanalysis, Subjectivity*. New Haven and London, Yale University Press, 2000.

Bataille wrote little about Picasso, but in 1930 he put together a special number of *Documents*, the periodical he edited, entirely dedicated to the artist. Though his own contribution was a short piece, it has been the focus

of a quantity of recent analysis out of all proportion to its length, from myself among others.[5] This text is entitled 'Soleil pourri' (Rotten Sun). 'The sun, speaking from the human viewpoint […],' writes Bataille, is 'the most elevated of conceptions.' Its perfect circularity means that it possesses 'the sense of mathematical serenity and of spiritual elevation.'[6] Yet it is impossible to look at. The eye is drawn to it, but it blinds, and in myth it is associated with death: the sun and blood are fused in the symbol of the eviscerated man, bull or cockerel of sacrificial ritual. The aspiration to ascend to the sun has its inevitable consequence: 'the pinnacle of elevation is merged, in effect, with a sudden fall, of exceptional violence.' There are 'two suns from the human standpoint' one ascending to the ideal, the other falling like Icarus to death.[7] For Bataille, Picasso's recent painting – the work that succeeded *The Kiss* and *The Dance* – decomposes form, and in overturning the idealism of the academy breaks the impulse to ascend to the sun. In post-psychoanalytic terms, taking account of Freud's late theory of the drives, it is a manifestation of the dominance of the sadistic death drive over Eros and the life drive.[8]

Nothing could be further from Apollinaire's sun, and especially from the way he applied solar imagery to Picasso's work (the name Apollinaire was, of course, a pseudonym whereby the poet identified himself with Apollo and the sun). In May 1917, Apollinaire published a short text for the programme of the Diaghilev production of Cocteau and Massine's ballet *Parade*, which was performed to Eric Satie's music, with costumes and sets by Picasso. Massine's choreography, Apollinaire writes (to which, as he put it, Picasso's costumes and scenery 'bore witness'), was so human and so joyful that it could have lit up the terrible black sun of Albrecht Dürer's famous sixteenth-century print, *Melancholy*.[9] For Apollinaire, Picasso's art was always ascending, raised upwards to the sun. His very first piece on the artist, published in May 1905, just months after their first meeting, introduces his art as solar in this sense: 'these eyes are alert like flowers which always want to gaze upon the sun.'[10] The piece, complete with this metaphor, was re-used with minor changes to open the Picasso chapter in Apollinaire's collage of texts published in 1913 as 'Méditations esthétiques: Les Peintres cubistes' (the chapter of the book with which he would later express most satisfaction).[11] If Picasso and his art grow towards the sun, like the flowers, they are also winged like a bird. As Peter Read has pointed out, Picasso is repeatedly associated with bird imagery in Apollinaire's writing, perhaps most

5 Georges Bataille, 'Soleil pourri', *Documents*, Paris, 2nd Year, no. 3, 1930, pp. 173–74.
6 Ibid.
7 Ibid., p. 174.
8 Freud's late topography is developed in: Sigmund Freud, *Beyond the Pleasure Principle* (1920) and *The Ego and the Id* (1923).
9 Guillaume Apollinaire, 'Programme de *Parade*' (18 May 1917); in Apollinaire, *Œuvres en prose complètes*, vol.II (Pierre Caizergues and Michel Décaudin, eds). Paris, Gallimard, 1991, pp. 865–67.
10 Guillaume Apollinaire, 'Les Jeunes: Picasso, peintre', *La Plume*, Paris, 15 May 1905; in Guillaume Apollinaire, *Œuvres complètes*, vol. IV (Michel Décaudin, ed.). Paris, A. Ballant et J. Lecat, 1966, p. 65.
11 Guillaume Apollinaire, 'Méditations esthétiques: Les Peintres cubistes' (Paris, 1913), in *Œuvres en prose complètes*, vol. II (1991), op. cit., pp. 19–22.

tellingly when he compares him to Michelangelo in an article of 1912. Here he presents Picasso's career as an uninterrupted ascent towards the light. 'Picasso is among those of whom Michelangelo said that they deserve to be called eagles because they overtake all others and rise towards day through the clouds as far as the light of the sun.'[12] Apollinaire ends this piece with Goethe's last words: 'More light!'

At this date, in 1912–13, light had come to signify for Apollinaire something close to the conventional idea of light as knowledge, but that idea was given a particular inflection by his commentaries on Cubism alongside those in particular of another member of Picasso's circle, Maurice Raynal.[13] For them, Cubism had come to stand for an approach to painting as representation that was conceptual rather than perceptual. Picasso, the Cubist, painted from his knowledge of things, not merely by observing them: he illuminated them with his knowledge of them from many viewpoints. Picasso becomes, in a sense, a solar force himself, infusing dead things with life. He dissects a dead world of objects as a surgeon dissects a corpse, Apollinaire writes in 1913, but his knowledge illuminates it and so gives it life.[14]

Light thought of in this way gives some metaphorical purchase when one views the mysteriously diffused light with no single identifiable source which gives salience to the sharp, faceted geometry of Picasso's so-called 'hermetic' Cubist paintings of 1910–12, as if objects and things are lit from within (Fig. 3, p. 44). Most memorably, however, it is when Apollinaire writes, in 1913 again, about the introduction of real objects into Picasso's work with collage, that the poet finds the words for this idea of dead material infused with light in his friend's painting. A song-sheet, a postage stamp, a newspaper cutting, a piece of oilcloth, all are transformed by 'the immense light of the depths'.[15]

There is, however, another aspect to this imagery of light and the sun in Apollinaire's writing on Picasso and art: the flame, and the flame does not merely illuminate, it burns. Writing about painting in general, not exclusively about Picasso, he first brings fire, the flame and light together in 1908, in a passage reprised five years later in his 'Méditations esthétiques: Les Peintres cubistes': 'Flame is the symbol of painting …

12 Guillaume Apollinaire, 'De Michel-Ange à Picasso', *Marches de Provence* (February and October 1912), in Apollinaire, *Œuvres en prose complètes*, vol. II (1991), op. cit., pp. 396–98. Read's analysis of the relationship between Picasso and Apollinaire is the most searching and the most dependable. Inevitably I have greatly benefited from his work here. See Peter Read, *Picasso et Apollinaire: Les Métamorphoses de la mémoire, 1905/1973*. Paris, Jean-Michel Place, 1995.
13 Read calls light a 'lexical thread' in Apollinaire's writing. See Guillaume Apollinaire, *The Cubist Painters* (translated by Peter Read), in Peter Read, *Apollinaire and Cubism*, vol. II. Forest Row, East Sussex, UK, Artists Bookworks, 2002, p. 59. It is significant that Apollinaire's view that Cubism is essentially 'conceptual' is especially clearly stated early in 1913, at the date of his promotion of Robert Delaunay's commitment to the painting of light in colour. See Guillaume Apollinaire, 'Die moderne Malerei', *Der Sturm* (Berlin, February 1913); *Œuvres en proses complètes*, vol. II (1991), op. cit., pp. 501–5.
14 The surgeon metaphor is applied to Picasso in the article immediately preceding Apollinaire's 'Méditations esthétiques: Les Peintres cubistes' and again in the Picasso chapter of the book. See Apollinaire, *Œuvres en prose complètes*, vol. II (1991), op. cit., p. 24.
15 Guillaume Apollinaire, 'Méditations esthétiques: Les Peintres cubistes' (1913), in 'Pablo Picasso', *Montjoie!* (Paris, 14 March 1913); in Apollinaire, *Œuvres en prose complètes*, vol. II (1991), op. cit., p. 22.

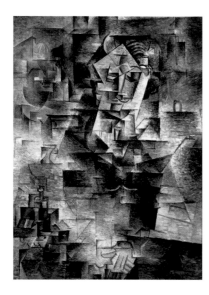

Fig. 3 *Daniel-Henry Kahnweiler*, 1910
Oil on canvas, 101.1 x 73.3 cm
The Art Institute of Chicago. 1948.561

Flame has that purity which will tolerate nothing foreign to itself and cruelly transforms into itself all that it reaches.'[16] The flame may illuminate, but it also consumes 'cruelly' what it touches. Ultimately, even in Apollinaire's imagery of the flame and of light, there is a hint of Bataille's blinding, burning, rotten sun.

Glasses, bottles and musical instruments that recline, jostle and dance on stage-like tables (pp. 137 and 139); assemblages of furniture and objects that have legs and bodies and heads (pp. 78 and 97): this exhibition is full of images in which Picasso can seem to infuse dead things with an anthropomorphic vitality. They are images in which Apollinaire would have seen an invented world created from the imaginative transformation of the visible world: our world consumed by the flame of Picasso's art, revived in the light of his knowledge of the human figure and of everything else that fell under his gaze. From that little sketch of plant-like heads of 1907 into the early 1920s, these images are more easily placed under the sign of Apollinaire's life-giving than that of a burning sun, though one painting, *Musical Instruments, Skull* (p. 175) reserves a place for the sign of death. Also in this exhibition are still lifes (pp. 163 and 167) where objects are like dismembered yet sexually animated body parts whose organic forms are of the same order as those that do combat in *The Kiss*. In these dismembered still lifes, Picasso has sometimes violently attacked the picture surface, cutting into the wet paint with a sharp point to draw, as if his objects-as-bodies can only be won by sadistic force. It is

16 The passage first appears in Guillaume Apollinaire, 'Les trois vertus plastiques', preface to the catalogue of the 'IIIe Exposition de l'art moderne' (Hôtel de Ville, Le Havre, June 1908). It is cited here from Apollinaire, 'Méditations esthétiques ...', op. cit., p. 6.

easier to place these works under the sign of Bataille's burning sun, in the heat of which death will always win.

Such a simple binary analysis of Picasso's work in which either the life drive or the death drive incontrovertibly dominates is, however, misleading. Picasso's art, whether his subjects are human figures or dead things, always concerns both the living and the dead, and does so in ways that, I believe, we its viewers have to resolve or leave unresolved for ourselves. It is to be viewed under both Bataille's suns: the sun to whose illumination Apollinaire imagined Picasso ascending, and the sun in whose blazing heat Bataille imagines Picasso falling.

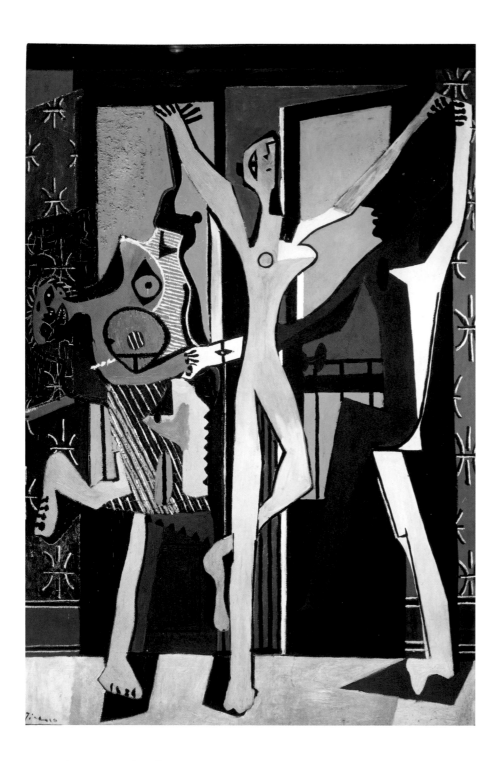

Fig. 4 *The Dance (The Three Dancers)*, 1925
Oil on canvas, 215.3 x 142.2 cm
Tate, London

II Apollinaire, Breton, Bataille:
The Dance and Life and Death Relationships

The ambivalence of the relationship between the living and the dead in Picasso's work is nowhere more disturbing than in *The Dance* (Fig. 4). Reading from left to right, we move from the ecstatic dancer whose elastic mobility threatens to tear her body into pieces to the upright figure of the central dancer, lithe, corporeal and whole, and then to the rigid angular geometry of the dancer on the right whose profiled shadowy head is that of the dead Pichot. One of the best and earliest extended analyses of the picture, Lawrence Gowing's, reads all three figures in a highly sophisticated post-Cubist way, the multiplication of breasts in the ecstatic dancer signalling movement, and the twisting of ribbon-like planes in the dancer on the right signalling shifts of viewpoint.[1] I would emphasize instead, however, the fact that Cubism in its architectural idioms – Cubism as geometry – dominates only in the dancer on the right, so we have, it follows, a movement, left to right, from sexualized life in motion to the dead geometry of the inanimate, from frenzied vitality to the frozen rigidity of the automaton.

But is the reading invited necessarily from the left to the right? Gowing has convincingly suggested that it is the deathly dancer on the right who 'ordains' or directs the dance, as a painter might pose his models, which gives this dancer the function in the picture of the curtain-raiser in the *Demoiselles d'Avignon* (Fig. 2, p. 41), just as the erotic release enacted by the ecstatic dancer on the left echoes that invited by the dangerously sexualized crouching nude on the right of the 1907 picture. In the *Demoiselles*, the curtain-raiser invites from the viewer a simple left-right move across the painting, which is stopped by the croucher and her companion on the right. In *The Dance*, the deathly dancer on the right, the Cubist figure-as-dead-object who 'ordains the dance', meets that movement and reverses it. This left-to-right movement is consistent with normal reading behaviour

1 Lawrence Gowing, 'Director's Report',
The Tate Gallery Report, 1964–1965.
London, Tate Gallery, 1966, pp. 7–12.

for a Western viewer, but entry from the left is repulsed rather than invited by the flung-back motion of the ecstatic dancer. The inclination to follow the movement of the dance left-to-right is resisted and then reversed. The movement invited is neither towards nor away from the stern presence of death; a never-resolved oscillation is invited between erotic release and the immobility of death, between animation and lifelessness.

Even where the relationship between the living and the dead is not so directly dramatized, where Picasso's work moves, sketchbook page by sketchbook page, canvas by canvas, between simple schematized signs for human figures and for dead objects, there is in general terms this kind of ambivalence: there is no clear direction from the dead to the living or vice versa, but rather a continual oscillation, a bewildering succession of exchanges in which figures and objects can be either dead or alive, or both at once, like the proverbial dancing skeleton.

Hal Foster's far-reaching critical reassessment of the Surrealist project sets up an opposition between a Bataillean acceptance of the primacy of the death drive and an aspiration promoted by the Surrealist leader André Breton towards the resolution in imagination and in dream of the forces of love and death.[2] Against the Bataille of 'Soleil pourri' is pitched the Breton of a famous passage from the *Second Manifesto of Surrealism* (1929), where Surrealism is defined as the point at which all the fundamental antinomies, above all life and death, are no longer experienced as contradictory.[3] And against Bataille's acceptance of the immanence of violence and death in human life, Foster pitches Breton's devotion to Eros.

The 'uncanny' is the key to Foster's argument that, for all Breton's aspiration to such a resolution and his devotion to Eros, the death drive invariably underlies much Surrealist art. The notion of the uncanny he brings to bear is that developed in a much-cited essay of 1919 by Freud.[4] This essay identifies the automaton as the paradigm of the uncanny, a dead mechanism that appears alive – my allusion to the automaton in my characterization of the dancer on the right of *The Dance* is an allusion to the uncanny. The automaton, in Freud's argument, inspires fascination yet also fear, and it does so because, he believes, it is a reminder of our prior state before conception in the

2 Hal Foster, *Compulsive Beauty.* Cambridge, Mass./London, MIT Press, 1993, p. xviii and chapter 1, 'Beyond the Pleasure Principle', pp. 1–18.
3 André Breton, 'Seconde manifeste du surréalisme', *La Révolution surréaliste*, Paris, no. 2, 15 December, 1929.
4 Foster (1993), op. cit., and Sigmund Freud, 'The Uncanny' (German edition, *Imago 5* (5–6), pp. 297–324); in Sigmund Freud, *Art and Literature.* London, Penguin, 1985 (The Pelican Freud Library; 14).

inanimate condition of death. The death drive as a regressive impetus to return to that condition is the topic of *Beyond the Pleasure Principle*, his major realignment of his theory of the drives published almost simultaneously with the essay on the uncanny.[5] Freud's uncanny induces anxiety because with it the repressed returns; in this instance, the repressed attraction of death.

Picasso's strange fusions of the dead and the living in his anthropomorphic still lifes are certainly, on the face of it, as uncanny in Freud's and Foster's terms as the mannequins and automata that fascinated Breton and his friends, and so might seem to demand an analysis that privileges the inanimate and death above animation and life. Especially in the proliferation of pedestal-table still lifes and reclining musical instruments on paper and canvas between 1916 and 1922 (pp. 78, 99–101 and 103–4), we can identify on Picasso's part a compulsive need for repetition (to which I shall return), and so it can seem that the anxiety associated with the return of the repressed can be straightforwardly diagnosed: the secret and feared attraction of death.[6] And yet, these are not images that, by any stretch of the imagination, could be said to induce anxiety in the viewer, and it is difficult to imagine that they were produced compulsively under the pressure of anxiety. They are dead and alive, but not simply to be identified as uncanny, as perhaps the deathly dancer on the right of *The Dance* can be.

The uncanny as theorized by Freud will figure in my discussion of the dead and the live in Picasso, but it will not drive that discussion, and I shall not allow death a dominant role in my analysis. I am not concerned to uncover in Picasso's repeated invention of dead-alive objects and figures the symptoms of anxiety and thus a compulsive manifestation of the death drive. I want instead to bring out his images' openness to often unresolved, contradictory responses, where the dead and the live confront each other without a winner, and where, too, an invigorating wit often supervenes on the side of life and the pleasure principle. After all, Freud himself recognized that there is a fundamental difference between the uncanny in actual experience and the pictured or fictionalized uncanny. What should be uncanny, he observes, need not be uncanny in fiction, and taking an instance easily aligned with Picasso's wittier anthropomorphic inventions, he himself acknowledges that while household utensils,

5 Sigmund Freud, *Beyond the Pleasure Principle* (German edition; 1920); in Sigmund Freud, *On Metapsychology*. London, Penguin, 1991 (The Pelican Freud Library; 11).
6 The compulsion to repeat was certainly central to Freud's thesis in *Beyond the Pleasure Principle* and is also important to his essay 'The Uncanny'. Foster, in *Compulsive Beauty*, makes it central also to his argument for the uncanny as an essential feature of Surrealism. See notes 2, 4 and 5.

furniture and tin soldiers may be brought to life in Hans Christian Andersen's stories, 'nothing could be more remote from the uncanny'.[7] The uncanny requires the disruptive presence of anxiety. As I have suggested, there is little to induce anxiety in the anthropomorphic pedestal-table and reclining musical-instrument still lifes of 1916–22.

It is the ambivalence of the dead-alive in Picasso that most concerns me: his acceptance of contradiction and of the impossibility of the stasis of resolution or the finality of victory for either Eros or death. *The Kiss* might seem to represent the irresistible force of violence within the erotic, and so the equally irresistible attraction of death, but, as we have seen, *The Dance* returns the relationship of love and death to the circularity of the *ronde*, where neither dictates.

I have argued elsewhere that Picasso's work can be thought of as bringing together, often confrontationally, the architectural and the vertiginous. In this context, the architectural is understood as the urge to build structures both formal and iconological, and so to identify with traditions and with the collective within society, and the vertiginous is understood as the urge to pull structures apart on every level, and is associated especially with the eroticization of Picasso's art in the context of Surrealism, when the ecstatic and the murderous converge.[8] As will become clear, it is a simplification to say that the conflict explored here between the living and the dead is merely the confrontation between architecture and vertigo in another register, but in both cases Picasso refuses any final resolution or *dénouement*.[9]

Breton might have aspired to reach that point where the life/death antinomy would be resolved; but there is nothing to indicate that it was more than an aspiration. Unresolved contradiction remains a consistent feature of Surrealist theory and practice. The 'marvellous' in Surrealism occurs only when 'distant realities' are brought into confrontation, while the three categories of 'la beauté convulsive' (compulsive beauty) identified by Breton between 1928 and 1937 – the veiled erotic, the fixed explosive and the magic-circumstantial – are all

7 S. Freud, 'The Uncanny', op. cit., p. 369.
8 Christopher Green, *Picasso: Architecture and Vertigo*. New Haven and London, Yale University Press, 2005.
9 I argue for an oscillating relationship between the poles of 'architecture' and 'vertigo' in Picasso's work in ibid., chapter 2.

contradictory, as is the very notion of a beauty that is convulsive.[10] It is worth remembering, too, that Apollinaire, in his very first piece of critical writing on Picasso, did not evade the unresolved contradictions he already found in his painting but rather drew them out as a positive quality. He writes of everything about the work he saw in 1905 as enchanting, and remarks of Picasso: 'his talent appears to me at the service of a fantasy that mixes in just the right proportions the charming and the horrible, the abject and the refined.'[11]

10 Breton writes of 'the marvellous' as the coming together of distant realities so that a spark is extracted, in 'Max Ernst', May 1921; reprinted in André Breton, *Les Pas perdus*. Paris, Éd. de La Nouvelle Revue Française, 1924, p. 87.
11 See section 1, note 10.

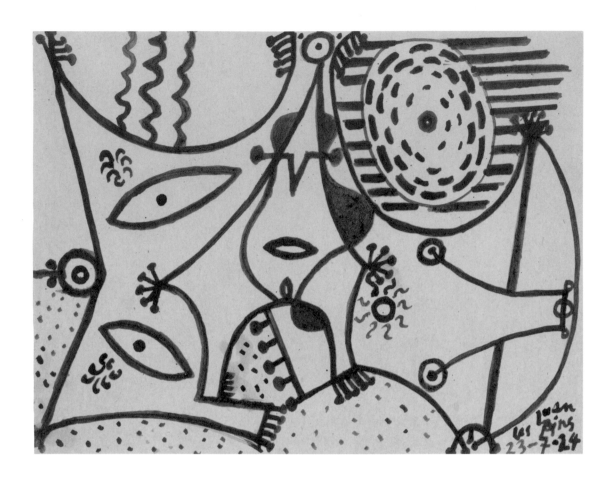

Three Bathers, 23 July 1924
Violet ink on paper, 15.6 x 20.1 cm
Musée National Picasso, Paris. MP 999. Z V, 460

Faces, 1907
Pencil on paper, 22 x 16.3 cm
Musée National Picasso, Paris. MP 1990-56. Z VI, 962

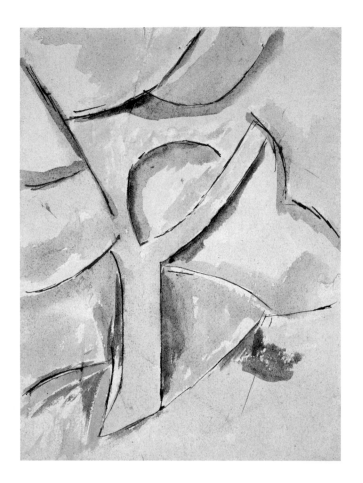

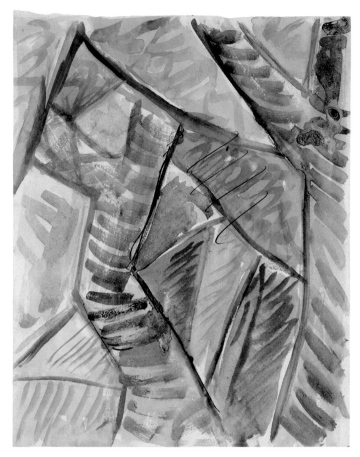

Tree, 1907
Watercolour on paper, 22 x 16.5 cm
Private collection

Landscape related to *The Harvesters*, Spring 1908
Watercolour on paper, 22.3 x 17.5 cm
Private collection

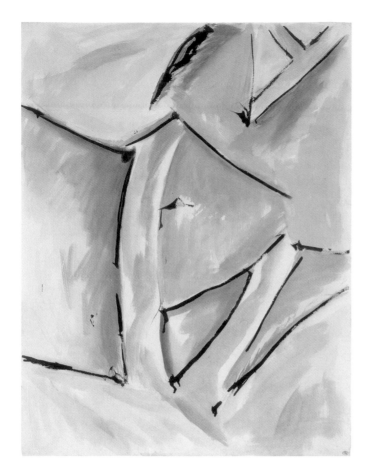

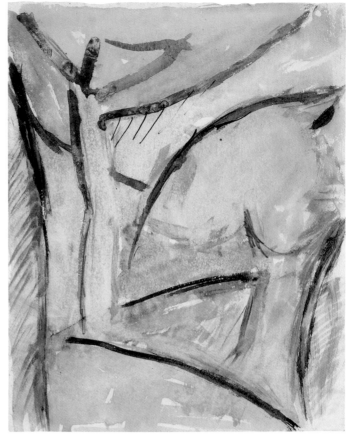

Landscape related to *The Harvesters*, 1907
Gouache on paper, 63 x 48 cm
Musée National Picasso, Paris. MP 544. Z XXVI, 173

Landscape related to *The Harvesters*
Paris, Spring–Summer 1907
Watercolour on paper, 22.4 x 17.5 cm
Private collection. Z VI, 955

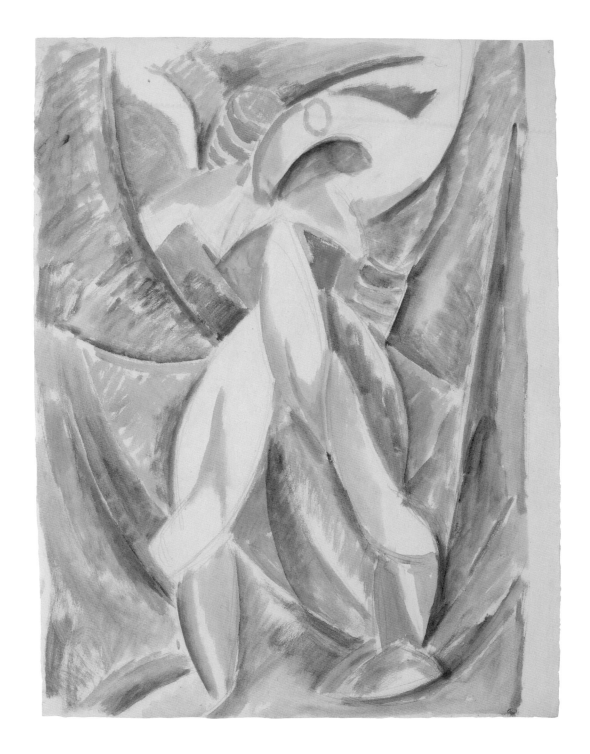

Study for *Standing Nude*, Paris, 1908
Gouache and pencil on paper, 62.6 x 47.8 cm
Musée National Picasso, Paris. MP 568. Z XXVI, 325

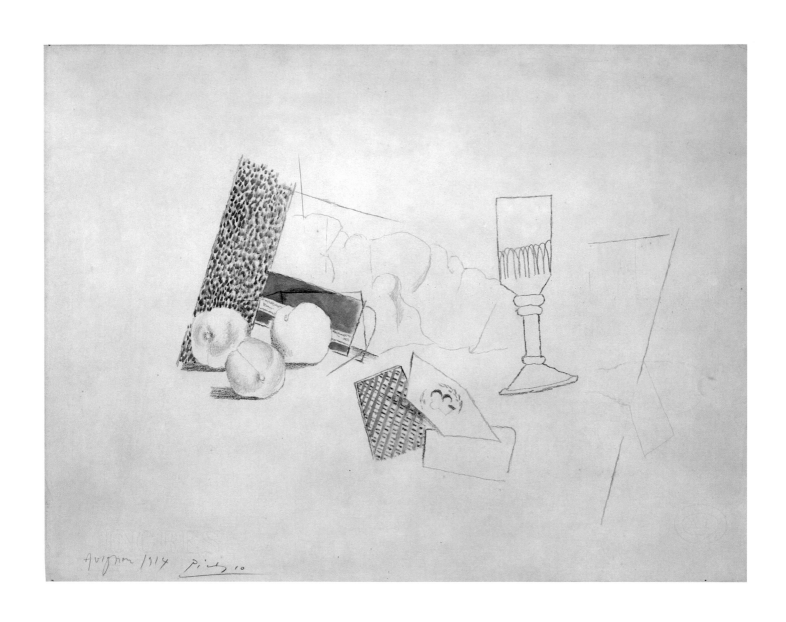

Still Life with Playing Cards and Peaches, Avignon, 1914
Watercolour, charcoal and pencil on Ingres paper, 48.5 x 62.3 cm
Galerie Beyeler, Basle

III Transformations

The dead and the live confront each other in Picasso's work, but fundamental to how that confrontation is played out as both he and his viewers experience it is the fact that one can be transformed into the other, and their availability to such an exchange is there to be seen. As I suggested at the beginning, Picasso's ability to transform plants into heads and suns into sexes is central to this exhibition. Crucial to gaining some purchase on that bewildering capacity of his is the development of Cubist practices – both as he took them forward and as Juan Gris appropriated, adapted and capitalized on them. Cubism unfixed identities, and was seen to do so.

Surprising inclusions in the exhibition, perhaps, are one of Picasso's 'classical' Harlequins of 1923 – *Harlequin with a Mirror* (p. 141) – and Gris's late Cubist *Pierrot* of two years earlier (p. 83). Cubism, however, was indelibly associated with the *Commedia dell'Arte* by the early 1920s, and that association went with its unfixing of identities. In 1924, the French critic-curator Claude Roger-Marx called Cubism 'le manteau d'arlequin' (the cloak of harlequin).[1] Picasso's willingness to switch between the 'neo-classicism' of his *Harlequin with a Mirror* and the Cubism of, say, the great series of tabletop still lifes painted at Juan-les-Pins in the summer of 1924 (pp. 135, 137 and 139) was a major cause of his notoriety among middle-of-the-road critics like Roger-Marx. The characters of the *Commedia dell'Arte* – Harlequin, Pierrot, Colombine – still had currency in the party-going Paris of the 1920s as the fancy-dress characters of carnival and Mardi Gras, and Harlequin's role as trickster was accepted within that near-ritual party format: Harlequin, the master of style as disguise. To say, as Roger-Marx did, that Cubism was the cloak of Harlequin was to say that the tricks and the transformations of Cubism amounted to a kind of dishonesty, a frivolous refusal on the part of the Cubists to be, transparently, themselves. Picasso's readiness to

1 Claude Roger-Marx, 'Chronique artistique', *Les Nouvelles littéraires*, Paris, 12 January 1924, p. 5.

switch styles made him, for such critics, the clearest possible manifestation of that deceitfulness, of the hollowness of the entire avant-garde project in its Cubist and post-Cubist forms.

One can understand Roger-Marx's insistence on the connection between Cubism and the figure of Harlequin, since so many of the Cubists, Gris among them, replaced the individualized portrait with the masked characters of the *Commedia dell'Arte*. Picasso's *Harlequin with a Mirror* is posed in the act of taking on a new identity, at least in his mirror: by putting on the hat, this youthful *saltimbanque* takes on the identity of Harlequin. Even more than Picasso's Harlequin, Gris's *Pierrot* is an image that speaks of masking and the switching of identities, and does so in ways that anticipate my discussion here. Gris's Pierrot is masked, and his masked head is almost exchangeable with the object (is it a glass or is it a fruit bowl?) in front of the figure. One can turn into the other.

As we shall see, certain opportunities opened up by Cubist practice were crucial to both Picasso's and Gris's capacity to turn one thing into another. Also crucial was, and still is, the viewer's willingness to take part in the performance. Harlequin and Pierrot are maskers. Harlequin in particular uses disguise to change identity, but every change of identity depends, of course, on the beholder's willingness to go along with it: his audience has to be knowingly or unknowingly complicit. Early on in the critical history of Cubism as a public phenomenon, it was realized that Cubist works invited the active engagement of the viewer in finding meaning. Cubist works were, in a sense, made by their viewers as well as their artists.[2] By the 1920s, if the question of honesty or sincerity was at issue, it was the viewer's as much as (or even more than) the artist's good faith: what can we, as individuals, really see in the images offered us? Are there meanings to be found where all that is offered is a mask?

The analysis of Cubist art, especially that of Picasso, as a set of consciously exploited sign systems is the development of the last two or three decades that has done most to deepen understanding of its transformational capacity, and at the same time has done most to focus attention on the degree to which Cubist art gave the viewer a newly active role in making meaning. The moment now commonly accepted as the point of

2 Perhaps the first to make this point explicitly in these terms was Roger Allard. As early as 1910, he was writing of objects in paintings by Jean Metzinger appearing subjectively as thought by each of their viewers. He makes the point most clearly, however, writing for a German readership. See Roger Allard, 'Au Salon d'Automne de Paris', *L'Art libre*, Lyon, November 1910, p. 442, and Roger Allard, 'Die Kennzeichen der Erneuerung in der Malerei', *Der Blaue Reiter*, Munich, 1912.

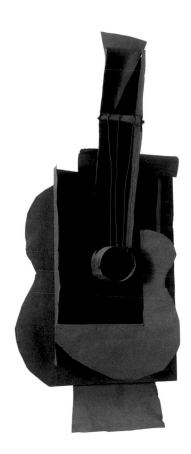

Fig. 5 *Guitar*, Paris, 1912–13
Sheet metal and wire, 77.5 x 35 x 19.3 cm
The Museum of Modern Art, New York

departure for Cubism as a practice open to this kind of play with identities in an unprecedented way is late in 1912. It was then that Picasso cut and folded the cardboard and string maquette for the sheet-metal *Guitar* now in the Museum of Modern Art, New York (Fig. 5).[3] I am one of many to have brought out the possibilities opened up by Picasso in this piece, but it is necessary for me briefly to sum them up again here.[4]

Two major kinds of possibility were opened up. One might be called constructive, 'architectural' and, especially in the case of the iron version, modern in an optimistic, progressive sense. It opened up the possibility of assembling sculptures from components as if from a plan or blueprint in emulation of the building of an industrialized, modern world. The second kind of possibility that was opened up came from the emphatically semiotic character of the piece. The viewer is confronted not with a straightforward simulacrum of a guitar, but with a collection of signs that, put together as they have been, can

3 The importance of the conception late in 1912 of the iron *Guitar* to this development was given entirely new emphasis by Yve-Alain Bois's essay 'Kahnweiler's Lesson', *Representations*, no. 18, Spring 1987.
4 See C. Green, *Picasso: Architecture and Vertigo*. New Haven and London, Yale University Press, 2005, pp. 153–63.

denote a guitar, but which put together in other ways could denote entirely different things: a head, for instance.

Two *Heads* of 1913, one from the Museu Picasso, Barcelona, the other from the Musée National d'Art Moderne in Paris (pp. 68–69) reveal just how interchangeable in Picasso's practice were signs that could contribute to representations of musical instruments and signs that could contribute to representations of heads. One is usually titled *Head of a Young Girl* (p. 69) and incorporates a double curve and a circle which in another context could easily function as guitar body and sound hole. That double curve reappears in the other (p. 68), bracketing, as the wavy hair of a woman might, an arrangement of signs easily read as a caricature-like face in which even the nostrils of the nose can be discerned. It is a symmetrical arrangement which announces just as clearly the possibility that the signs can be re-combined to make a guitar. The signs for dead things and living beings have become easily interchangeable, and the Barcelona *Head* in particular has the dead-alive character of a strangely fashioned puppet, its eyes fixed to wires. The months leading up to these two *Heads* had seen Picasso fill sketchbooks with drawings of possible figure sculptures assembled like over-elaborate automata (p. 70), for some of which he imagined heads that are *both* guitars *and* heads, not unequivocally one or the other (Fig. 6).

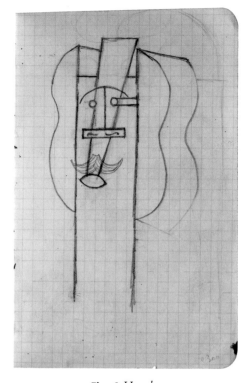

Fig. 6 *Head*
Céret, 1913
Graphite pencil on
squared paper
13.5 x 8.5 cm
Carnet 17, MP 1865, f. 26 r
Musée National Picasso, Paris

Between 1913 and 1915, Picasso moved from head-guitars or head-violins into a succession of exchanges between whole figures and both bottles and whole still-life arrangements, in anticipation of the anthropomorphic pedestal-table still lifes and the reclining musical instruments of 1916–22. Thus, in 1915 he produced a series of drawings and watercolours on paper, where a fruit bowl filled with fruit sits atop a table on which are crowded together musical instruments, often a clarinet, a guitar and a violin (pp. 71–73).[5] It some of these, stuck on top of a stem that has become an elongated stalk (or neck), the bowl of the fruit bowl can sometimes become a head, while the musical instruments throw 'arms' out from the 'body' of the table, so that the whole arrangement becomes a crazily gesticulating personage. The two heads discussed above are heads whose signs could be re-combined to become guitars; these

5 Pierre Daix and Joan Rosselet, *Picasso. The Cubist Years, 1907–1916. A Catalogue Raisonné of the Paintings and Related Works.* London, Thames & Hudson, 1979, nos 820–824, pp. 343–44.

watercolours of 1915 are *both* still lifes *and* strange figures, relying on the viewer to give them their double identity.

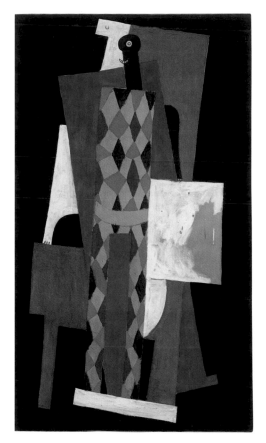

Fig. 7 *Harlequin*
Paris, late 1915
Oil on canvas
183.5 x 105.1 cm
The Museum of Modern Art
New York. Z II, 555

The year 1915 also saw Picasso paint a work that was immediately recognized by those who saw it, including Matisse, as especially important: the full-length *Harlequin* now in the Museum of Modern Art, New York (Fig. 7). The uncanny understood as a disquieting reminder of death is without a doubt a factor in this painting (if biography is to be brought into the discussion, it is usually associated with the death of Picasso's lover Eva). Harlequin is picked out as if by spotlight, wearing his garish motley on a stage plunged in darkness. The planes that give him presence are tilted far enough from the vertical to suggest a rocking vitality, the clockwork movement of an automaton. His grin is that of a death's head.

Unequivocally a dead-alive Harlequin, this figure is also the direct relative of the dead-alive bottles that feature in a series of 1914–15 still lifes. In closely related works on paper (p. 75), the stretched neck and tiny knob-head of the New York *Harlequin* reappears as a bottle that rocks as the figure rocks, making it, too, mobile. It jerks across the paper accompanied by a glass whose doubled bowl and stem can be read almost too easily as a body with legs. There are watercolours, also of 1915, where these bottle-figures or figure-bottles are costumed as Harlequin, and others where they dance.

Everything is treated as if alive, even when there can be no doubt that Picasso's subject is a still life. Certainly the most important of the 'living' still lifes that accompany the New York *Harlequin* is a relatively small but brilliant, jewel-like painting in the Detroit Institute of Fine Arts (p. 77). The object that 'dances' centre stage here is a bottle of Anís del Mono, a very distinctive kind of bottle (still in production) whose ridged and crevassed pattern of lozenges moulded in the glass is instantly recognizable, but acts simultaneously as an allusion to the lozenge pattern of Harlequin's costume.[6] Primed thus to find figures in objects, it is easy to find another in the glass to the bottle's right. Above the

6 I am by no means the first to have made these connections between Harlequins, dancing figures and the Detroit still life. They are made obvious by the juxtaposition of illustrations in William Rubin (ed.), *Pablo Picasso: A Retrospective* (exh. cat.). New York, The Museum of Modern Art, 1980, pp. 190–91. They are also discussed in Jean Sutherland Boggs, *Picasso and Things* (exh. cat.). Cleveland, The Cleveland Museum of Art, 1992, pp. 172–73.

multi-coloured speckled body of the glass Picasso has placed a combination of an ellipse (the rim of the glass) and an irregularly shaped six-sided figure surmounted by a triangle. Is it a glass or a guitar-player with a conical hat? Once figures are read, they are read in movement, endowed once again with the jerky mobility of automata. That jerky mobility animates even where the figurative reference is far harder to read, as for instance in the glass that rocks in from the right of a watercolour featuring fruit and playing cards (p. 58).

The animation of objects that went with the doubling of objects and personages in these still lifes of 1914–15 opened the way to the prolific series of anthropomorphic pedestal-table still lifes and reclining musical instruments of 1916–22.[7] Another still life that can be placed between the New York *Harlequin*, the Detroit *Bottle of Anís del Mono* still life and this series is the *Still Life with Door, Guitar and Bottles* of 1916 from the Statens Museum for Kunst in Copenhagen (p. 81). That jerky rocking motion is there again, and the blocky, hefty guitar and the lightweight, curvaceous bottle on the right are on a collision course. Their differences are now easily read as differences of 'character', even of gender, yet they remain objects, a guitar and a bottle, dead-alive like the New York *Harlequin*. So mixed are the codes in use in the series of 1916–22 that their owners (those viewers who have most engaged with them) have often given figurative titles to what are clearly more still life than figure subjects. There are two works on paper from a Barcelona collection that might seem easier to read simply as stringed instruments and fruit bowls on a pedestal table, but one now bears the title *Personage with Guitar* and the other *The Guitarist* (pp. 78 and 79).[8]

There remains one further property of Picasso's transformational sign-making to bring out. The key to the unfixing of identities that followed from the iron *Guitar* was rhyme. Heads could become guitars, guitars on pedestal tables could at the same time be guitar-players, because Picasso's simple range of iconic signs allowed the proliferation of visual rhymes: heads rhyme with guitars or fruit bowls. By the early 1920s, it was Juan Gris who was working most conspicuously with visual rhymes as a Cubist, and indeed he was doing so explicitly enough for critical commentary to theorize his rhyming practice.[9]

[7] It is worth noting that pedestal tables might dominate in Picasso's anthropomorphized still lifes from 1916, but that he also used still lifes on mantelpieces anthropomorphically. See Daix and Rosselet (1979), op. cit., nos 891 and 892, p. 356.

[8] Especially where works on paper are concerned, the titles of Picassos are constantly open to redefinition.

[9] I have discussed Gris's use of visual rhymes at greater length in Christopher Green, *Juan Gris* (exh. cat.). London, Whitechapel Art Gallery/Yale University Press, 1992, pp. 63–68.

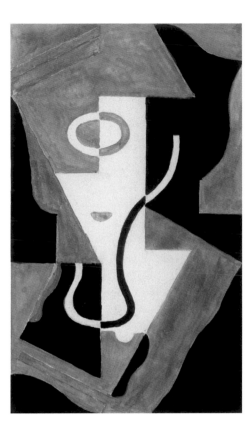

Fig. 8 Juan Gris
The Glass, April 1919
Watercolour on paper, 28.2 x 20.2 cm
Musée des Beaux-Arts de Dijon. Inv. DG 49

Two exemplary displays of what Juan Gris could do with visual rhymes are *Guitar and Fruit Bowl* of 1919 in the Henie Onstad Art Centre (p. 82) and the *Pierrot* of 1921 from the National Gallery of Ireland (p. 83). So like the guitar is the fruit bowl with bunch of grapes in the still life, and so like the Pierrot's masked head is the fruit bowl or glass in the figure-painting, that we can see instantly how one can become the other. In Gris's practice, as in Picasso's, there are many instances where it is possible to see from one painting to another how the sign for one thing can become the sign for another, how identities can become unfixed as he works between ideas. There are a watercolour (Fig. 8) and a small oil by Gris, both from 1919, whose subject is the relationship between a glass and a pipe, which show us almost certainly how the idea for the Henie Onstad still life began. As with Picasso's pedestal-table still lifes that become guitarists when titles are added, the slipperiness of identity in Gris's practice is underlined by the fact that the watercolour was once titled *Head of a Harlequin*. Differently styled, the glass and pipe from that small-scale idea reappear in the big still life. Above them is a guitar, and the guitar

seems literally to have been generated by the ascending curves that echo the silhouetted shadow above the glass in the little still-life idea. In turn, the guitar seems to have generated the bunch of grapes in its fruit bowl in rhyming response, the angled stalk of the grapes repeating the angled neck of the guitar, its body repeating the curves of the sound box. Pictorial invention here is a series of transformative shifts provoked by rhyming, which in the Dublin *Pierrot* move between the living (the Pierrot) and the dead (that glass or bowl on the table).

As I have shown elsewhere, it was Picasso's and Gris's critic friend Maurice Raynal who was led by the visible role of rhyming in the work of Picasso's friend to theorize the practice.[10] Writing in 1923, he aligned Gris's visual rhymes with poetic metaphor, the practice of going beyond likeness to fuse one thing with another: lips of coral *are* coral and yet also lips. Metaphor, Raynal contends, produces not mere likeness but wholly new entities out of the fusion of things, and he picks out as particularly illuminating in the case of Gris's rhymes-as-metaphors the rhetorical figure of catachresis, where two things are put together to designate something else entirely. A leaf of paper is neither a leaf nor just paper, but a leaf of paper. A table leg is neither a table nor a leg, it is a table leg.[11] In the case of Picasso's head-guitars, we have a head that is a guitar and vice-versa; and there is a level on which Gris's head-fruit-bowl or head-glass in his Dublin *Pierrot* are also both at once; but Raynal suggests that a new thing, a third thing, is created in this way, a thing that has its own cohesion and yet uses *both* the head *and* the fruit bowl to produce that third identity.

Picasso certainly used rhyming relationships to allow him to slip between identities as he drew or painted, though his rhymes were rarely as clear cut as Gris's and almost never as composed in their juxtapositions. It is necessary, however, to stress one important difference between Raynal's conclusions about rhyming in the practice of Gris and Picasso. Raynal suggests that the connections Gris made were in some way essential: that the artist found fundamental similarities at a deep level between different things, dead or alive. His metaphors have about them, then, something definitive: they are so cohesive and right in this combination as to constitute a new, third thing, with its own completeness. This is not, I believe, how Picasso approached such relationships. His practice was altogether

10 See my discussion in ibid.
11 Maurice Raynal, 'Juan Gris', *Feuilles libres*, Paris, April 1923; reprinted with minor changes in M. Raynal, *Anthologie de la peinture en France de 1906 à nos jours*. Paris, Montaigne, 1927, pp. 174–78.

more open. It was never oriented towards arriving at something decisively complete, at a definitive conclusion. Where visual rhymes were concerned, he tended to leave identities at least potentially open, even when he put down his pencil, pen or brush and moved on to something else. By the same token, the dead could often be alive, and if the dead-alive constitutes a third thing – as, for instance, in the bottles that are dancers or the tables that are figures – the third thing displaces neither the dead nor the living: it is both.

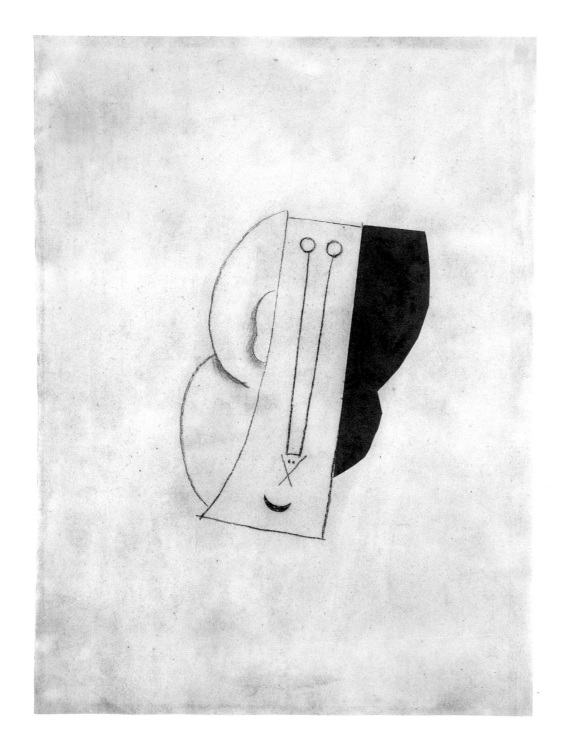

Head, Paris, 1913
Charcoal and collage on paper, 60 x 44 cm
Museu Picasso, Barcelona. MPB 70.801

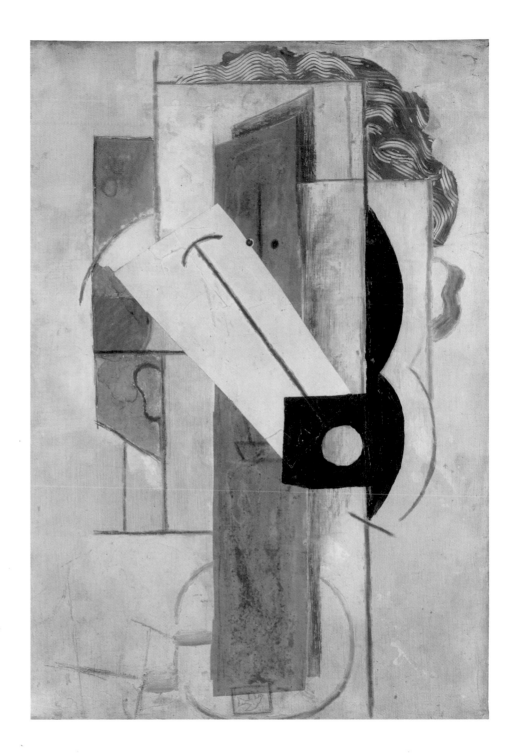

Head of a Young Girl, 1913
Oil on canvas, 55 x 38 cm
Centre Georges Pompidou, Paris. Musée National d'Art Moderne/Centre de Création
Industrielle. AM 4212 P. Gift of Henri Laugier 1963

Guitar, Clarinet and Fruit Bowl
Paris, 1915
Charcoal and watercolour on paper, 12.4 x 8.5 cm
Private collection. Z VI, 1322

Guitarist (Study for a Sculpture)
Sorgues (?), 1912
Indian ink on paper, 21 x 13 cm
Marina Picasso Collection. Courtesy Galerie Jan Krugier & Cie, Geneva
Inv. 1437. Z XXVIII, 128 [●]

Musical Instruments on a Table (obverse and reverse)
Paris, 1915
Charcoal on paper, 16 x 9 cm
Private collection. Z VI, 1292

Instruments on a Table, Paris, 1915
Charcoal and watercolour on paper, 19.5 x 16.5 cm
Private collection. Z XXIX, 147

Instruments on a Table, Paris, 1915
Charcoal and watercolour on paper, 31.5 x 23 cm
Private collection. Z XXIX, 148

Musical Instruments and a Fruit Bowl on a Table, [Summer 1915]
Pencil and watercolour on paper, 31.5 x 23 cm
Private collection. Courtesy Fundación Almine y Bernard Ruiz-Picasso para el Arte. Z XXIX, 149

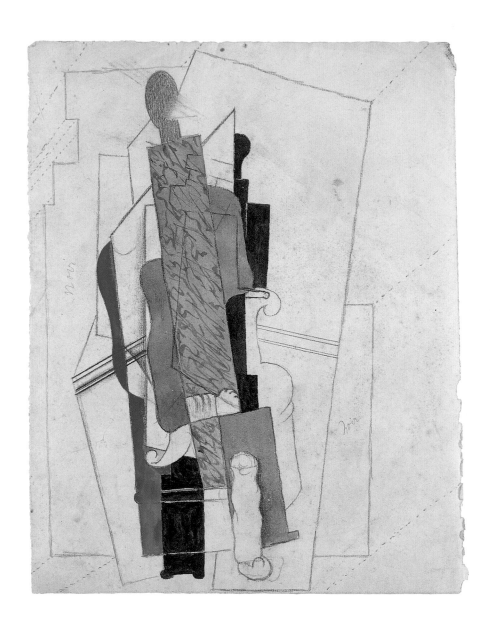

Man Seated in an Armchair, [1916]
Pencil and watercolour on paper, 31 x 24.7 cm
Private collection. Courtesy Fundación Almine y Bernard Ruiz-Picasso para el Arte. Z XXIX, 166

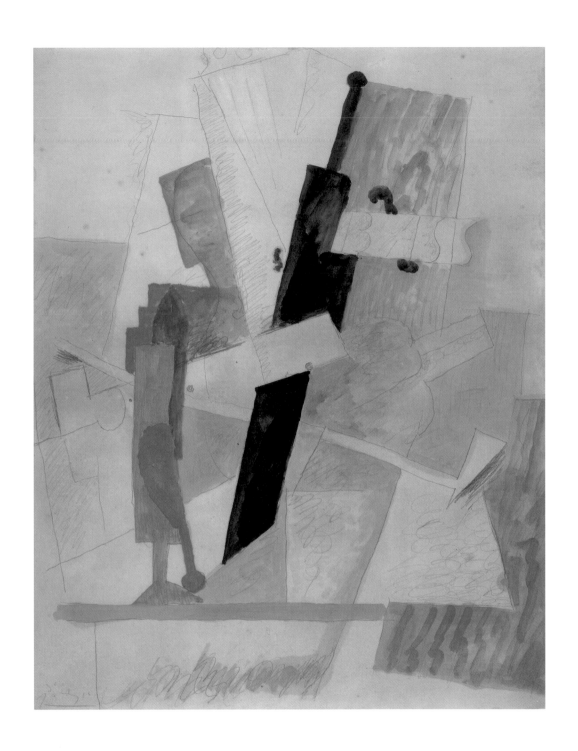

Still Life with Bottle of Bass, 1913
Pencil and watercolour on paper, 65 x 50.5 cm
Centre Georges Pompidou, Paris. Musée National d'Art Moderne/Centre de Création Industrielle
AM 2915 D. Gift of Marie Cuttoli 1963

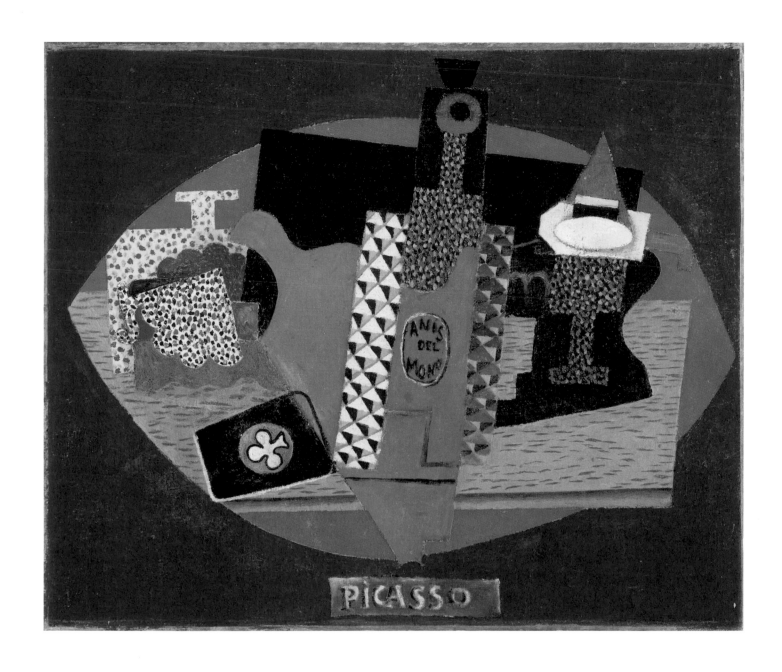

Bottle of Anís del Mono, Wineglass and Playing Card, 1915
Oil on canvas, 46 x 54.6 cm
The Detroit Institute of Fine Arts. Bequest of Robert H. Tannahill. 70.192

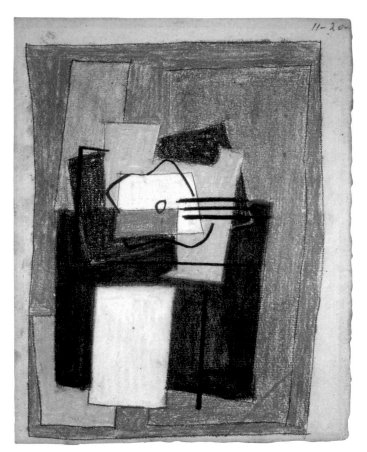

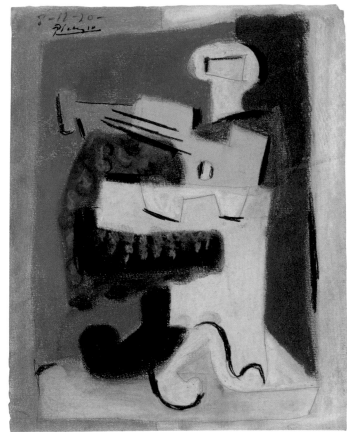

Still Life with Guitar, Paris, November 1920
Charcoal and pencil on paper, 27 x 21 cm
Private collection. M. B. Italy

The Guitarist, 1920
Gouache and pastel on paper, 27 x 21 cm
Private collection

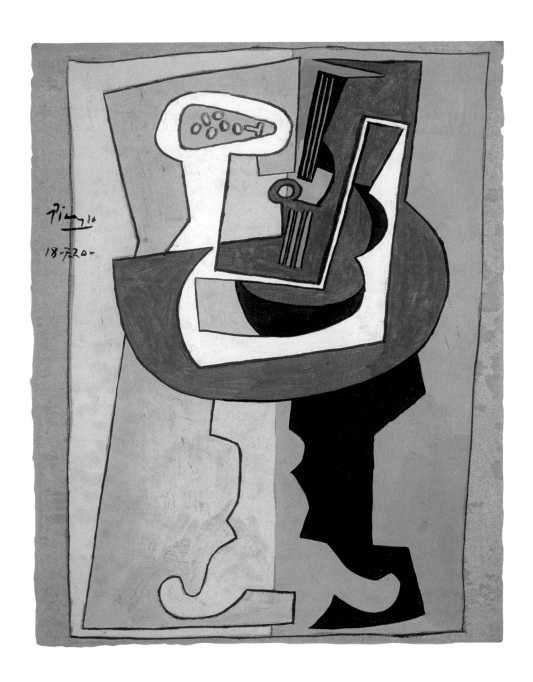

Personage with a Guitar, 1920
Gouache on paper, 27 x 21 cm
Private collection

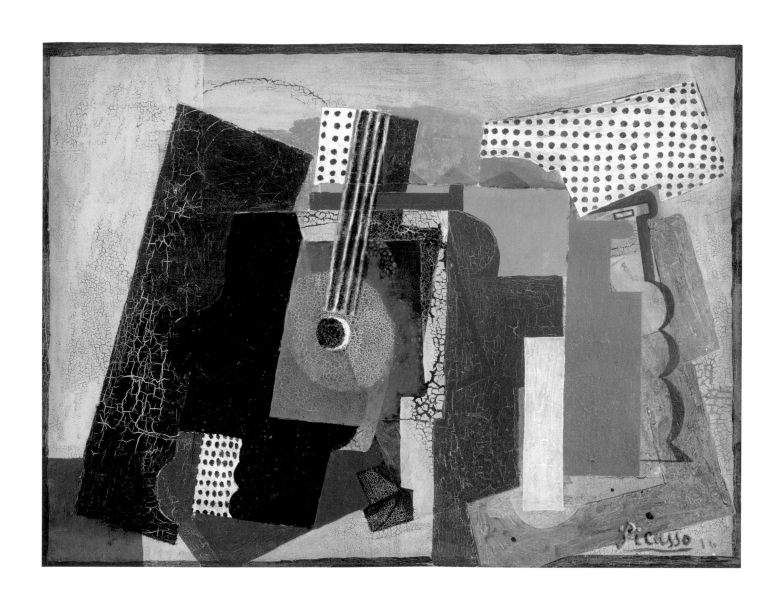

Still Life with Door, Guitar and Bottles, 1916
Oil on canvas, 60 x 81 cm
Statens Museum for Kunst, Copenhagen. Inv. KMSr193

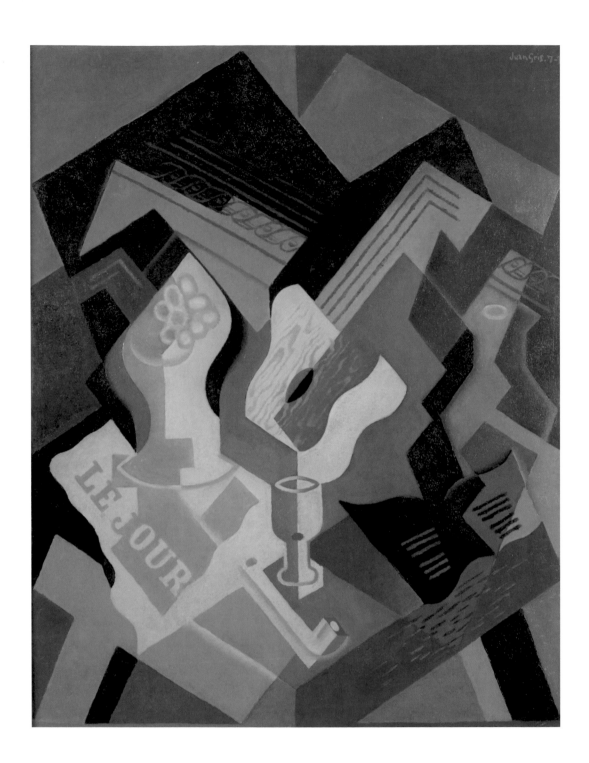

Juan Gris
Guitar and Fruit Bowl, 1919
Oil on canvas, 92 x 73.5 cm
Henie Onstad Art Centre, Høvikodden

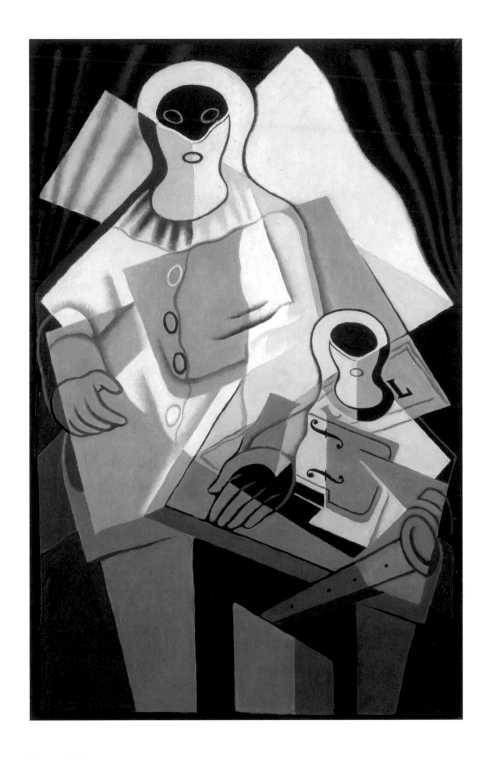

Juan Gris
Pierrot, 1921
Oil on canvas, 115 x 73 cm
National Gallery of Ireland, Dublin. NGI 4521

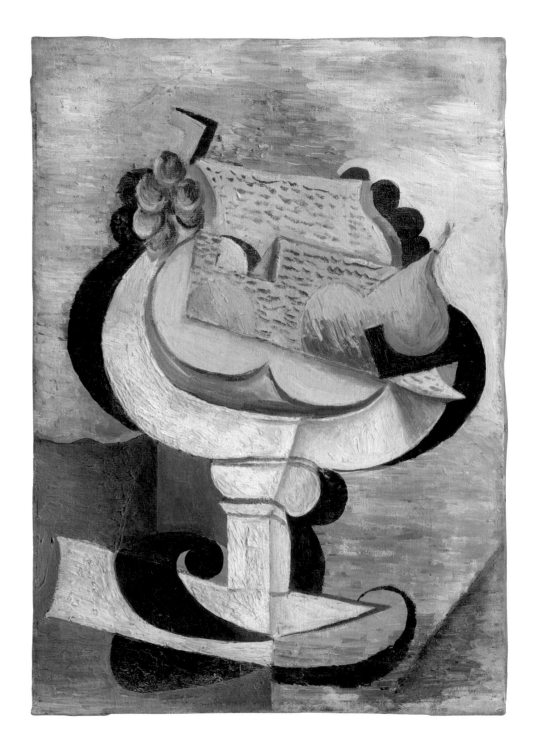

Fruit Bowl, Barcelona, 1917
Oil on canvas, 40 x 28.1 cm
Museu Picasso, Barcelona. MPB 110.029

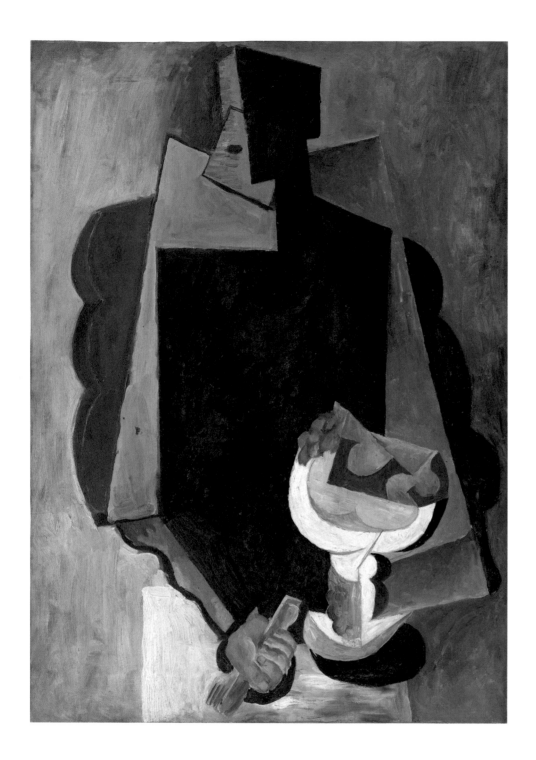

Figure with Fruit Bowl, Barcelona, 1917
Oil on canvas, 100 x 70.2 cm
Museu Picasso, Barcelona. MPB 110.006

Woman Seated in an Armchair, Barcelona, 1917
Oil on canvas, 92.5 x 64.4 cm
Museu Picasso, Barcelona. MPB 110.007

IV Geometry and the Crystal; Death and Transcendence

Space in the pedestal-table still lifes is constructed from overlapping and abutting planes. It can have a shadowy indoor presence, as for instance in *Fruit Bowl and Bottle on a Pedestal Table* (p. 99), but flatness prevails: the flatness of the shaped, cut-out planes of Picasso's *papiers collés* of 1912–13. The many Cubist series that followed the iron *Guitar* rarely offer the sensation of weight or three-dimensional presence. Light does not model the surfaces to form volumes or masses: it is emitted from the paper or canvas as colour on the flat surface, smooth or textured, hot or cool. Whether they are figures or objects or both at once, the images from these series lack palpable presence in fundamentally the same way as computer icons, and the openness of their identities to change depends on the degree to which they have been abstracted, on their simplicity as signs.

In his first piece on Picasso in 1905, Apollinaire already found in him both a 'mystic' and a 'realist': a need to imagine and invent alongside a need to realize for himself the sensuous presence of things.[1] By the late 1920s, the German critic Carl Einstein, who would work in close collaboration with Georges Bataille on *Documents*, could write of Picasso as an artist concerned with both the inner and the outer. By then, Einstein could believe that Picasso was able to fuse his internally generated 'hallucinatory shapes' with his external mastery of the world of appearances – in Apollinaire's terms, his mysticism and his realism.[2] Between 1912 and the 1920s, however, there is good reason to think of his art as developing out of two almost diametrically opposed compulsions: one an obsession with the possibility of realizing in painting and drawing the living presence of bodies in the world as he experienced them, the other an obsession with the malleability of signs in a rarified aesthetic sphere; one taking him back to the museums, to Ingres, Poussin and antiquity, the other allowing him to explore, as Apollinaire or Raynal would have put

1 Apollinaire (15 May 1905). See section 1, note 10.
2 Carl Einstein, 'Picasso', *Neue Schweizer Rundschau*, no. 4, 1927, pp. 357–59. I have used the French translation in Jean Clair with Odile Michel (eds), *Picasso. The Italian Journey* (exh. cat.). London, Thames & Hudson, 1998, pp. 329–31.

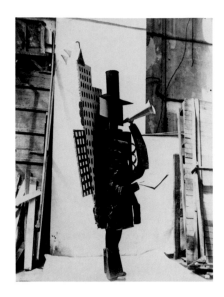

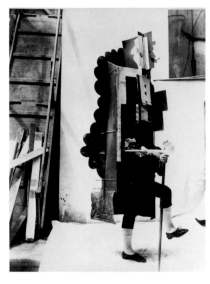

it, the 'conceptual' possibilities opened up by Cubism. Picasso's anthropomorphic pedestal tables are certainly on one side of that dual-track development, and if they infuse dead things with life, it can only be artificial, no more to be experienced as life, as we have seen, than the liveliness of automata – or the liveliness on stage, I would add, of the Cubist assemblages constructed from his designs in 1917 (pp. 96–97) to represent the French and American managers in the ballet *Parade* (Figs 9 and 10).

The flat planar spaces of the Cubist figures and still lifes that followed the iron *Guitar* are spaces governed by geometry. Even where curves oppose the angular, for instance in the two figure-pieces of 1917 in the collection of the Museu Picasso, Barcelona (pp. 86–87), Picasso's simple pictorial vocabulary invites geometric terminology: rectangles and lozenges are accompanied by circles and arcs.

From its earliest beginnings in the Parisian public eye, Cubism and geometry went together, and where the writer was hostile, as for instance in the case of Louis Vauxcelles, that conjunction went with the rejection of nature, of life. Geometry was not merely abstract and intellectual, it was dead. This is an association given perhaps its most extreme and strongest expression by an English writer, T. E. Hulme, whose experience of Cubism was mediated by his connection with the major English artist Wyndham Lewis. For Hulme, geometry and the machine in their very lifelessness offered an escape from time, one that he urged modern artists to take.[3]

3 For extensive analyses of T. E. Hulme's preference for geometry over 'vital art' see Richard Cork, *Vorticism and Abstract Art in the First Machine Age*, vol.1: *Origins and Development*. London, Gordon Fraser Gallery, 1976, pp. 138–41, and Paul Edwards, *Wyndham Lewis: Painter and Writer*. New Haven and London, Yale University Press, 2000, pp. 112–13.

Hulme's severely consistent logic is not in tune with Apollinaire's delight in contradiction, but Hulme's ideal of an art freed by geometry from time and from the transience of the human condition connects nonetheless with the French poet's idea of art, in its highest form, as elevated above time and as thereby 'inhuman'. His discourse of 1908 on the flame as the symbol of painting, discussed above, develops into a discourse that moves beyond the idea of art humanized by 'purity' to the idea of the painter as a divinity who aims to go beyond the reach of the senses and so become 'inhuman'. 'Above all, artists are men who wish to become inhuman,' writes Apollinaire. 'Arduously they search for the traces of inhumanity, traces which are to be found nowhere in nature.'[4] There is a sense in which art and artists reach beyond life.

Apollinaire, like Picasso in painting, would never resolve the contradictions at the heart of his writing: above all, the contradiction between this belief in the imagination as somehow capable of creating another 'reality' above the material world and his urge to engage directly with the always changing, always for him exhilarating reality of life around him. When he wrote in 1913 of 'surnaturalisme' and in 1917 of 'surréalisme', he was not concerned with an art of the ideal or of dreams, but with what he thought of as reality intensified.[5] As Peter Read has pointed out, the dichotomy between the mystic and realist that Apollinaire perceived in Picasso as early as 1905 was mirrored in his own work by his ability to see and digest as well as to imagine and invent, and above all by his ability to bring the 'real' and the imagined together, to be both human and 'inhuman' at once.[6]

A minor but telling indication of Apollinaire's and Picasso's mutuality in this regard is their shared admiration of Cervantes' novella *El licenciado vidriera* (The Glass Graduate), which they twice tried unsuccessfully to publish in a French translation by Apollinaire with Picasso's illustrations, first in 1910 and then in 1917.[7] The attraction of the story surely lay not just in the wit of Cervantes' wordplay but in the figure at the centre of the story: a 'graduate' who is turned to glass by a love potion taken to cure him of his coldness, and who travels the land slung across a donkey, protected by a straw cover, like a wine bottle, insulting all who come

4 Apollinaire (June 1908), cited from 'Méditations esthétiques: Les Peintres cubistes' (1913), in Apollinaire, *Œuvres en prose complètes*, vol. II (Pierre Caizergues and Michel Décaudin, eds). Paris, Gallimard, 1991, p. 8.

5 For 'surnaturalisme', see Guillaume Apollinaire, 'Surnaturalisme', *Les Soirées de Paris*, Paris, no. 24, May–June 1914, p. 248. Apollinaire, writing of himself in the third person as 'le poète d'Alcools', denies that he is an out and out 'fantaisiste', and insists instead that his is 'un naturalisme supérieur, plus vivant et plus varié que l'ancien, un surnaturalisme'. For 'surréalisme', the key text is his programme piece for the ballet *Parade*, see section 1, note 9. Cubism is seen here to have led painting into a 'grand mouvement surréaliste' by which the real is made more real in art.

6 P. Read, *Picasso et Apollinaire: Les Métamorphoses de la mémoire 1905/1973*. Paris, Jean-Michel Place, 1995. As Read puts it, essential to Apollinaire's poetry is 'le glissement vers l'imaginaire à partir du vécu.' (p. 33).

7 The contents of the Cervantes story are outlined and the evidence for the unrealized project is fully presented in Pierre Caizergues and Hélène Seckel (eds), *Picasso Apollinaire: Correspondance*. Paris, Gallimard/Réunion des Musées Nationaux, 1992, letters 45, 48 and 121, pp. 48 and 149.

Fig. 11 Brassaï (Halasz Gyula)
La maison que j'habite, c. 1932
15 x 23 cm
Centre Georges Pompidou, Paris
Musée National d'Art Moderne/
Centre de Création Industrielle
© Estate Brassaï – RMN

across him, until a priest at last restores him to flesh. The glass graduate is living
and dead, corporeal yet transparent, cold like geometry yet hot like a man.

If there is a material with which Cubism of the period between 1916 and the mid-
1920s has been associated, however, it is not glass but a transparent material found
in nature which is always geometric: crystal. In 1976, I introduced the term 'crystal
Cubism' for the geometrically structured architectural Cubism found in several
Cubists besides Picasso during those years.[8] The term followed from the title given
to an article of 1924 on this development in Cubism by the so-called Purists, Amédée
Ozenfant and Le Corbusier, 'Vers un cristal'.[9] For them, certainly, the clarity as well
as the geometric sharpness of, say, the reclining guitars of 1920 (p. 103) or even the
shadowy *Fruit Bowl and Bottle on a Pedestal Table* (p. 99) would have been evidence
of the move 'vers le cristal' (towards the crystal).

The crystal, like geometry, is easily associated with death, and so opposed to the
vital and the organic; but it is also easily associated with perfection, and at the same
time with liberation from time because of its role in clairvoyance. André Breton
gave a special prominence to the crystal when he published his piece 'La Beauté
sera convulsive' (Beauty will be convulsive) in *Minotaure*, no. 5 (1934).[10] Above
the title, he printed a photograph of rock crystals (Fig. 11), and as he moved
towards a climax he wrote what he described as his 'éloge du cristal' (elegy
to the crystal). For Hal Foster, it is the inertia of death that ominates in
Breton's convulsive response to the crystal, its petrified immobility, and

8 Christopher Green, *Léger and the Avant-garde.*
New Haven and London, Yale University Press, 1976,
pp. 130–31.
9 Le Corbusier & Amédée Ozenfant, 'Vers un cristal',
L'Esprit Nouveau, Paris, no. 25, 1924.
10 André Breton, 'La Beauté sera convulsive',
Minotaure, Paris, no. 5, 1934, pp. 8–16.

he adds that crystals form underground and therefore can be associated with the wish to return to the womb, the regressive impulse of the death drive (in Breton's case he encountered them magically in the 'Grotte des fées' [Fairies' Cave] close to Montpellier).[11] Yet, as James Harrison has remarked, the crystal is, for Breton, above all a transcendent natural analogue of art, fixed and perfect yet the product of a spontaneous, automatic process.[12] 'There could not be any higher lesson for art,' he writes, 'than that received from the crystal. The work of art, in the same way … as the meaning of any particle of human life considered in the most far reaching terms, seems to me stripped of value if it does not display the hardness, rigidity, regularity, the lustre across all its external faces, of the crystal.'[13] For Breton, the perfection of the crystal lifts it beyond death.

Conceptual, geometrical and crystalline: these are epithets which could all have been applied in the period from both a positive and a negative viewpoint to Picasso's anthropomorphic pedestal-table still lifes, as indeed they could have been to the New York *Harlequin* (Fig. 7, p. 63) and the Detroit *Bottle of Anís del Mono* still life of 1915 (p. 77). If geometry and the crystal went so emphatically with the denial of life and the aspiration to transcend life, Picasso's persistence in infusing even the most crystalline of the tables, musical instruments, vessels and containers in his *natures mortes* with vitality again and again must be seen, I would argue, as resisting death. The line in some of his neo-classical drawings has been called 'mechanical', but these suites of closely related yet always different still lifes, invariably mobile and alive, are demonstrations that he could not have tolerated the rigid immobility of mechanical drawing (T. E. Hulme's model of a properly geometric anti-Humanist art). In Picasso, abstraction, geometry and the crystal do not ultimately stand for the refusal of life.

11 Hal Foster, *Compulsive Beauty*. Cambridge, Mass. and London, MIT Press, 1993, pp. 23–24.
12 James Harrison, 'Reading *Minotaure*: An Active Interpretation of Text and Image in Numbers Five and Seven', unpublished dissertation submitted for the degree of MA (Courtauld Institute of Art, 2007), pp. 10–17.
13 Breton (*Minotaure*, 1924), op. cit., p. 13.

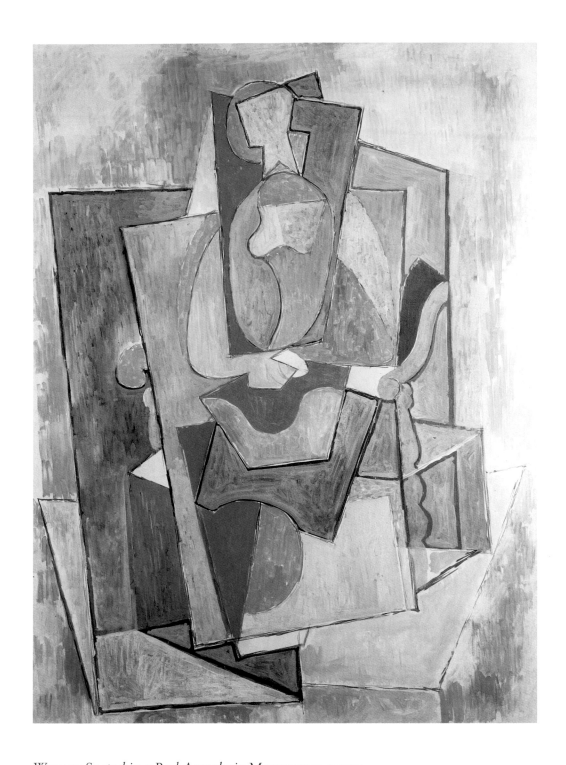

Woman Seated in a Red Armchair, Montrouge, 1917
Oil on canvas, 133.5 x 100 cm
Private collection

Study for a Manager, Rome, 1917
Pencil, 27.6 x 22.5 cm
Musée National Picasso, Paris. MP 1611. Z II, 958

Study for a Manager and a Pig, Rome, 1917
Pencil, 27.5 x 22.5 cm
Musée National Picasso, Paris. MP 1613. Z II, 957

Study for a Manager, Rome, 1917
Pencil, 27.6 x 22.5 cm
Musée National Picasso, Paris. MP 1614. Z II2, 961

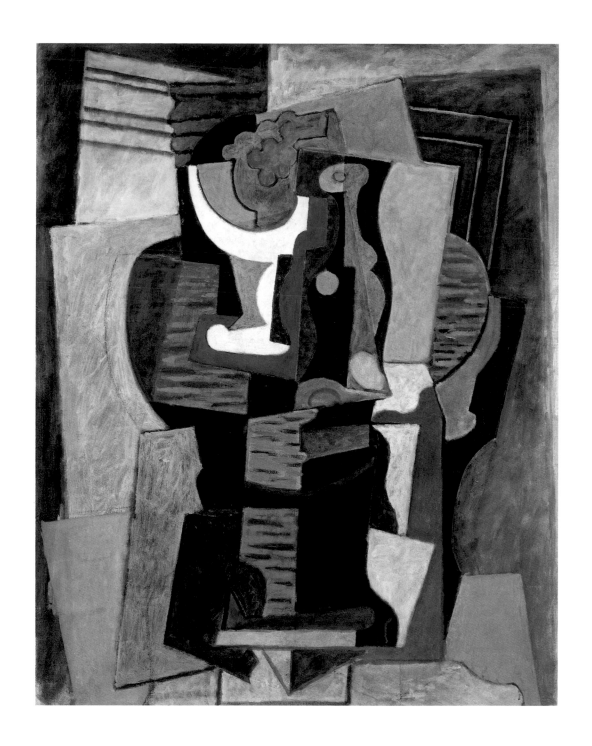

Fruit Bowl and Bottle on a Pedestal Table, 1920
Oil on canvas, 92 x 73 cm
Private collection, Courtesy Richard Gray Gallery

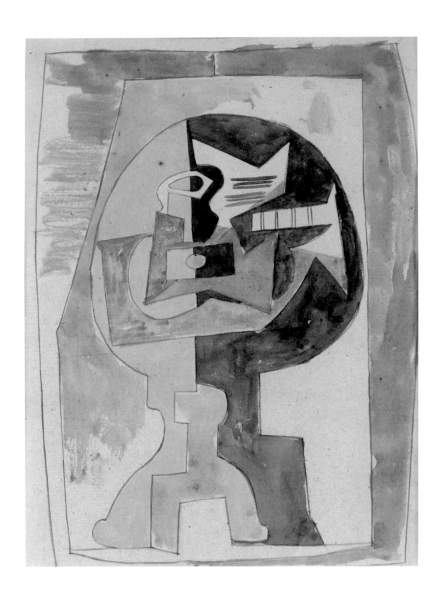

Pedestal Table and Guitar, 1920

Gouache on paper, 27.5 x 21 cm

Marina Picasso Collection, Courtesy Galerie Jan Krugier & Cie, Geneva. Inv. 2787

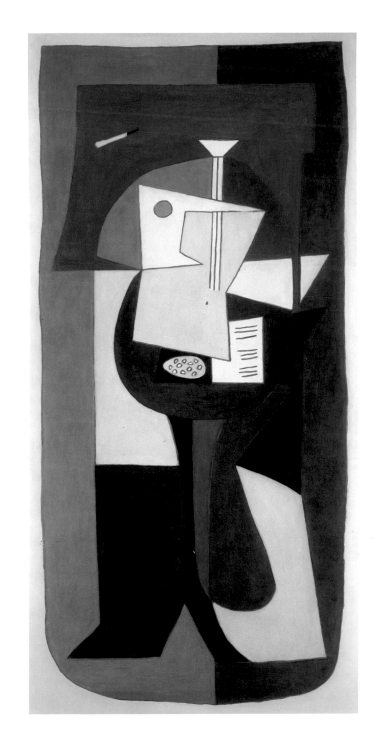

Guitar and Scores, 1920
Oil on canvas, 212 x 102 cm
Marina Picasso Collection. Courtesy Galerie Jan Krugier & Cie, Geneva
Inv. 12250. Z XXX, 74 [•]

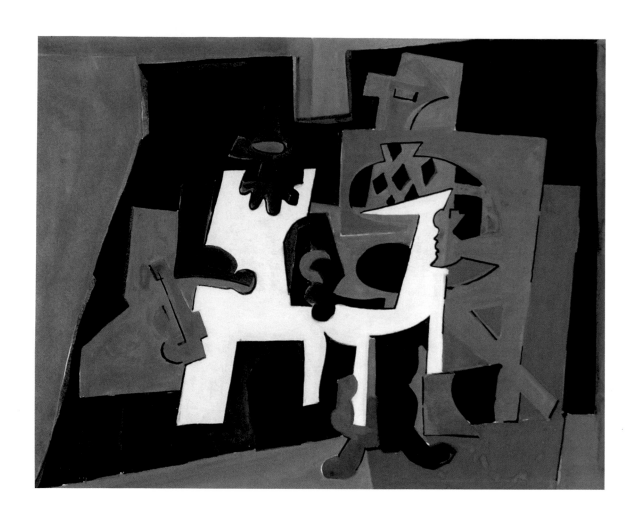

Harlequin and Punch, 1920
Tempera on paper, 23.7 x 29.5 cm
Colección Fundación Mapfre

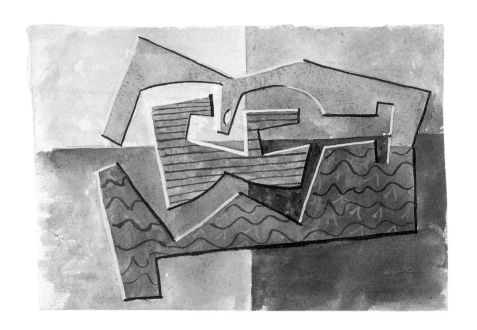

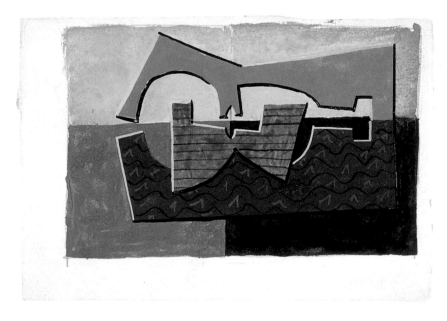

Still Life with Guitar, Paris, 25 April 1920
Gouache, pencil and ink on laid paper, 11 x 15.5 cm
Museo Picasso Málaga

Still Life with Guitar, Paris, 24 April 1920
Gouache, pencil and ink on laid paper, 11 x 16 cm
Museo Picasso Málaga

Still Life with Guitar on a Pedestal Table
18 April 1922
Oil on wood, 15 x 10 cm
Museo Picasso Málaga

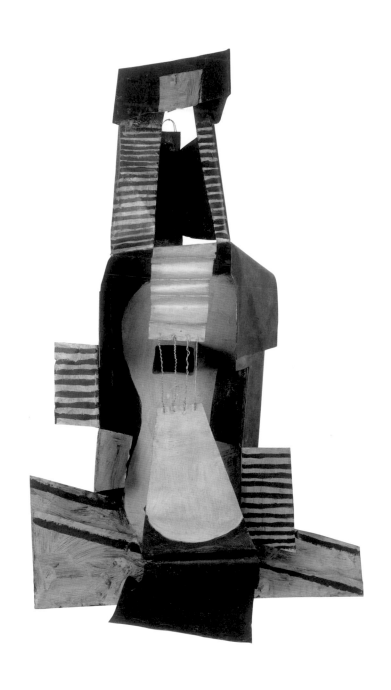

Guitar, Paris, 1924
Construction: cut-out and bent sheet metal, painted tinplate and wire
111 x 63.5 x 26.6 cm
Musée National Picasso, Paris. MP 260. Z V, 217 [•]

V Repeating Patterns

The culminating group of paintings to be considered here are the grand, almost monumental still lifes that Picasso painted in 1924–25, each one of which makes a distinct and individual statement. Though they do not form a suite (or suites) like the pedestal-table or the reclining-guitar still lifes of 1916–22, it is clear that an important core group of these still lifes (pp. 135 and 139) were ideas that could not have been produced without Picasso's prior engagement in suites of works on paper and canvas mostly devoted to the proliferation of still-life ideas, which go back at least to 1922. Moreover, a feature of these works is that, even more than before 1922, Picasso is repetitive. It can seem that, in these suites at least, he accepted mechanization's reproductive imperative, that he gave up the making of distinctive originals for a kind of assembly-line approach to serial production.

Of the major still lifes of 1924, the one that most clearly connects with these serially produced works from the 1922–24 period is the painting sometimes titled *Still Life with Mandolin*, now more often titled *Still Life with Guitar*, in the Stedelijk Museum, Amsterdam (p. 135).[1] There are no studies on paper directly related to the other 1924 still lifes, but behind the Stedelijk canvas lies a suite of studies so closely related to one another as to be considered repetitive (p. 132). Besides this origin in the near repetition of a single idea in drawing after drawing, repetition is a factor within each closely related variant: the repeats of pattern-design. The Stedelijk picture is as flat and spatially shallow as any of the pedestal-table still lifes and returns to the motif of the reclining stringed instrument on a table, which in the preliminary studies is a pedestal table. All of the series, including the final painting, employ a vocabulary of signs reduced almost to the point of abstraction, hence that uncertainty about whether the instrument ends up being a guitar or a mandolin. It is a mandolin in the Stedelijk picture if we read the bulging white shape on which its sound hole and strings are inscribed as the fattened sound box of that instrument; it is a

1 The argument for identifying the stringed instrument with a mandolin is put by Jean Sutherland Boggs in Boggs, *Picasso and Things* (exh. cat.). Cleveland, The Cleveland Museum of Art, 1992, p. 212. The work is currently catalogued by the Stedelijk Museum, Amsterdam, as *Still Life with Guitar*.

guitar if we accept the angular suggestions of narrower proportions. With the paring down of Picasso's vocabulary of signs goes the introduction of patterns, which function to ensure compositional cohesion along with the architecture of planar structure: a repeated zig-zag motif suggestive of textile design, and a repeated six-pointed star motif, white on sky blue and black on nocturnal grey.

The consensus is that the major still lifes of 1924 were mostly all painted when Picasso was summering on the Côte d'Azur at Juan-les-Pins, and it is likely that the Stedelijk picture was the first to be painted there.[2] Its chromatic brilliance and the stridency of its patterns convey something of the light and warmth of summer. Another product of Picasso's summer at Juan-les-Pins in 1924 was a suite of drawings which employ a very limited range of graphic elements even more repetitively (pp. 113–15). They are usually referred to as the dot-and-line drawings, because they are composed almost entirely of lines joining dots, sometimes enhanced by inked-in areas of black; Picasso went on producing them after that summer.

Much has been made of the fact that two sketchbook pages covered in these drawings were illustrated in the second number of the Surrealist mouthpiece, *La Révolution surréaliste*. This has led to the suggestion that the dot-and-line drawings can be seen as 'automatist' in the sense that the Surrealists used the term: that is to say, the product of unthinking mark-making, not of drawing consciously aimed at producing representations of one kind or another. This, combined with their decorative look – so easily connected to that of the Stedelijk still life – can make them seem to demonstrate nothing more demanding than that Picasso is making patterns to induce the simplest kind of visual pleasure, the analogue of the pleasure principle that so obviously takes over on the beach in the sun that summer (though not entirely, as we shall see). A closer look at Picasso's engagement with pattern-making and repetition between 1922 and 1924 makes it clear, I shall argue, that we are confronted neither with unthinking 'automatism', nor with mere decorative pattern-design, nor with anything that can be aligned with the reproductive repetition of mass production. Pattern-making and repetition come together in what was a further and important phase in his ongoing exploration of the transformational capacity of signs.[3]

2 I go along with Richardson's identification of this work as the first. See John Richardson, with the collaboration of Marilyn McCully, *A Life of Picasso*, vol. III: *The Triumphant Years, 1917–1932*. London, Jonathan Cape, 2007, p. 268.
3 Here I expand, bringing in the Stedelijk picture and the ballet *Mercure*, on the argument I have made in C. Green, *Picasso: Architecture and Vertigo*. New Haven and London, Yale University Press, 2005, pp. 191–93.

Conceptual, geometric, crystalline: rarely does Picasso invite those epithets more insistently than in the suite of still lifes he painted at Dinard in the summer of 1922. It is in this series that I find the beginning of the repetitive pattern-making development that brings him two summers later to the dot-and line drawings and the Stedelijk still life. Many of the Dinard pictures are small, painted quickly like coloured sketches (pp. 116–17); a few are almost as grand in scale as the major still lifes of 1924, but their expansive flatness and the degree to which their signs are abstracted gives them a different, more spacious character, a kind of grandeur (pp. 118–19). They deploy very simple, predominantly angular, configurations to denote the bottles, musical instruments or fruit bowls of Picasso's well-established still-life repertoire, integrated into a very limited range of patterns using nothing but stripes and checks.

A diversion is necessary at this point, a diversion once again in the direction of death. Not only are we concerned here with the deathly timelessness of geometry and the distanced flatness of Cubism at its most conceptual, but we also have to take account of the fact, already mentioned, that the compulsion to repeat was itself taken by Freud to be the key manifestation of the drive towards death. His 1919 essay on the uncanny makes reference to the argument already drafted in *Beyond the Pleasure Principle* that 'a "compulsion to repeat"' exists in the unconscious mind, which is 'probably inherent in the very nature of the instincts – a compulsion powerful enough to overrule the pleasure principle, lending to certain aspects of the mind their daemonic character.' For Freud, 'whatever reminds us of this inner 'compulsion to repeat' is perceived as uncanny.'[4] Repetition, like the double or the automaton, carries with it the repressed attraction of death: we have a profound need to return to our beginning.

Are we then to see above all in the reductive geometry of the Dinard still lifes of 1922, and in the dot-and-line drawings of 1924, Freud's compulsion to repeat as 'the harbinger of death'? Hal Foster reminds us of the example Freud uses to show the early emergence of the compulsion to repeat in *Beyond the Pleasure Principle*. It comes from early childhood: the *fort/da* game which Freud's eighteen-month-old grandson played, where the child repeatedly threw a spool attached to a string away (*fort* – gone) then pulled it back (*da* – there). Freud interpreted this as an activity designed to compensate for the absences of his mother, before exploring the deeper significance of compulsive repetition as he saw it.[5] Within the

4 S. Freud, 'The Uncanny', in S. Freud, *Art and Literature*. London, Penguin, 1985 (The Pelican Freud Library; 14), pp. 359–63.
5 S. Freud, *Beyond the Pleasure Principle*, in S. Freud, *On Metapsychology*. London, Penguin, 1991 (The Pelican Freud Library; 11), pp. 283–86; and Hal Foster, *Compulsive Beauty*. Cambridge, Mass. and London, MIT Press, 1993, pp. 9–10.

field of psychoanalysis, play is above all symbolic and so symptomatic in relation to the anxiety associated with the neuroses, but play has its positive aspect in manual and cognitive development: children experiment, test and learn by play, and do so through repetition. My argument here, as it has been elsewhere, is that Picasso's stripe-and-check still lifes of 1922 and his dot-and-line drawings of 1924 are better looked at as serious experimental games-playing than as evidence of Freud's 'compulsion to repeat'.[6] It is, however, a kind of games-playing that can take place on a grand public scale (pp. 118–19), and these are games that are pursued with such intensity that the word 'compulsive' is not misplaced.

Of the small-scale Dinard still lifes of 1922, four feature here (pp. 116–17). Three of them use the same angular sign with minimal alterations for an object that can be read either as a glass or as a fruit bowl (p. 116 and p. 117, top). Two of them almost exactly repeat the same juxtaposition of angular signs for tobacco packet and glass/fruit bowl (p. 116), while another (p. 117, top) translates the glass/fruit bowl into a softer, more cursive configuration but keeps the same arrangement of objects. The largest of the small pictures (whose colour combinations are markedly cooler) is painted with such obvious immediacy that the word 'automatic' might almost apply (p. 117, bottom), and all of them display the signs of having been thrown together at speed. Yet even the two that most closely reproduce one another are different in the way the stripes impinge or not on the objects and in the way their almost identical range of pink, blue, orange and red works with the stripes. Moreover, when seen together, the differences make their mark just as compellingly as the similarities. These paintings work together to form a project of the most disciplined kind. Picasso has reduced his Cubist vocabulary to so simple a range of configurations that his faith in originality itself is challenged. It is as if he is proving to himself that even where everything is the same, there is difference, and in doing so he is testing the threshold between pattern-making (putting together repeats) and the making of meaning (representation).

The stripe-and-check still lifes might follow the pedestal-table still lifes, but they are almost never anthropomorphic in a so comprehensive and mobile a way. This kind of over-all anthropomorphism, where figures and objects can often be read simultaneously, returns, however, in still simpler form with the dot-and-line drawings. In this suite, Picasso much more obviously tests for himself not only the threshold

6 See note 1. Another possible reason for the repetitive production of large numbers of often small works is market pressure. I know of no evidence of such pressure being placed on Picasso in the early 1920s.

between pattern-making and representation, but the openness of his Cubist signs to transformation, for every guitar or musical instrument he invents in these drawings might also be something else: a figure or a star-system. These sketchbook drawings are not just a game to play while relaxing on the beach in the Mediterranean sun; they test the very rules of the game.

Picasso's repeating patterns might seem aimless, but, as I shall show, they led somewhere.

Guitar, Squares and T's, Paris, 1925
Charcoal and ink on paper, 26 x 35 cm
Private collection

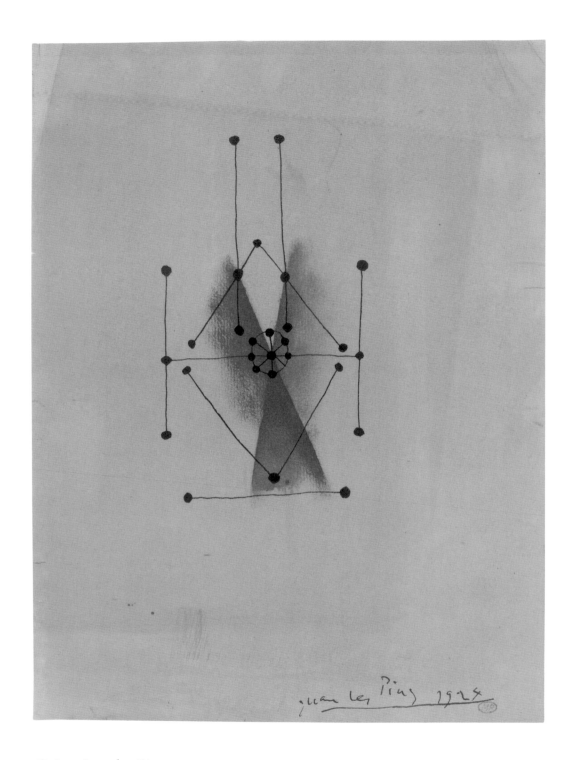

Guitar, Juan-les-Pins, 1924
Pencil and Indian ink on paper, 30.2 x 28.8 cm
Musée National Picasso, Paris. MP 1000

Three Studies for a Guitar; Study for Bottle, Guitar, Fruit Bowl and Score on a Table;
Study for a Still Life with Guitar on a Table; Four Studies for a Guitar
Juan-les-Pins, [Summer] 1924

Pen and Indian ink on Arches paper, 31.5 x 23.5 cm

Sketchbook 30, MP 1869, f. 15 v, 18 r, 19 r and 22 v. Musée National Picasso, Paris [•]

Four *Studies for a Guitar*, Juan-les-Pins, [Summer] 1924
Pen and Indian ink on Arches paper, 31.5 x 23.5 cm
Sketchbook 30, MP 1869, f. 23 r, 24 v, 25 r and 26 v. Musée National Picasso, Paris [•]

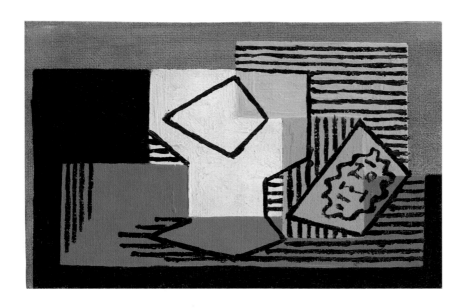

Fruit Bowl and Tobacco Packet, 1922
Oil on canvas, 14 x 22 cm
Private collection

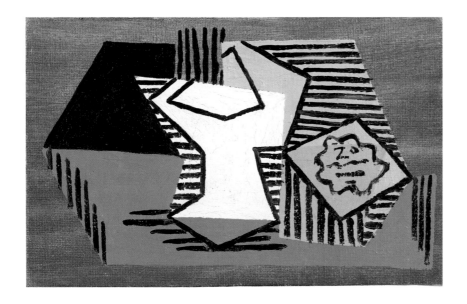

Composition with black scratches, [Dinard, Spring 1922]
Oil on canvas, 14 x 22 cm
Private collection. Courtesy Fundación Almine y Bernard Ruiz-Picasso para el Arte
Z XXXI, 285

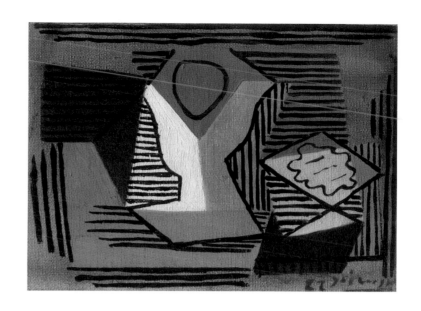

Still Life with a Glass and a Package of Tobacco, 1922
Oil on canvas, 16.2 x 21.9 cm
Philadelphia Museum of Art. A. E. Gallatin Collection, 1952. Inv. 1952-61-97

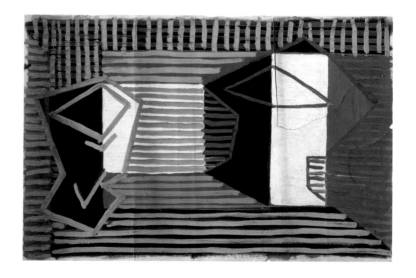

Still Life with Glass, 1922
Oil on canvas, 48.5 x 32 cm
Private collection. Z XXX, 287

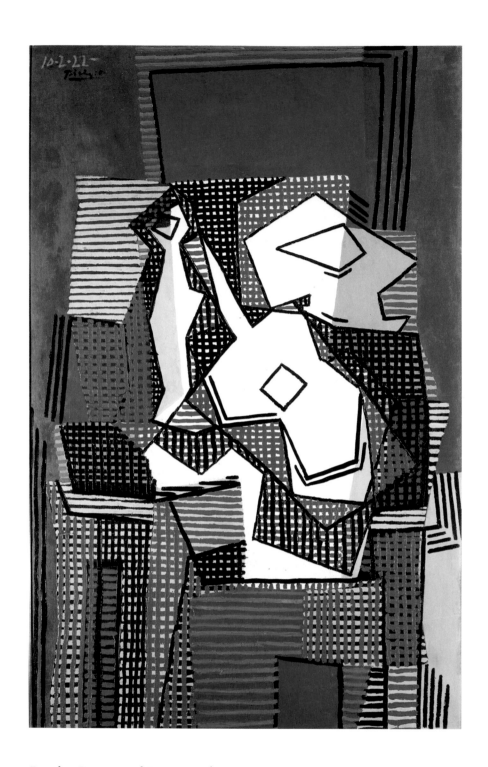

Bottle, Guitar and Fruit Bowl, 1922
Oil on canvas, 116 x 73 cm
Nahmad Collection

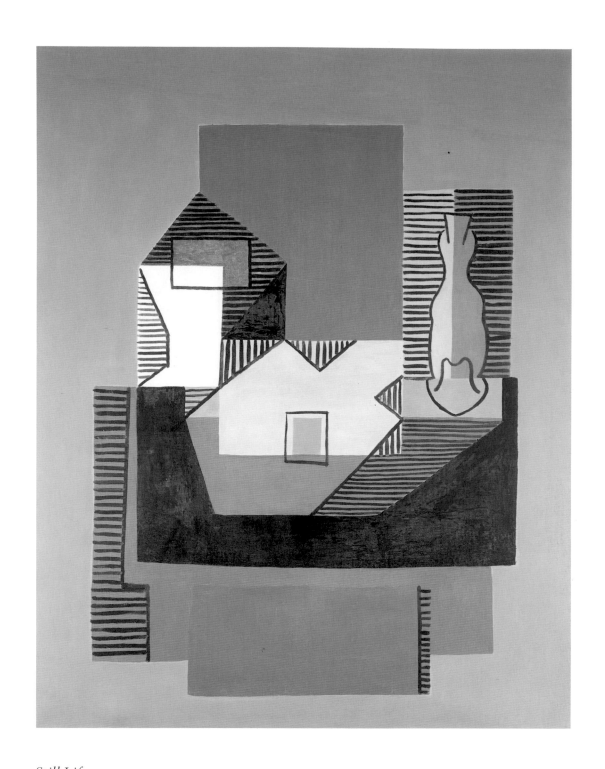

Still Life, 1922
Oil on canvas, 122.5 x 97.5 cm
Marina Picasso Collection. Courtesy Galerie Jan Krugier & Cie, Geneva
Inv. 12307. Z XXX, 279 [•]

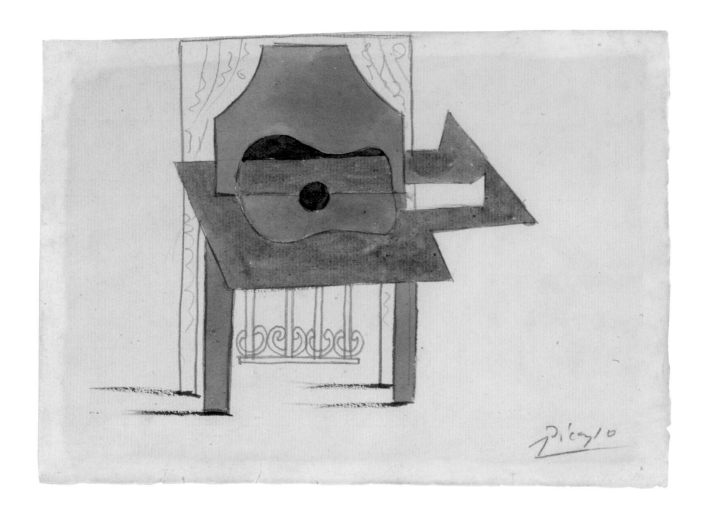

Guitar on a Table in front of a Window, 1919
Watercolour on paper, 16.7 x 22.7 cm
Private collection

VI *Mercure* and the Theatre of Still Life

Guitars, figures, star-systems: the dot-and-line drawings are easily read as constellations. John Richardson has it on good evidence that Picasso started to put stars into his pictures in 1924 when he saw a set of zodiac signs in the studio of friends.[1] Then as now, an urge to read the stars is an accepted demonstration of the human capacity actively to find meaning, indeed to create myths, as evidenced in many cultures, from Mediterranean Antiquity to the tribes of Amazonia. Picasso was not the first European avant-gardist to respond to that urge in his work. Two years before Picasso made the first dot-and-line drawings at Juan-les-Pins, the German Dadaist Max Ernst, soon to ally himself to Surrealism, had shown collages in Paris under the patronage of André Breton. Dot-and-line diagrams of constellations had featured from 1920 in his collage paintings (Fig. 12, p. 122). They are simpler than many of Picasso's dot-and-line combinations, but just as easily read as creatures, beings or objects. There may not be any direct influence here, but there is plainly a related engagement with the human ability to see into things, to fashion meaning in the most abstract configurations. The night sky becomes a magnetic field of relationships bristling with meanings.

As I have pointed out, there are stars in the Stedelijk still life (p. 135). The same elementary asterisk star signs appear in two other still lifes from the core group painted by Picasso in the summer of 1924: the *Still Life with Mandolin* from the National Gallery of Ireland in Dublin, and the *Mandolin and Guitar*, the most monumental of them all, from the Guggenheim Museum in New York (pp. 137 and 139). The Stedelijk picture more directly suggests stars in the sky, with its allusion to a window in which stars shine both day and night. The Dublin and the Guggenheim pictures display their stars as decorative motifs, despite the shadowy night setting of the former. They are stars stitched onto what might be a cushion in the Dublin still life and a tablecloth in the Guggenheim canvas. Moreover, these stars are not joined up by

1 John Richardson, with the collaboration of Marilyn McCully, *A Life of Picasso*, vol. III: *The Triumphant Years, 1917–1932*. London, Jonathan Cape, 2007, p. 258.

lines to create figures in which meanings can be read. The stars in all three of these paintings, however, are their simplest and most direct connection to the Juan-les-Pins dot-and-line drawings and so to Picasso's exploration of pattern and sign-making from the early 1920s.

The painting in which that connection is clearest is the first of the major 1924 still lifes painted at Juan-les-Pins, the Stedelijk picture, especially when it is seen in the context of the studies associated with it. The connection is so direct in this case because of the Stedelijk picture's relationship to an enterprise that had completely absorbed Picasso in the period immediately prior to his departure from Paris for the Côte d'Azur the day before the summer solstice in June 1924. This was the ballet *Mercure*, which was put on privately as part of the Comte Etienne de Beaumont's 'Les Soirées de Paris' season at the Montmartre music-hall Théâtre de la Cigale.[2] Working with Massine, Picasso devised the thirteen tableaux that comprised the ballet; they were set to music by Eric Satie. It was in the studio of the husband-and-wife team of scene painters, the Polunins, who scaled up his designs for the stage, that Picasso saw the sets of zodiac signs mentioned above. Stars had a prominent place in the ballet; to begin with, its scenes materialized out of a starry sky. Tellingly, Picasso's costumes and sets excited the particular admiration of Breton (Picasso, not Satie, was picked out).[3] *Mercure* marked the beginning of Breton's attempt to appropriate the painter for Surrealism just as it marked the beginning of Picasso's move towards a more explicitly eroticized art.[4] Picasso's work for de Beaumont's production opened the way to the great Juan-les-Pins still lifes in which, as we shall see, new image-making possibilities are opened up that have both a theatrical and sometimes an erotic dimension.

The myths of Antiquity were the point of departure for the tableaux of *Mercure*. De Beaumont called it a 'danse mythologique' (mythological dance), but the last thing he wanted was theatrical pedantry. 'I have taken mythology only in so far as it is a universal alphabet,' he wrote to Picasso early in 1924, 'not as connected with any time or place.' From that 'alphabet' he had asked the artist to 'faire des mots' (make words) as children make words from 'le catalogue des lettres', (a collection of letters) or, one might add, as signs are made from

Fig. 12 Max Ernst
Khatarina Ondulata, 1920
Gouache, pencil and ink on
printed paper, 31.5 x 27.5 cm
Scottish National Gallery
of Modern Art, Edinburgh
GMA 3885

2 For an excellent account of this, see Richardson (2007), op. cit., pp. 257–62.
3 André Breton, 'Hommage à Picasso', *Paris-Journal*, 21 June 1924.
4 For *Mercure*, Picasso and Surrealism, see Anne Baldassari, *Picasso sur-real/Picasso sur-réaliste/The Sur-realist Picasso* (exh. cat.). Basle, Fondation Beyeler, 2005, pp. 21–23, 42–44, 60–62.

stars.[5] There was certainly a kind of studied childlike simplicity in the range of signs, or 'words', that Picasso produced for de Beaumont's 'danse mythologique', and that simple vocabulary of signs shows Picasso giving a new elasticity to the elementary range of transformable Cubist signs developed through the years of the Great War and the early 1920s.

One marker of the connection between Picasso's designs for the ballet and his earlier Cubist practice is the presentational role given Harlequin and Pierrot in introducing the performance. As his motif for the drop curtain, Picasso chose the figures of Harlequin and Pierrot making music. The project came immediately after the series of Harlequin paintings of 1923 to which *Harlequin with a Mirror* is linked (pp. 141 and 143, top), and the drop-curtain design infuses the Cubist *Commedia dell'Arte* figures of the previous half-decade with a quasi-naturalist vitality. Colour now floats free from the figures. It is absorbed into misty blues, greys and browns as if into the air. And line dances free of geometry as it presents the players with their instruments who in turn present the performance to come. These are costumed bodies that move in air, but they are signs as open to transformation as any from the geometric vocabulary of the pedestal-table still lifes or of the New York *Harlequin* of 1915. Indeed, Picasso's *Mercure* sketchbooks reveal that this Pierrot actually began as a still-life arrangement comprising fruit bowl, tablecloth and pedestal table (p. 142). It is a particularly anthropomorphic still life: a fruit bowl head and table-top body seem not just mobile but actually to run or dance on muscular table legs. The soft anatomy of this pedestal-table still life gives it a new kind of vitality, a mobility no longer now to be associated with mechanized automata. Between sketchbooks, this dancing still life became the singing, violin-playing, gesticulating Pierrot of the drop curtain.

Given my emphasis here on transformation, it is worth adding that for Picasso, Mercury in his Greek form, Hermes, had long been identified with Harlequin and, through the figure of the master alchemist Hermes Trismegistus (Hermes Thrice Great), with magic and the European esoteric tradition. De Beaumont's title for his season of performances, 'Les soirées de Paris', invokes Apollinaire and his periodical of that title, so important to the Cubist vanguard before the Great War. The decision to give Mercury/Hermes the role of linking the tableaux in the ballet *Mercure* and Picasso's decision to have Harlequin and Pierrot introduce it from the drop curtain again invokes that name. Just months

5 The letter, dated 21 February 1924, is given in full in Laurence Madeline, *'On est ce que l'on garde!', Les Archives de Picasso* (exh. cat.). Paris, Réunion des Musées Nationaux, 2003, p. 156.

after Picasso's meeting with Apollinaire in 1905, the poet
had concluded his poem 'Les Saltimbanques' with the image
of 'arlequin trismégiste' (harlequin trismegistus).[6] Harlequin,
Mercury and Hermes Trismegistus were to be thought of as
one; trickery and alchemical transformations were brought
together in a new, third poetic figure which was much more
than simply Hermes/Mercury or Harlequin alone. Moreover,
it is clear that the Harlequin Trismegistus in Apollinaire's poem
is Picasso as he painted himself in the great 1905 canvas *Family
of Saltimbanques* (Fig. 13). The twinning of the trickster god
and the 'thrice great' alchemist, and the identification of both
with Picasso himself dressed as Harlequin is still there to be
read in the saltimbanque of *Harlequin with a Mirror*, just as
it is in the Harlequin guitar player of the *Mercure* drop curtain.
Theodore Reff has persuasively read the Pierrot of Picasso's
Commedia dell'Arte painting, the *Three Musicians*, as
Apollinaire, so perhaps the dead poet is summoned up to
join Picasso as Harlequin and present the ballet.[7] It is, after all,
Pierrot who sings (as the poets of Antiquity sang), and Harlequin
(Picasso) who plays the Spanish guitar.

Fig. 13 *Family of Saltimbanques*, 1905
Oil on canvas
212.8 x 229.6 cm
National Gallery of Art, Washington
Chester Dale Collection. 1963.10.190

Though there is no direct connection between the drop curtain and the Stedelijk still life,
the connection is made, in fact, by Picasso's designs for certain of the *Mercure* tableaux.
The openness to transformation of his simple signs is key to that connection, and
as I have suggested, the cue for the connection is the stars, something
that is clearer in the suite of studies for the painting than in the painting
itself. The studies expose the pattern-making starting point more
straightforwardly than the painting does: in particular the way that
pattern can remain pattern or switch to sign. In certain of the studies,
the elegant curvy legs of the table are unmistakeably both pattern
and sign. The asterisk star signs in the final canvas may read as
textile-pattern motifs, but it is clear that they began not in the
still-life studies but in designs for *Mercure*, where they *are* stars
shining in the sky.

6 The poem is cited in full and discussed in relation
to Picasso in P. Read, *Picasso et Apollinaire: Les
Métamorphoses de la mémoire, 1905/1973*. Paris,
Jean-Michel Place, 1995, pp. 43–44. It was first
discussed in the context of Picasso, Apollinaire and
alchemy in Marilyn McCully, 'Magic and Illusion in
the Saltimbanques of Picasso and Apollinaire', *Art
History*, vol. 3, 4 December 1980, pp. 425–34.
The identification of the Harlequin in the *Family of
Saltimbanques* with Picasso was first made by Reff in
Theodore Reff, 'Themes of Love and Death in Picasso's
Early Work', in Roland Penrose and John Golding
(eds), *Picasso 1881/1973*. London, Elek, 1973,
p. 71. Reff attempts to identify all the figures in this
painting with Picasso's friends. I agree with Read in
thinking he goes too far. See Read (1995), op. cit.,
pp. 47–48.
7 Theodore Reff, 'Picasso's Three Musicians: Maskers,
Artists and Friends', *Art in America*, New York,
December 1980, pp. 124–42.

A sketchbook stuffed with ideas for the ballet contains a cluster of sketches for the opening tableau, *Night* (pp. 134 and 146, top). It is likely that they were produced around the time of the studies for the Stedelijk painting. Scattered asterisk stars fill the sky behind a pin-figure on a bed. The figure is female and has raised herself from rest as if woken at dead of night. De Beaumont's 'danse mythologique' begins, thus, with a dreamer in the presence of the constellations. Later in the same sketchbook, Picasso replaces his asterisk stars with words: 'étoile', 'étoile', 'étoile' ('star', 'star', 'star') (p. 146, top). A word (a written sign) does the same job as the drawn signs: the stars are writing, and writing is drawing. In the ballet as performed, at one point dancers carried placards printed with the word as the stars for the *Night* tableau.

This is not the first time that stars have been pinpointed as cueing the relationship between Picasso's drawings for *Mercure* and his Cubist practice generally. Gertrude Stein did so in 1938, very possibly with the studies for the Stedelijk still life in mind. For her, the *Mercure* designs give us drawing as 'calligraphy'. Calligraphy, she added, was something that Picasso, with an Andalusian's appreciation of Islamic visual culture, had internalized. 'Calligraphy, as I understand him,' writes Stein, 'had perhaps its most intense moment in the *décor* for *Mercure*. That was written, so simply written, no painting, pure calligraphy. A little before that he had made a series of drawings, so purely calligraphic, the lines were extraordinary lines, there were also stars that were stars which moved, they existed, they were really Cubism.'[8] Stein is not always a witness to be trusted, but in this case she puts her finger on what was essential to Picasso's open sign-making in the designs for *Mercure* and the Cubist studies that relate to them. He was thinking on paper, as if writing and drawing had fused. He could still use the straight lines and arcs of geometry, as in the drawings for *Night*, but another range of sweeping calligraphic lines was unleashed in the drawings for other tableaux, for instance in drawings of dancers (p. 148) that anticipate the ecstatic dancer on the left of *The Dance* (Fig. 4, p. 46), as well as in the final two tableaux especially, *Baccanale* and *The Rape of Proserpine* (p. 149).

If it is the asterisk stars that cue the connection between the *Mercure* designs and the Stedelijk still life, it is the figure in the drawings for *Night* that cues their connection not just with the painting but also with the dot-and-line drawings he made on the

8 Gertrude Stein, *Picasso*. London, Batsford, 1938, p. 37.

Côte d'Azur. The figure too, therefore, signals the connection between *Mercure* and pattern-making in the core group of large-scale still lifes painted in 1924 at Juan-les-Pins. In the sketches for *Night*, the half-reclining, half-raised figure on the bed is always generated from the most elementary linear elements. On one or two occasions – for instance, the drawing that uses the word 'étoile' (star) – the lines generating the figure connect dots. We have a dot-and-line figure. The stars behind may not join up to give us the creatures and gods of mythology, but the figure herself is drawn as if, in contemplating the glittering spectacle of the constellations, she has herself become a constellation. This figure, in its dot-and-line and other forms, rests on its bed very much as the guitar or mandolin rests on the table of the Stedelijk still life; it is difficult to believe that there is no direct relationship between them. So elastic has Picasso's 'calligraphic' drawing become, that it is easy to imagine how the roused sleeper of Picasso's *Night* tableau could turn into the musical instrument on the table, just as a pedestal-table still life turned into the Pierrot of the drop curtain.

The Stedelijk painting's close relationship with Picasso's designs for *Mercure* does not endow the painting with theatricality in any obvious sense. The way its flat planar elements are contained by frames within frames keeps it emphatically within the realm of painting. Space here is a flat expanse, not at all to be compared with the contained perspectival recession of a conventionally conceived stage set. Theatricality is, by contrast, an unmistakeable factor in the two other starry 1924 still lifes referred to here, the day-lit Guggenheim *Mandolin and Guitar* and the nocturnal *Still Life with Mandolin* from Dublin (pp. 139 and 137). John Richardson has called the Guggenheim picture a 'grand *coup de théâtre*', and has developed an elaborate argument for reading it in relationship to Prokofiev's *Commedia dell'Arte* opera, *The Love for Three Oranges*.[9] Of the two paintings, however, it is the Dublin picture that can more directly be connected with the designs for *Mercure* and so with Picasso's work in the theatre, although both display a fluidity of curve in the forming of their signs that Gertrude Stein might have associated with the 'calligraphic' line she found so essential to the *Mercure* designs.

It is a fluidity of line found in much smaller works of this moment too, for instance *Glass and Packet of Tobacco* of 1924 in the Museu Picasso, Barcelona (p. 153), which is almost a translation from the crystalline geometric idiom of the little stripe still lifes with packets of tobacco of 1922 into the new 'calligraphic' idiom.

9 Richardson (2007), op. cit., pp. 269–70.

It is Picasso's studies for the Three Graces theme in the ballet that connect with the Dublin picture. The Three Graces figured in more than one of the tableaux of the ballet. They disport themselves in a swimming pool, played by bewigged men with bright red cardboard breasts (p. 150, top). Their pearls are stolen by Mercury, who is chased away by the three-headed dog Cerberus, and they then appear on stage as bizarre life-size puppets moved by wires and assembled from bamboo and cane (p. 150, bottom). On stage, these constructed Graces have criss-cross armatures that overlay flat curvy backboards above which are projected tiny disc heads on long stalk necks. Their relationship with the 1915 New York *Harlequin* and the bottle of Anís del Mono in the Detroit still life of that year is obvious (Fig. 7, p. 63; p. 77). It is most directly the swaying bottle centre stage in the Dublin still life that relates to Picasso's ideas for the Graces. Specifically, it relates to the elegantly shaped, rising ensemble of curves given to the central Grace in one of the sketchbook drawings (p. 136, bottom). The distance from the 'calligraphic' sign for the female Grace to the swaying bottle in the Dublin picture is less than from the figure in *Night* to the musical instrument in the Stedelijk still life. The relationship is so clear that it is even easier to imagine that one quite literally became the other. Picasso's Graces on stage were constructed as stiff unwieldy objects (p. 150, bottom), but his still-life bottle (unlike the bottle of Anís del Mono from 1915) has the suppleness of the drawing, a suppleness that can be associated, like the pedestal table that became a Pierrot, with the mobility of a living body.

Moreover, the bottle in the Dublin painting is not the only object that has a relative among these ideas for female Graces. Suppleness is certainly not the right epithet for the fat, squat mandolin on the right, stolidly standing apart from the encounter between the fruit bowl and the bottle. Yet, even if the relationship is not as clear as in the case of the bottle, the mandolin does have something of the blob-like immobility of the Grace on the left of Picasso's sketchbook drawing. The fruit bowl has no relative in the drawings for the Three Graces, but, given the animation so easily imagined in the mandolin and especially the bottle, it also contributes to the idea of objects interacting as if alive. The bottle's swaying seems to be in direct response to the way the fruit bowl nudges and pecks at it, affectionately or perhaps not affectionately at all.[10] Both here and with the Guggenheim painting, we do not simply contemplate a still life, we attend a performance, and the objects that perform move like warm-blooded actors in costume, not like mechanized automata.

10 Boggs sees nothing but affection in the relationship.
It does not seem so clearly one or the other to me.
See Jean Sutherland Boggs, *Picasso and Things*
(exh. cat.). Cleveland, The Cleveland Museum of Art,
1992, p. 216.

At present, no sketches are known to me that relate closely enough to the other still lifes from the core group painted in the summer of 1924 to be called studies for them. There are, however, sketchbook drawings where Picasso combines and re-combines in different ways a mandolin, a bottle and a fruit bowl in pursuit of just such a combination as in the Dublin still life. In one instance he treats them with the simplicity of the Three Graces, simply placing them side by side (p. 136, top). In another he binds them into a richly patterned conglomeration involving a pedestal table and a wrought-iron balcony (p. 138, top left), where the legs of the table are on the point of lurching into a trundling run. In other drawings (p. 138, top right), table and still life taken together in combination become animate in a way that recalls the gesticulating still-life series of gouaches and watercolours from 1915 (pp. 71–73). It is worth stressing that all the drawings discussed here are in the same sketchbook as one of the two sheets of dot-and-line drawings illustrated so prominently in *La Révolution surréaliste*. The visual thought processes that took Picasso from his ideas for *Mercure* into the Dublin and Stedelijk still lifes were so integrally bound up with those that took him into the dot-and-line drawings that ideas for both proliferated between the covers of the same 1924 sketchbook.

As in the Dublin picture, the objects in the Guggenheim's *Mandolin and Guitar* of summer 1924 have been organicized, and, as I have suggested, both are theatrical in a way that connects with the tableaux of *Mercure* much more overtly than does the Stedelijk still life. If the animation of their objects can be called quasi-natural, their theatricality accentuates both the artifice entailed in their animation and the invitation they make to us, the audience, to find meaning in them for ourselves.

Still life and the stage had co-existed in Picasso's visual imagination for at least a half-decade before 1924. In 1919, when he was working with Diaghilev on the set and costume designs for the ballet *Tricorne*, Picasso cut, folded and fixed together a couple of still-life maquettes for constructions, perhaps with the idea of making a more complex follow-up to the pre-1914 metal *Guitar*. They were accompanied by a series of studies (p. 120). One of the little constructions is a still life with guitar on a table (Fig. 14) which almost doubles as a stage-set, its layered planes like stage-set flats framed beneath an open curtain. The open window, also a feature of this flimsy little construction, returns in the Guggenheim *Mandolin and Guitar* five years later,

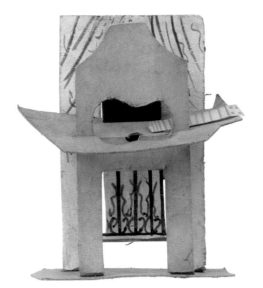

Fig. 14 *Table and Guitar in Front of a Window*
Paris, 1919
Construction: cut-out and painted cardboard, paper
and crayon strokes, 12 x 10.5 x 4 cm
Musée National Picasso, Paris. MP 258. Z III, 415

and is alluded to in the nocturnal backdrop of the Dublin picture. In both, there is an obvious staginess, often remarked upon, in the way the objects move and relate to one another on their tabletops.[11] Still life now does not merely feed off ideas developed for the theatre, it is presented *as* a kind of frozen theatre, its performers (wine bottles, fruit bowls, musical instruments) as familiar and as conventionalized as the characters of the *Commedia dell'Arte*.

Quasi-natural to the point of warm-bloodedness these objects may be, but their theatricality keeps them decisively removed from the 'realism' of the still-life tradition: the materiality of, say, the Spanish seventeenth-century *bodegón* or the perceptual hesitancy yet acuteness of, say, Cézanne. The semioticians of the Prague School in the 1930s were to demonstrate that one inevitable effect of the stage is to lift things out of their practical situations in life and turn them into signs, representations: to semiotize everything.[12] Even tables and the things placed on stage have their roles in setting the scene, or, like actors, in developing the action. Picasso's staged objects are neither objects nor figures: they *perform* as objects which can be responded to as organic, mobile and alive. A distinction can also be made between 'natural signs' – for instance smoke, which naturally goes with fire – and signs which need spectators or audiences to give them meaning, 'artificial signs', though

11 For instance, by Boggs. See ibid., pp. 214 and 216.
12 My discussion here is developed and applied to Picasso from the discussion of Gris's still lifes in chapter 7, 'Gris's Objects' in C. Green, *Juan Gris* (exh. cat.). London, Whitechapel Art Gallery/Yale University Press, 1992, pp. 157–58. Here as in 1992, my analysis owes much to Keir Elam, *The Semiotics of Theatre and Drama*. London and New York, Methuen, 1980, pp. 5–9. The crucial Prague School figures for the development of a semiotics of the theatre are Otakar Zich, Jan Mukarovsky, Petr Bogatyrev and Jiri Veltursky.

the point is made that on stage even natural signs are artificialized.[13] Applying this to the Guggenheim still life of 1924 (p. 139), we might focus perhaps on the colour and texture of the fruit, which as we usually experience them are 'natural signs' arousing expectations of certain desirable taste sensations, but in Picasso's theatre of objects the green and red of the fruit are clearly not 'natural' – they are engaged in a performance. The artificiality of every object is strikingly enhanced by the theatrical setting in which they 'perform'; and at the same time, that artificiality places the onus on the spectator or audience knowingly to join in: to turn these objects into representations which are not necessarily fixed. In the Guggenheim picture, John Richardson sees three oranges where others might see three apples, and imagines them, as already mentioned, performing the opera *The Love for Three Oranges*.[14] His case is that Picasso intended the association, but even if the artist did not intend it, the work asks its spectators to see it as a performance and so to connect it with their (our) memories of other performances.

This painting too has invited not merely readings in which the mandolin, guitar, bottle and fruit become actors, warm-blooded and alive, but in which they become eroticized to the extent of taking on sexual identities; they become not merely gendered figures but performing genitalia. Jean Sutherland Boggs finds in the standing guitar something 'yearning' but also 'voluptuous', and writes of the bottle in the middle with its 'red ring for an eye' inspecting the guitar 'with some admiration'.[15] Elizabeth Cowling adds extra punch to this erotic relationship by reading the sound hole of the mandolin as the female sex and/or anus, and its furry strings as pubic, which gives the erect stiffness of the bottle and especially its 'admiration' for the guitar a wholly different meaning.[16]

Picasso's theatrical still lifes of 1924, in the artfulness of their artifice and the warm-bloodedness of their organic forms, could be said to bring to a climax the oscillating relationship between the dead and the live played out in his compulsive engagement with still life between 1912 and the early 1920s. The mobility of the objects in these pictures no longer has the mechanistic jerkiness of automata, but they perform as the products of artifice as much as the New York *Harlequin* and the Detroit *Bottle of Anís del Mono* of 1915 do. The distinction between the Picasso who engages with the imaginary and the Picasso who engages with the 'real',

13 The distinction is made by Tadeusz Kowzan in 'The Sign in the Theatre' (1968). See Elam (1980), op. cit., p. 20.
14 See note 7.
15 Boggs (1992), op. cit., p. 214.
16 Elizabeth Cowling, *Picasso: Style and Meaning*. London, Phaidon, 2002, p. 461.

as Apollinaire and Carl Einstein identified it in 1905 and the late 1920s, still holds here, with these still lifes firmly on the side of the imaginary or the inner. At Juan-les-Pins in the summer of 1924, however, something closer to the fusion between the inner and the outer which a few years later Einstein would claim had occurred in Picasso's work was already apparent in some of the less theatrical still lifes painted there. Those possible objects-as-genitalia in the Guggenheim *Mandolin and Guitar* make a link with these less theatrical still lifes, for not only are objects organicized in them, they are also more to be felt as body parts than seen as actors in a theatre of still life, and the painting-as-material-object returns at the expense of the stage set.

Still Life: Fruit Bowl and Guitar, 1924
Oil and pencil on paper folded in four, 15.8 x 20.2 cm
Musée National Picasso, Paris. MP 1001

Still Life with Mandolin on a Table, 1924
Watercolour and pencil on laid paper prepared with a white ground, 25.1 x 15.9 cm
Philadelphia Museum of Art. A. E. Gallatin Collection, 1952. Inv. 1952-61-100

Study for the tableau *Night* in the ballet *Mercure*, Paris, 1924

Graphite pencil on laid paper, 27 x 21 cm

Sketchbook 27, MP 1990-104, f. 41 r. Musée National Picasso, Paris [●]

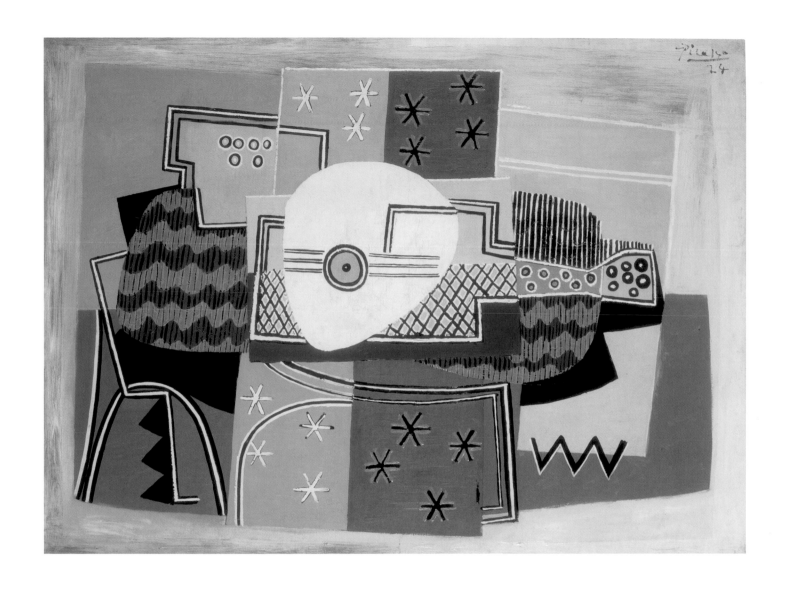

Still Life with Guitar, Juan-les-Pins, 1924
Oil on canvas, 97.5 x 130 cm
Stedelijk Museum, Amsterdam. Inv. A 6437. Z V, 224

Fruit Bowl, Guitar and Score on a Table
Juan-les-Pins, [Summer] 1924
Charcoal and sanguine on Arches paper, 31.5 x 23.5 cm
Sketchbook 30, MP 1869, f. 14 r
Musée National Picasso, Paris. Z V, 232 [•]

Study for the tableau *The Three Graces*
in the ballet *Mercure*, Paris, 1924
Graphite pencil on laid paper, 27 x 21 cm
Sketchbook 27, MP 1990-104, f. 8 r
Musée National Picasso, Paris [•]

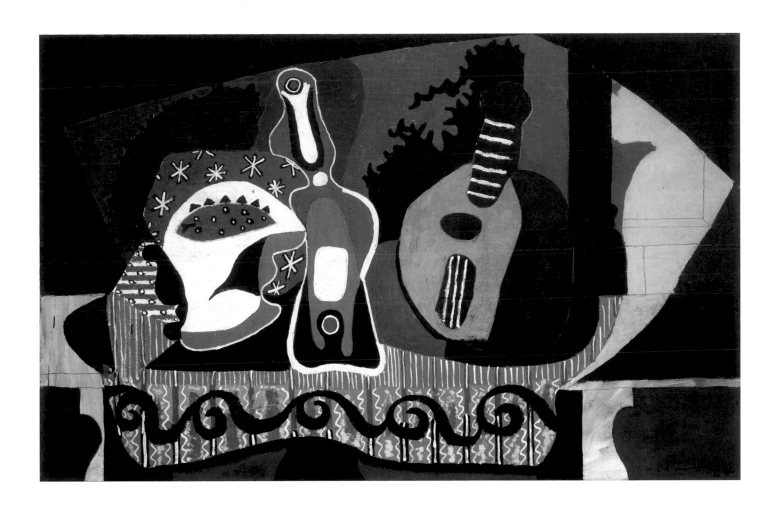

Still Life with Mandolin, 1924
Oil on canvas, 101 x 158 cm
National Gallery of Ireland, Dublin. NGI 4522. Z V, 228

Guitar and Fruit Bowl on a Pedestal Table
Juan-les-Pins, [Summer] 1924
Pen, Indian ink and wash on Arches paper
31.5 x 23.5 cm
Sketchbook 30, MP 1869, f. 9 r
Musée National Picasso, Paris. Z V, 305 [•]

Bottle and Mandolin on a Pedestal Table
Juan-les-Pins, [Summer] 1924
Pen, Indian ink and wash on Arches paper
31.5 x 23.5 cm
Sketchbook 30, MP 1869, f. 11 r
Musée National Picasso, Paris. Z V, 310 [•]

Guitar and Fruit Bowl on a Pedestal Table
Juan-les-Pins, [Summer] 1924
Pen, Indian ink and wash on Arches paper
31.5 x 23.5 cm
Sketchbook 30, MP 1869, f. 7 r
Musée National Picasso, Paris. Z V, 301 [•]

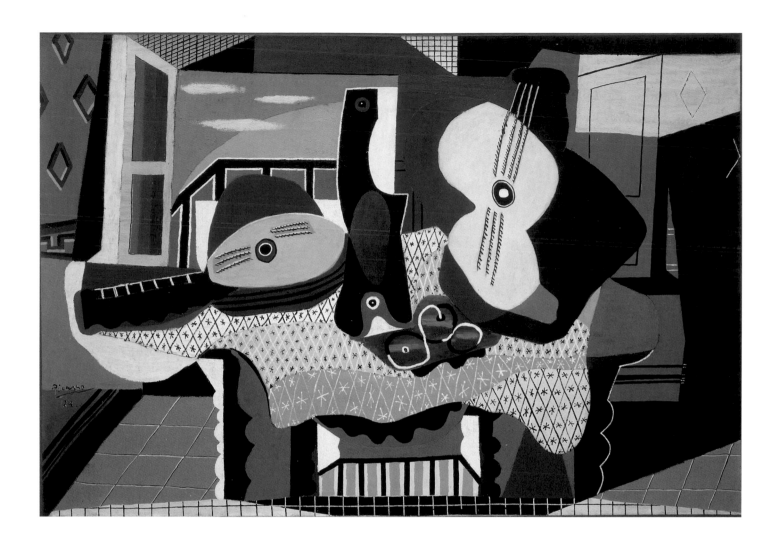

Mandolin and Guitar, Juan-les-Pins, 1924
Oil with sand on canvas, 140.7 x 200.3 cm
Solomon R. Guggenheim Museum, New York. 53.1358. Z V, 220

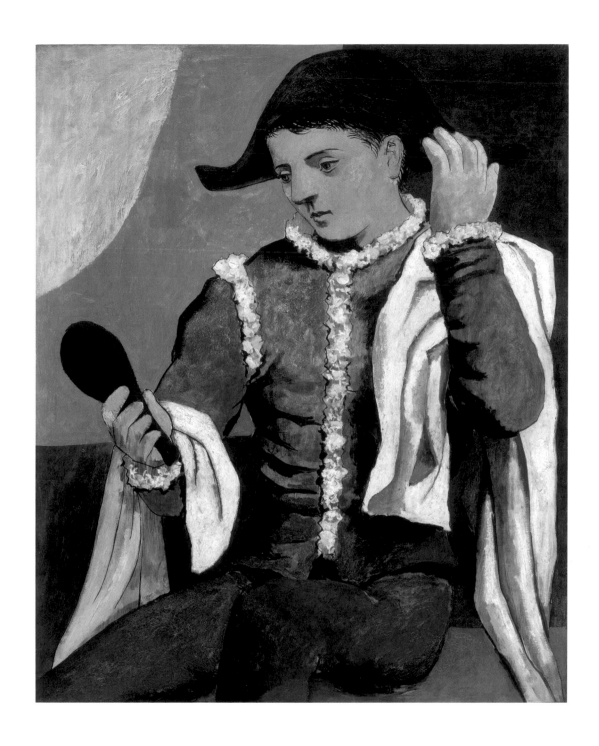

Harlequin with a Mirror, 1923
Oil on canvas, 100 x 81 cm
Museo Thyssen-Bornemisza, Madrid. Z V, 142

Studies for the drop curtain of the ballet *Mercure*
Harlequin with Guitar and Fruit Bowl on a Pedestal Table, Paris, 1924
Graphite pencil on laid paper, 27 x 21 cm
Sketchbook 27, MP 1990-104, f. 90 r. Musée National Picasso, Paris [•]

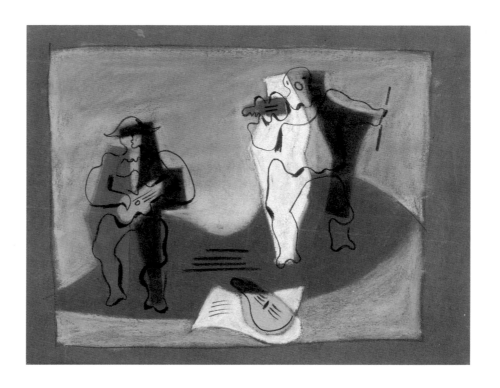

Study for the drop curtain
of the ballet *Mercure*, 1924
Pastel on grey paper, 25 x 32 cm
Musée National Picasso, Paris. MP 1825

Studies for the ballet *Mercure*, 1924
Pastel and pencil on beige paper
20 x 22.2 cm
Musée National Picasso, Paris. MP 1826

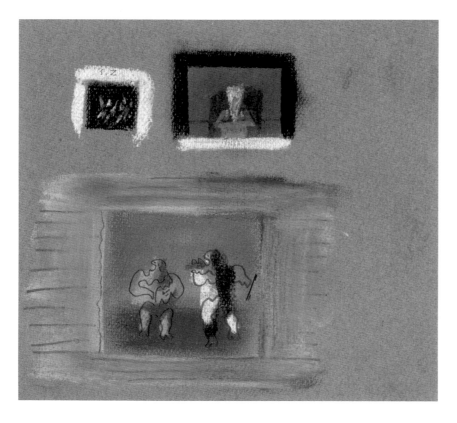

Studies for the drop curtain of the ballet *Mercure*
Harlequin with Guitar and Fruit Bowl on a Pedestal Table, Paris, 1924
Graphite pencil on laid paper, 27 x 21 cm
Sketchbook 27, MP 1990-104, f. 86 r, 87 r. Musée National Picasso, Paris [•]

Studies for the drop curtain of the ballet *Mercure*: *Harlequin with Guitar and Fruit Bowl on a Pedestal Table*, Paris, 1924
Graphite pencil on laid paper, 27 x 21 cm
Sketchbook 27, MP 1990-104, f. 88 r, 89 r. Musée National Picasso, Paris [•]

Studies for the tableau *Night* in the ballet *Mercure*, Paris, 1924
Graphite pencil on laid paper, 27 x 21 cm
Sketchbook 27, MP 1990-104, f. 81 r, 3 r. Musée National Picasso, Paris [●]

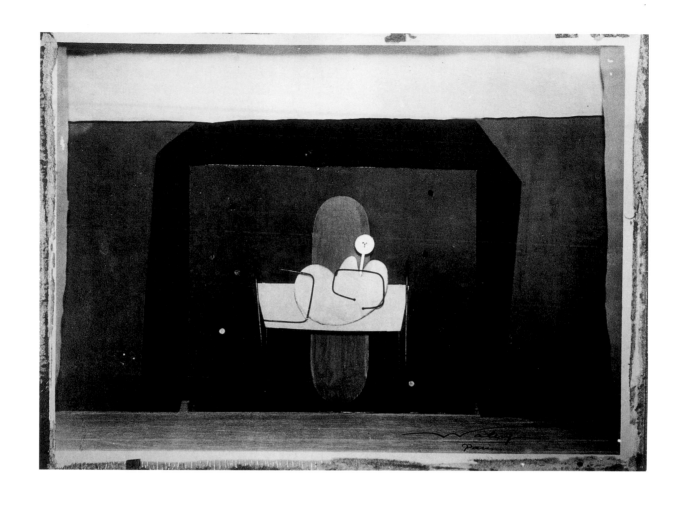

Waléry
Night, June 1924
Photograph of the ballet *Mercure*, 17 x 22 cm
D.A.F., Fonds Erik Satie, on permanent loan to Imec

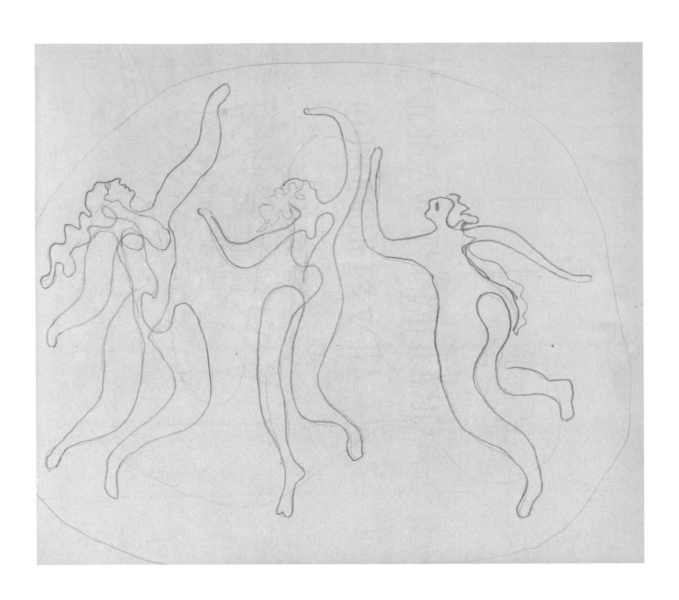

Three Dancers, Paris, 1924
Graphite pencil on laid paper, 27 x 21 cm
Sketchbook 27, MP 1990-104, f. 94 r. Musée National Picasso, Paris [•]

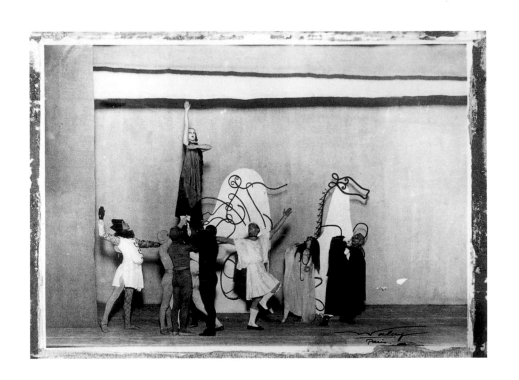

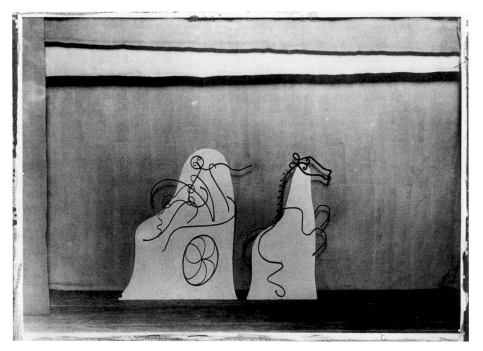

Waléry
Baccanale, June 1924
The Rape of Proserpine, June 1924
Photograph of the ballet *Mercure*, 17 × 22 cm
D.A.F., Fonds Erik Satie, on permanent loan to Imec

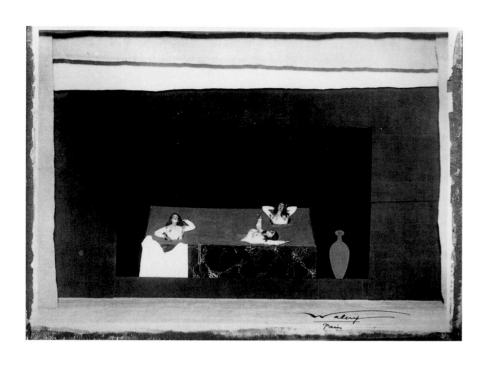

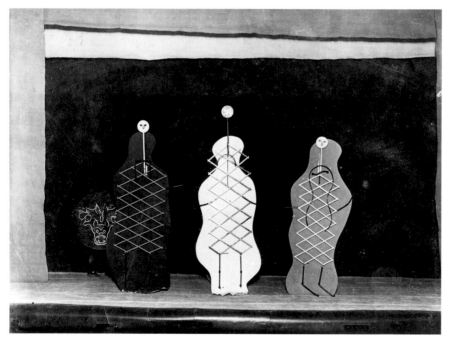

Waléry
The Bath of the Graces, June 1924
The Dance of the Three Graces and Cerberus, June 1924
Photograph of the ballet *Mercure*, 17 x 22 cm
D.A.F., Fonds Erik Satie, on permanent loan to Imec

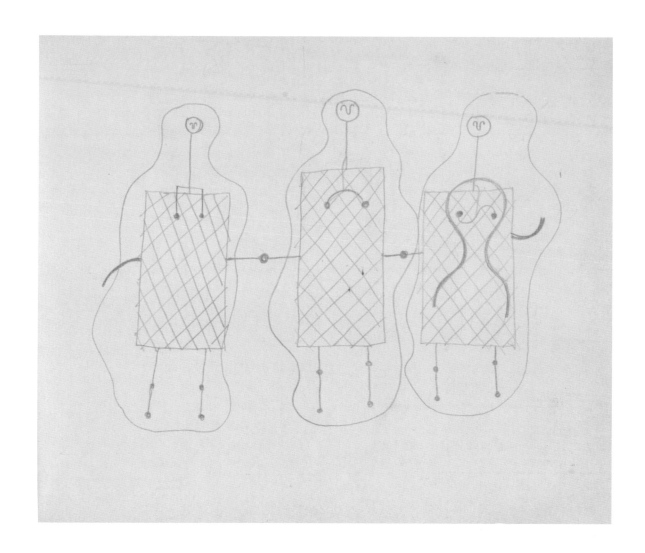

Study for the tableau *The Three Graces* in the ballet *Mercure*, Paris, 1924
Graphite pencil on laid paper, 27 x 21 cm
Sketchbook 27, MP 1990-104, f. 62 r. Musée National Picasso, Paris [●]

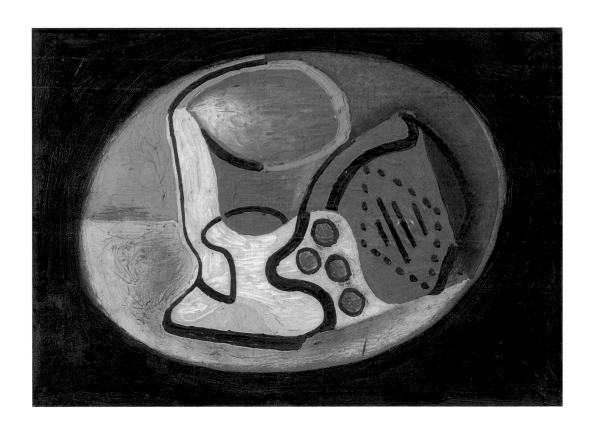

Glass and Packet of Tobacco, 1924
Oil on canvas, 16 x 22 cm
Museu Picasso, Barcelona. MPB 70.243

VII Monstrous Objects

At Juan-les-Pins, comfortably ensconced with his small family in the Hôtel du Cap and the château-style villa La Vigie, it might seem that Picasso let the pleasure principle take over altogether, if we are to believe the superficial impression made by his little sunbather drawing (p. 52) and both the brilliance of the Stedelijk picture and the blue sky of the Guggenheim picture. He worked, it might seem, under Apollinaire's sun. But even in a canvas both as decorative and as theatrical as the Dublin still life, something threatening can be sensed. The flowers behind the stars are black. They do not raise themselves to the sun, their colour has been dowsed in the black of night. And the fat mandolin does not just stolidly stand there, he or she has a shadow side. Night draws the picture towards death.

Any threat is muted here: a mere suggestion, not necessarily to be taken far. The fact is, though, that this and the sense of dislocation created by Picasso's refusal to fix definitively the meanings of his signs in the Guggenheim picture, allow these theatrical still lifes to emit a faint echo of the threat offered by two other still lifes (Fig. 16 and p. 163). These two very different paintings were also produced at Juan-les-Pins that summer; they anticipate the fall from the sun (as Bataille would have seen it) to be experienced in *The Kiss* and *The Dance*. I shall focus on these two darker works later. One small but clear sign of the link between the transformative pattern-making of Picasso's still lifes of 1922–24 and this turn away from Apollinaire's sun is ironically present, as I showed at the beginning of this text, in the little sunbather drawing with its female sex or navel surrounded with hairs like sun-rays. We have already seen how, out of its decorative symmetry, there came the blazing, consuming vagina of the murderous lover in *The Kiss* a year later.

Another indication of the turn towards violence to come lies in the coarse, tactile, material character of one or two of the theatrical still lifes of 1924, for instance the

Dublin picture and also *Mandolin, Fruit Bowl, Bottle and Cake* from the Gelman collection in the Metropolitan Museum, New York (p. 161), a work that shows Picasso making the theatrical connection even before his departure for the south – while he was at work on *Mercure*, in fact.[1] Artfulness, artifice, artificiality may all be epithets that fit the staging of the still-life performance in the Dublin picture (p. 137), but very different epithets are invited by its material character as a painted object. To confine ourselves to the way Picasso paints the riot of decorative devices above which the objects are placed, what is striking is the fact that he has simply ignored the finesse usually associated with the decorative arts. He makes his marks fast, often crudely. They are felt not just as marks with which patterns are put together, but as actions – often aggressive actions that entail cutting into the surface as well as using the brush. He may be able to transform everything in the process of working on paper or canvas, as if nothing he invents has the material factuality of things in perception, but this picture is very much a material thing, stimulating the sense of touch as well as sight, its surfaces built and then not only marked but scraped and scratched: attacked. It is real and vulnerable.

The Metropolitan's *Mandolin, Fruit Bowl, Bottle and Cake* lines up its dramatis personae on a tabletop stage, and does so without quite the material coarseness of the Dublin picture, but it too is manifestly vulnerable to Picasso's urge to attack the surface. And here the use of a sharp instrument to draw by cutting and scratching in order to expose the white under-painting is to be felt everywhere, not just where there is pattern. The signs for dado, terrace railing, grapes and bottle as well as for elements of the mandolin and the bottle are all gouged into the wet paint.

This coarseness of surface and the evidence it bears of attack is also characteristic of the two canvases now known to have been painted by Picasso in the summer of 1924 that uncompromisingly mark a turn to eroticized violence in anticipation of *The Kiss* and *The Dance* (Fig. 1, p. 38; Fig. 4, p. 46): the musical-instrument still lifes in the Fondation Beyeler, Basle (Fig. 15), and in the Reina Sofía, Madrid (p. 163). These are the still-life counterparts of those two figurative dramatizations of the fatal relation-ship between love and death. For that reason, until the recent publication of the third volume of John Richardson's biography of the artist, and because of their dating in Zervos, they have been thought of as accompanying or following *The Kiss* and *The*

1 Picasso dated the work 16 May 1924.

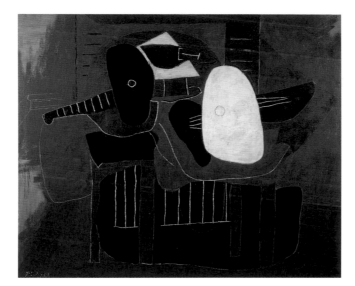

Fig. 15 *Musical Instruments on a Table*, 1924
Oil on canvas, 168 x 203 cm
Fondation Beyeler, Riehen/Basle
Z VII, 3

Dance in 1925. Richardson's discovery of photographs of the musical-instrument still lifes in progress in the garage Picasso used as a studio at Juan-les-Pins in the summer of 1924 has established incontrovertibly that they were in fact painted in the same summer as the theatrical still lifes.[2] Just how formidable the challenge to the pleasure principle in Picasso's painting already was that summer is thus made clear.

Like the Beyeler painting, the Madrid *Musical Instruments on a Table* (p. 163) is monumental in scale, as large as the Guggenheim *Mandolin and Guitar*. All three, though horizontal in format, match the scale of *The Dance*. The black, the moist greens and the greys of the Madrid picture are built up over a white undercoat, which is exposed by scratched incisions, as in the Metropolitan's *Mandolin, Fruit Bowl, Bottle and Cake*, generating a *sgraffito* line in white that in turn generates some of the forms, and details of the interior features, of the table and the things on it.[3] Broad, over-painted white areas complete the fruit bowl in the centre and the stringed instrument on the right; they are briskly brushed to give texture and to stimulate touch. The space is decisively pictorial rather than theatrical, the central conglomeration of objects being set loose to float in front of a framing surround which is painted sweepingly in atmospheric mid-tones. Things are not removed from us in a stage space; the still life comes to meet us.

2 John Richardson, with the collaboration of Marilyn McCully, *A Life of Picasso*, vol. III: *The Triumphant Years, 1917–1932*. London, Jonathan Cape, 2007, p. 271.
3 In fact, although there is *sgraffito* drawing in the wet paint in the Beyeler picture, the most telling white line drawing is done in white paint with the brush late in the working process.

And, like the theatrical still lifes, it is more than a still life. Picasso has inscribed a woman's profile into the over-painted white body of the

instrument on the right. Once seen, the loosely assembled biomorphic shapes that form the still life become the parts of a reclining woman. The calm of Picasso's colour range here does not, as Jean Sutherland Boggs has maintained, protect the work from menace.[4] If this is a body, it is a body in the process of dismemberment, and it is a body that Picasso has cut into as he has made it. This still-life-as-woman is under attack. Her body parts float apart. Wrapped in black, she is without the sun.

Just what is anticipated here can be brought out by a so-far rarely exhibited canvas painted two years later, in 1926, a picture that is strictly neither a figure painting nor a still life, although it goes by the title *Still Life with Palette, Easel and Water Jug* (p. 165). I shall call it here the artist's still life. Picasso not only left this canvas conspicuously uneven in its level of finish, but he left it disturbingly open in its body references. The easel's tall triangular structure can be read as a figure, with the palette that sits upon it as its wide-eyed, open-mouthed head in profile. It remains, however, an easel, hard and geometric by contrast to a collection of naked, fleshy forms that seem either to lean up against it or in some way to have been hung from it. Higher up, these forms bulge as if they have substance; below they are without substance, hanging like the skin from flayed limbs. Where they hang down there is a suggestion of legs or leggings, and the horizontal creases at the knees cue a relationship with the grotesquely bulbous elephant-legged models from a series of drawings made late in 1926 and early in 1927 (p. 164) that culminated in the huge painting *The Artist and Model* now in Teheran. In the artist's still life we are not given a monster model for the artist at the easel: we are left with the remnants of a body that is headless and armless, its legs stretched out of shape as if by the rack. The stable architecture of the easel-figure is accompanied by monstrous body parts, ghastly reminders of the indescribable horrors the body can be subjected to in life as well as death.

Between the Madrid *Musical Instruments on a Table* and the artist's still life, in 1925 Picasso painted another large biomorphic still life, which is now in the Musée National d'Art Moderne in Paris (p. 167). Significantly, Zervos catalogued this work as *Un coin d'atelier de Picasso* (a corner of Picasso's studio), so it possibly connects with the studio theme found in the artist's still life a year later; certainly there is a suggestion of a palette on the right.[5] Here the forms of the still life could nowhere be called fleshy, so it cannot evoke tortured limbs as disturbingly as the

4 Boggs sees the picture in a generally benign light. See J. S. Boggs, *Picasso and Things* (exh. cat.). Cleveland, The Cleveland Museum of Art, 1992, p. 228.

5 Christian Zervos, *Pablo Picasso*. Paris, Cahiers d'Art, 1932–78, vol. V, no. 462.

artist's still life, but the association between signs for objects and signs for body parts is altogether stronger than in the Madrid painting, and the violence done to the coarse material surface by Picasso's scraping and cutting is altogether more brutal. What is more, the surface attracts the sense of touch all the more intensely, because Picasso has scattered sand into the wet paint. His objects have become monstrous: so monstrous that it is no longer clear that they are objects at all. A stringed instrument can be read on the left, though its body has the amorphous form of a limbless torso, but on the right the shapes among which the palette-like element resides could also be read corporeally, though only in terms of unnameable body parts. Picasso is still a painter working with very simple signs out of his imagination, aware of the power of metaphor and the openness of signs to transformation, but he is now also a painter whose powerful sense of the real and whose consciousness of the violence in him are working together.

It is possible to see that fusion of the inner and the outer claimed for Picasso's work by Carl Einstein already emergent in such a painting of 1925; it is given a physical immediacy not found in either *The Kiss* or *The Dance*. These objects as dismembered body parts are not just imagined: the signs by which they are displayed for us have a material presence that makes them brutally 'real' to sight and touch. We are confronted here, as in *The Kiss*, by a Picasso for whom the death drive is in the ascendancy, a Picasso capable of extinguishing the sun altogether. This is a summer painting from the following year and it was made, like the sunniest paintings of 1924, at Juan-les-Pins, but its ghostly shrouds of white and its sickly yellow do not hold back the overwhelming weight of darkness.

Guitar and Fruit Bowl on a Pedestal Table
Juan-les-Pins, [Summer] 1924
Pen, Indian ink and wash on Arches paper, 31.5 x 23.5 cm
Sketchbook 30, MP 1869, f. 5 r. Musée National Picasso, Paris. Z V, 300 [•]

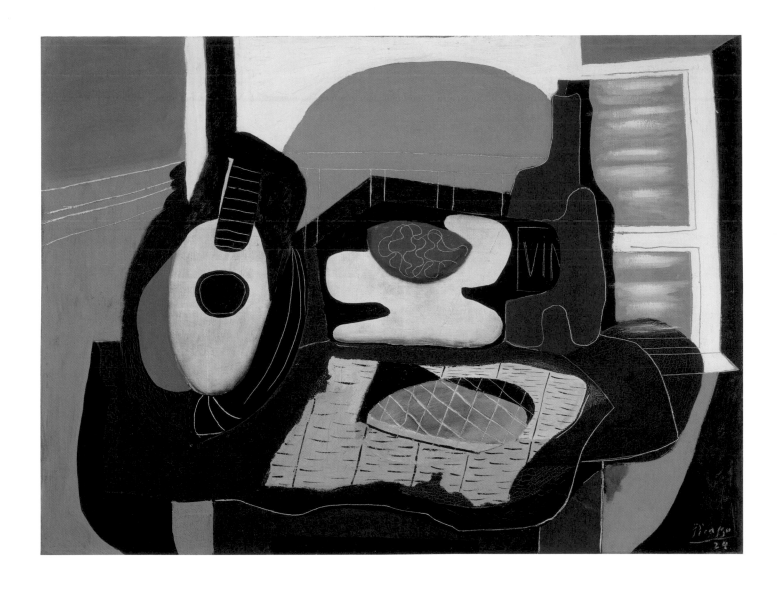

Mandolin, Fruit Bowl, Bottle and Cake, 1924
Oil on canvas, 97.8 x 130.8 cm
The Metropolitan Museum of Art, New York. Jacques and Natasha Gelman Collection, 1998 (1999.363.65)

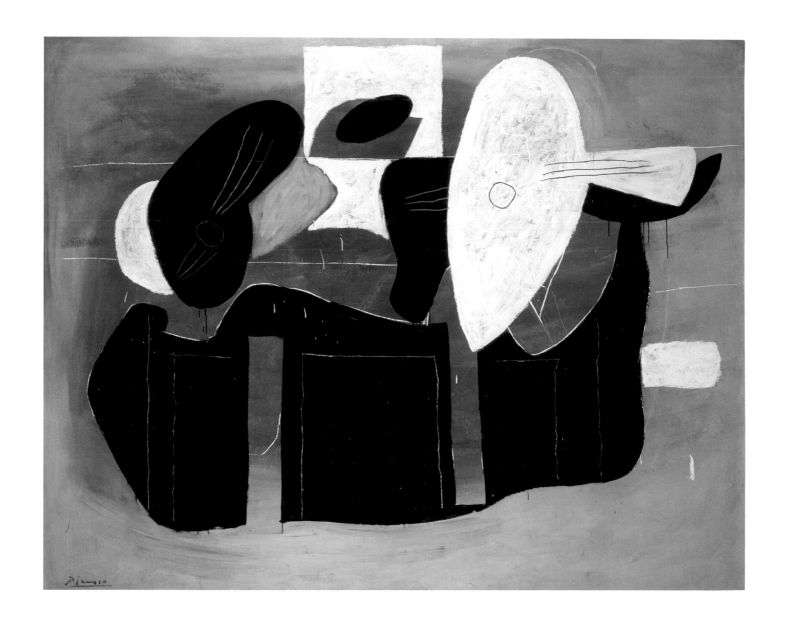

Musical Instruments on a Table, 1924
Oil on canvas, 162 x 204.5 cm
Museo Nacional Centro de Arte Reina Sofía, Madrid. Z V, 416

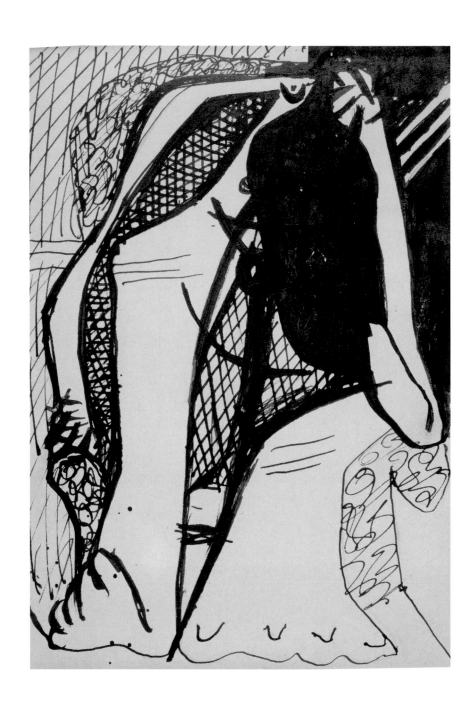

Nude Seated in an Armchair, Paris, December 1926–8 May 1927
Pen, Indian ink wash and grattages on Ingres paper, 17.5 x 26 cm
Sketchbook 34, MP 1873, f. 6 r. Musée National Picasso, París [•]

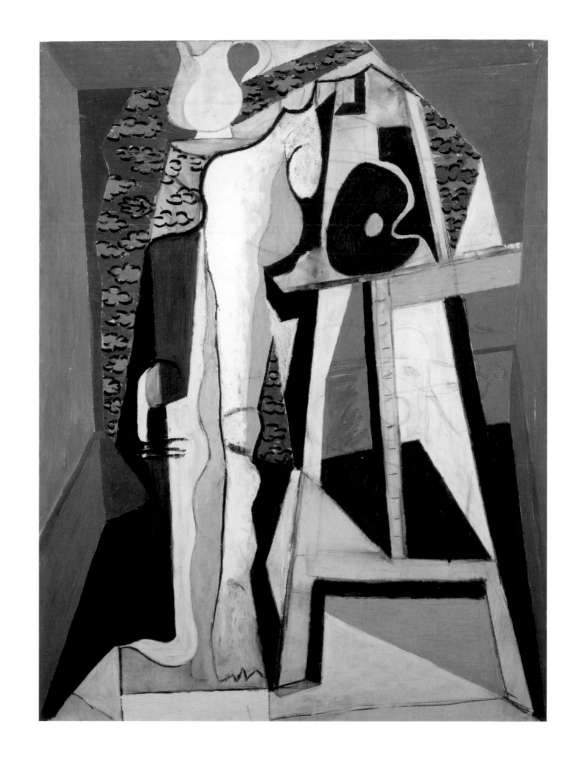

Still Life with Palette, Easel and Water Jug, 1926
Oil on canvas, 130 x 97 cm
Private collection

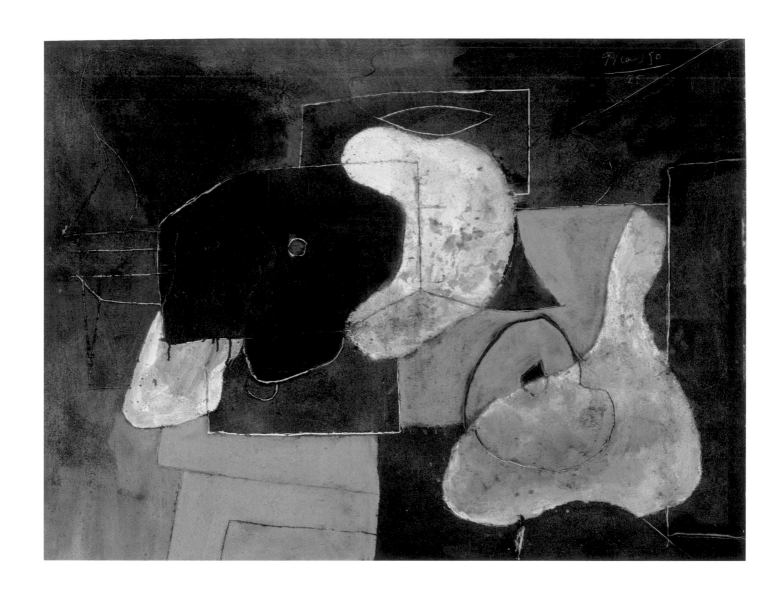

Still Life, 1925
Oil and sand on canvas, 97.8 x 131.2 cm
Centre Georges Pompidou, Paris. Musée National d'Art Moderne/Centre de Création Industrielle
AM 1982–434. Dation 1982. Z V, 462

Nymph and Sculpture, 4 May 1933
Etching on Montval laid paper with watermark *Picasso*, 44 x 33.5 cm
Museu Picasso, Barcelona. MPB 112.873

VIII Encounters

I shall conclude this study with a sequence of encounters, within works and between works, across the whole of the period covered.

The earliest I have chosen is an absolutely explicit meeting between life and death. It is the only such encounter to be found in Picasso's pre-First World War Cubist still lifes. It occurs in the *Musical Instruments, Skull* of early 1914 from Villeneuve d'Ascq (p. 175), which accompanied or followed one of the etchings he made for Max Jacob's stage play *Le Siège de Jérusalem* (p. 174) (Jacob was then as close to Picasso as Apollinaire).[1] The latest is an encounter between a classically idealized but living woman and what could be a ramshackle monument to Eros or a dead-alive harbinger of death. It occurs in the famous print from the Vollard Suite, *Nymph and Sculpture*, etched on 4 May 1933 (p. 168).

Elsewhere I have dwelt on the unresolved tensions within the etching between the European and the non-European, but there are other tensions than these.[2] The bizarre assemblage is both a still life and a figure; it is male and female (with ball breasts and testicles); it is droll yet uncanny; it is dead and alive (the shambolic automaton returns, but no longer in the harmless register of Hans Christian Andersen's living toys). The skull in the 1914 painting, a grey mask of death, floats above that emblem of modern transience, a newspaper, and directs its blind stare towards a palette-shaped guitar. On one side are music and art; on the other death and the passing of time. The two sides of the relationship are, it seems, unambiguous. Yet Rosenblum has pointed out that the dead eye sockets of the death's head could be taken in the witty terms of Picasso's collage wordplay to be the missing 'o' and 'u' of the word 'journal' below. The addition of these vowels allows us to go further than 'journal' to read, as he suggests, 'jouer'/play; 'jouir'/sexual release.[3] Life and death combine as the skull overlaps

1 The relationship between this painting and the etching used as an illustration in Kahnweiler's edtion of Jacob's play is very fully discussed by Boggs. See J. S. Boggs, *Picasso and Things* (exh. cat.). Cleveland, The Cleveland Museum of Art, 1992, p. 130.
2 See C. Green, *Picasso: Architecture and Vertigo*. New Haven and London, Yale University Press, 2005, chapter 8.
3 Robert Rosenblum, 'Picasso and the Typography of Cubism', in R. Penrose and J. Golding (eds), *Picasso 1881–1973*. London, Elek, 1973, p. 52.

Fig. 16 *Guitar*, Paris, Spring 1926
Cords, newspaper, cloth and nails on painted canvas
96 x 130 cm
Musée National Picasso, Paris
MP 87. Z VII, 9

the newspaper. Moreover, Sutherland Boggs has pointed out that the keyhole mysteriously painted over the blue palette-guitar is not inexplicable: if one attends to Jacob's text, *Le Siège de Jérusalem*, it could refer to the key to Jerusalem which Saint Matorel throws into the river in the play, condemning to death all who fight for Jerusalem as 'le symbole de perfection' (the symbol of perfection), (in the poet's words).[4] A sign which seems in this specific context to invoke death is inscribed over Picasso's hybrid emblem of music and art. The confrontation here between life and death might be explicit, but ultimately it is anything but straightforward.

I return to the point made by the circular or oscillating relationship between life and death evident in *The Dance*. Often within individual works by Picasso the relationship is unclear and unresolved, and as he moves from one work to another he allows neither life nor death ultimate ascendancy. One can isolate works to make it seem as if there is a direction. We could do so, obviously, by juxtaposing the Stedelijk still life and the Paris 'coin d'atelier' painting and inferring a one-way move from pleasure in the light of the sun to darkness and cruelty. Let us, however, take another confrontation on a smaller scale between a crystal Cubist painting and one of the progeny of *The Kiss*: between the little *Still Life: Pipe, Glass and Mask* from 1918 and *Faces on a Blue Ground* of 1926 (pp. 176–77). In this instance, the pipe and glass in the earlier picture could also be a head, the profile head of a pipe smoker. As such, this adds something comic to the perfection of geometric elements held in balance, something light and lively in a work whose solidity is enhanced by the mixing of sand

4 Boggs (1992), op. cit., p. 130.

into the paint. Its comic seriousness, at once lively and crystalline in its structural
perfection, confronts in *Faces on a Blue Ground* a violent sequel to *The Kiss*. The
divided circle just above the calm dead centre of the 1918 still life finds a distant
echo in the eyes of the two heads nearly a decade later, but now they are vaginas
that stare out from a violently erotic encounter where love is murderous. In such a
confrontation, polarities are unambiguous, but in fact Picasso never definitively
comes down on one side or the other.

Indeed, the impression of a clear direction towards darkness and death which is given
superficially by the story of Picasso's turn to the erotic and the murderous at Juan-les-
Pins between the summers of 1924 and 1925 is, in the end, misleading where still life
is concerned. There was a crueller, darker sequel to the scratched and dirtied Paris
Still Life (*A Corner of Picasso's Studio*) of 1925: the rubbish collages of 1926. When
they are on a smaller scale (pp. 178–79) they usually involve string stitched through
cardboard supports making lines and dots, the dots being the holes puncturing the
rough skin of the work. In the two largest collages, both titled simply *Guitar*, one
of which famously employs a floor cloth (Fig. 16), Picasso used nails and tacks to
puncture even rougher surfaces, the areas of filthy textile pinned up like ragged pieces
of flayed skin. But after that, the next major group of monumentally scaled still lifes
that he painted belong far more clearly under the sign of Apollinaire's life-giving sun
than Bataille's blinding, deadly sun.

These still lifes were painted during the darker months of 1931, in February and March, but they are characterized by sweeping curves which have the upward thrusting vitality of plant growth. Two of them feature a water jug and a fruit bowl on a table (p. 181 and Fig. 17, p. 171). The emptier of these, which also features a glass like a masked face, has the coarse roughness of surface found in the most brutal of the mid-1920s still lifes, but its three objects rise upwards on the turbulent surface of the table, towards the light. In the other there are broad leaves to accompany the water jug and fruit bowl; everything is treated as if it grows.

The light in these paintings is grey, but a month later Picasso was to deploy this growth-and-form idiom in perhaps the most dazzlingly sunny of all his still lifes, the *Still Life on a Pedestal Table*, dated 11 March 1931 (Fig. 18). It has often been pointed out that the curvy figure of Picasso's young lover Marie-Thérèse Walter is fused with the growth forms of these still lifes. If anyone could have convinced Picasso that, for a moment, Eros might prevail over death, it was Marie-Thérèse.

Fig. 18 *Still Life on a Pedestal Table*, Paris, 11 March 1931
Oil on canvas, 195 x 130.5 cm
Musée National Picasso, Paris. MP 134. Z VII, 317

Still Life with Skull, Paris, 1913
Drypoint on copper, 20.5 x 14.8 cm
MPB 110.103. From the book by Max Jacob, *Le Siège de Jérusalem. Grande tentation céleste de Saint Matorel* (MPB 113.100). Museu Picasso, Barcelona

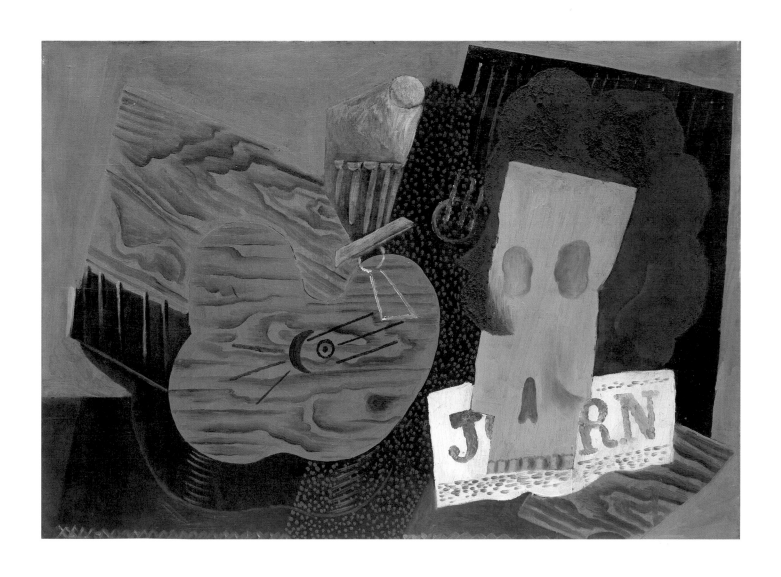

Musical Instruments, Skull, 1914
Oil on canvas, 43.8 x 61.8 cm
Musée d'Art Moderne Lille Métropole, Villeneuve d'Ascq
Gift of Geneviève and Jean Masurel. Inv. 979.4.114. Z II2, 450

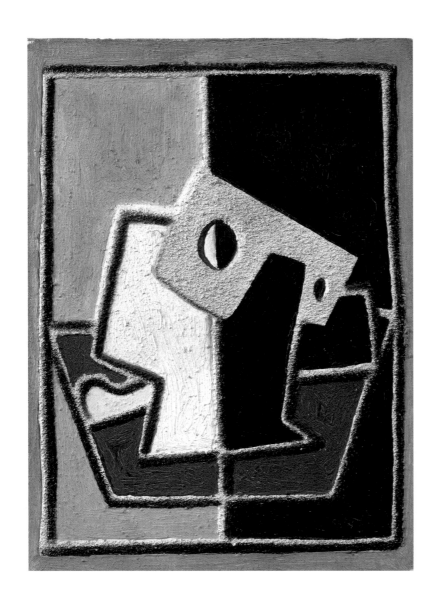

Still Life: Pipe, Glass and Mask, 1918
Oil and sand on canvas, 22 x 16 cm
Private collection

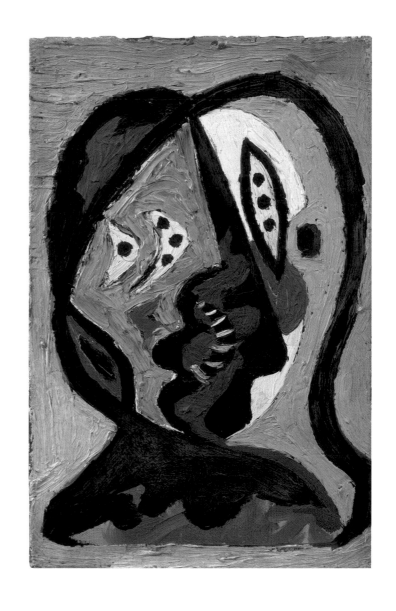

Faces on a Blue Ground, 1926
Oil on canvas, 22 x 14 cm
Private collection

Four Studies for a Guitar
Juan-les-Pins, [Summer] 1924
Pen and Indian ink on Arches paper, 31.5 x 23.5 cm
Sketchbook 30, MP 1869, f. 20 v.
Musée National Picasso, Paris. Z V, 282 [•]

Guitar, Paris, May 1926
Tulle, cord and traces of pencil on cardboard, 14 x 10 cm
Musée National Picasso, Paris. MP 93. Z VII, 21 [•]

Guitar, Paris, May 1926
Cord, pins, painted cardboard with pencil and
oil, cloth, ink and pencil on cardboard, 24.7 x 12.3 cm
Musée National Picasso, Paris. MP 95 [•]

Guitar, 1926
Cord, cloth, maple tree leaf and pencil on glued paper, 42 x 29 cm
Jan Krugier and Marie-Anne Krugier-Poniatowski Collection
Inv. CP 4419. Z VII, 19 [•]

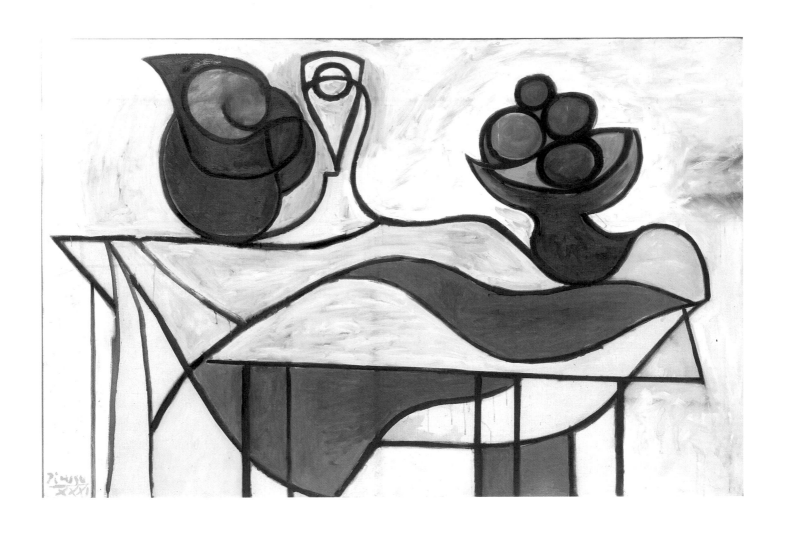

Water Jug and Fruit Bowl, 11 February 1931
Oil on canvas, 131 x 196 cm
Nahmad Collection. Z VII, 327

Chronology

DR refers to Pierre Daix and Joan Rosselet, *Picasso: The Cubist Years, 1907–1916. A Catalogue Raisonné of the Paintings and Related Works*. London, Thames & Hudson, 1979.
Z refers to Christian Zervos, *Pablo Picasso*. 33 vols. Paris, Cahiers d'Art, 1932–78.

1907

March At the first Salon des Indépendants in Paris, Matisse exhibits *Blue Nude (Souvenir de Biskra)* and Derain shows *Bathers*. The influence of these two paintings, together with that of Iberian art and primitive art, already evident in the works made the previous year in the village of Gósol, in the Pyrenees, is central to the conception of *Les Demoiselles d'Avignon*.

March–June Carries out numerous studies for *Les Demoiselles d'Avignon*, considered the first Cubist painting, which he completes in July.

Spring Paints *The Harvesters* (Thyssen-Bornemisza, Madrid), the only one of his works that can be considered Fauve. The tree, reduced to its skeleton, and the rhythm that dominates the space of the picture reveal concerns that will prevail from the summer of 1907, for example in the two canvases entitled *Landscape* related to *The Harvesters* (pp. 55).

Spring–Summer Paints the oil *Nude with Raised Arms* (DR 53), in which conventional elements of Iberian origin attain a higher degree of schematization and geometrization, according to Pierre Daix.

Summer Picasso paints *Landscape* (DR 62), according to Daix, one of the first abstract landscapes in modern painting.

Winter Paints an oil with two strong female nudes entitled *Friendship* (DR 104) and several studies for the picture. The abstract forms of the towel held by the figure on the left recall the *Landscape* (DR 62) painted that summer. Paints various imaginary landscapes, including *Landscape (Two Trees)* (DR 179) and *Landscape* (DR 180), that evoke the simplifications of landscape of Derain or Vlaminck.

1908

Late Spring Picasso stylizes his imagined landscapes and retains the essential volumes: tree trunks, masses of rock, earth and foliage reduced to large planes, as in *Landscape* (DR 181). These planes are converted into the faces of figures, as in the portraits of bathers in *The Bather* (DR 184).

Spring–Summer Braque paints his first Cubist landscapes in L'Estaque, near Marseilles; rejected by the Salon d'Automne in Paris, they are presented in November at Kahnweiler's gallery.

Summer At La Rue-des-Bois he paints *The Farmer's Wife* (DR 193), various landscapes and still lifes in an early Cubist manner. Paints *Landscape with Two Figures* (DR 187), in which the perpendicular position of the figures is signalled by the elements they relate to and fuse with: the ground in the case of the supine figure on the left and the trunk of the tree for the standing figure on the right.

November An article by Louis Vauxcelles, published in *Gil Blas* on the occasion of the Braque exhibition in the Kahnweiler gallery, gives a name to a new artistic style: Cubism.

Winter Paints the oil still-life *Bread and Fruit Dish on a Table* (DR 220), in the sketches of which, known as *Le Carnaval au Bistrot*, the objects are transformed into human figures. In December, takes part in a group exhibition at the Nôtre-Dame-des-Champs gallery in Paris.

1909

5 June Picasso and Fernande arrive at the little town of Horta de Sant Joan, south of Tarragona, to spend the summer. The landscapes, portraits of Fernande and still lifes that Picasso paints in Horta de Sant Joan manifest the transition to Analytical Cubism.

Autumn Makes his first purely Cubist sculpture, *Tête de Femme (Fernande)*. The plaster cast entitled *Apple* (Z II 2, 718, 719) is also from this year.

The Neue Künstlervereinigung München organizes the first Picasso exhibition in Germany at the Moderne Galerie Heinrich Thannhauser in Munich.

1910

End of June Travels with Fernande and Derain and his wife to Barcelona and later

spends two months in Cadaqués as the guests of Ramón and Germaine Pichot. There he paints *The Guitarist* (DR 362) and makes the four etchings for Max Jacob's novel *Saint Matorel*, which Kahnweiler publishes in February 1911.

Paints the Cubist portraits of the dealers Vollard and Kahnweiler (Fig. 3, p. 44) and the art critic Wilhelm Uhde.

Takes part in several group exhibitions: at the Müvészház gallery in Budapest in April; at the Nôtre-Dame-des-Champs gallery in Paris in May; in Düsseldorf in July; at the Thannhauser gallery in Munich in September, and at the Grafton Galleries in London in November. Vollard puts on a Picasso exhibition in Paris in December (without catalogue).

1911

July Travels to Céret, in the French Pyrenees, where he lives and works in the home of his friend Manolo Hugué. In August, he is joined by Braque, Fernande and Max Jacob. In Cubist compositions such as *Still Life with a Bottle of Rum* (DR 414) he follows Braque in using printed letters.

1 October Opening of the Salon d'Automne in Paris with a room devoted to Cubism, in which there is nothing by Picasso, despite the fact that the press is unanimous in identifying him as the father of the new movement.

Autumn Meets the painter Louis Markus and Eva Gouel (Marcelle Humbert). In his paintings he refers to Eva as '*ma jolie*'. Exhibits for the first time in the United States: Alfred Stieglitz's 291 gallery in New York presents eighty-three drawings and watercolours from 1905 to 1910. The exhibition, which opens in March, runs until May. In October, he has seven works in the Moderne Kunst Kring show in the Stedelijk Museum in Amsterdam.

1912

Spring Makes what is considered to be the first collage in art history: *Still Life with Chair Caning* (DR 466).

Early May Paints two oval still lifes entitled *Souvenir of Le Havre*, fundamental to the evolution and understanding of Cubism.

13 September In Sorgues, Braque makes the first *papier collé*, entitled *Fruit Dish and Glass*. Following his example, Picasso makes his first *papiers collés*, which lead to Synthetic Cubism.

Late 1912–early 1913 Paints the Cubist portrait of Apollinaire for his book of poems *Alcools*.

Publication of Albert Gleizes and Jean Metzinger's book *Du Cubisme*.

Takes part in various group exhibitions throughout the year, including the Jack of Diamonds show in Moscow in January and the second Der Blaue Reiter show at the Galerie Neue Kunst Hans Goltz in Munich in February, where he presents five works and the Max Jacob novel *Saint Matorel* with his etchings. In May, he takes part in the third group exhibition of graphic work at Der Sturm gallery in Berlin with twenty-two drawings and etchings, most of them prior to 1907. The same month sees the opening of the Sonderbund's 'Internationale Kunstausstellung' in Cologne, with a room devoted exclusively to Picasso. He also presents five works at the Berliner Secession exhibition in Berlin in the spring, three works in the exhibition organized by the Verein LIA in Leipzig in April, nine works at the Hans Goltz gallery in Munich in October, and twelve made between 1901 and 1912 in the international exhibition at the Stedelijk Museum in Amsterdam. He has thirteen paintings and three drawings in the second Post-Impressionist exhibition at the Grafton Galleries in London the same month and two drawings in the '3rd Show without a Jury' in Berlin in November.

In February, the Dalmau gallery in Barcelona puts on an exhibition of works from Picasso's blue and rose periods. In April, the exhibition 'Drawings by Picasso' opens at the Stafford Gallery in London, with twenty-six works in the catalogue, and in May twenty-two drawings and etchings by Picasso are shown at Der Sturm gallery in Berlin.

1913

Mid-March–Summer In Céret, he paints *Geometric Composition: The Guitar*.

15 November The magazine *Les Soirées de Paris*, edited by Apollinaire, posting pictures of constructions of Picasso.

Autumn After making a number of sketches he paints *Woman in an Armchair* (DR 642), a picture greatly admired by the Surrealists, and presents it at exhibitions in London in 1921 and Paris and Zurich in 1932.

Apollinaire's book *Les Peintres cubistes* is published in Paris.

In January, he takes part in the exhibition 'Die neue Kunst' in the Galerie Miethke in Vienna. In February, the 'International Exhibition of Modern Art', known as the 'Armory Show', opens in New York. The exhibition, which subsequently travels to Boston and Chicago, includes eight works by Picasso, of which two are loaned by Leo Stein, three by Kahnweiler and two by Alfred Stieglitz. In March, he has one work in a collective exhibition in Moscow, and in April contributes three works to the international exhibition at the Müvészház gallery in Budapest. In Prague in May, he takes part in the collective modern art exhibition of the group of Prague with thirteen works made between 1903 and 1912, and in August he shows five works at the Hans Goltz gallery in Munich. In October, the 'Post-Impressionist and Futurist' exhibition opens at the Doré Gallery in London with a painting and three photographs by Picasso. Also in October, he takes part in the international exhibition at the Neue Galerie in Berlin with three paintings, three drawings and two prints,

and in December he has two works in the Albert Bloch exhibition in Berlin. That autumn the exhibition of the work of the French masters in the Ernst Múzeum in Budapest includes two Picassos. He also takes part in the 'International Exhibition' in Prague and the exhibition in the Secession gallery in Berlin.

One-man exhibitions that year include the major retrospective 'Pablo Picasso' at the Thannhauser gallery in Munich in February, with works from 1901 to 1912: seventy-six paintings, thirty-seven watercolours and a number of drawings.

1914

January Kahnweiler publishes a book of poems by Max Jacob, *Le Siège de Jérusalem*, illustrated with three etchings and a drypoint by Picasso (p. 174).

Spring He makes six versions in bronze of the sculpture *The Glass of Absinthe*, decorated with paint and sand (DR 753–758).

Mid-June In Avignon, he paints still lifes and portraits with bright colours and a 'pointillist' style. He paints *Still Life with Playing Cards and Peaches* (p. 58).

Summer In Avignon, he begins work on *Painter and Model* (DR 763), in which he returns to naturalistic representation.

3 August Germany declares war on France and the First World War begins. In January, the Grafton Club in London hosts an exhibition of French artworks, including a Picasso. In February, the Miethke gallery in Vienna puts on an exhibition of fifty-seven works by Picasso, most of them after 1907. The same month he has six works in the international exhibition at the Kunsthalle in Bremen. A drawing by Picasso is presented in the fourth Jack of Diamonds show in Moscow and four works in a collective exhibition in Prague. In the summer, the Galerie Neue Kunst Hans Goltz in Munich organizes a group exhibition with works by Picasso.

In December, an exhibition of recent drawings and paintings by Picasso and Braque opens at the 291 gallery in New York.

1915

He paints a dozen variations of the compositions with musical instruments (pp. 70–73). He uses tin and wire for the construction *Violin* (DR 835) (Fig. 1, p. 19) reworking his guitars of 1912 (MP 244, MP 245) and looking forward to the guitars of 1924 (MP 260) (p. 105).

Autumn 1915 He paints *Bottle of Anís del Mono* (p. 77) (DR 838) which William Rubin first connected with the *Harlequin* in the MoMA (DR 844) (Fig. 7, p. 63), painted at the same time, on the basis of the placing of the bottle and the similarity between the harlequin's diamond-patterned costume and the raised prisms on the bottle. In a letter to Gertrude Stein, Picasso writes that the harlequin 'is the best thing I have done so far'. The painting *Seated Man* (DR 855) is also related to this play of forms.

14 December Eva Gouel dies. In February, he contributes *Glass and Bottle* to the group exhibition 'Secessione, III Internazionale, Bianco e Nero, Collezione Emil Richter' in Rome, and in October a selection from the Plandiura collection, which includes a score of works by Picasso, is presented at the Galeries d'Art Modern i Antiquitats in Barcelona.

1916

He paints *Guitar, Clarinet and Bottle on a Pedestal Table* (DR 886). The grainy strips on either side tend to define the space in all of the subsequent pictures of a table in front of a window.

5 February Birth of the Dada movement in Zurich, with the reading of Hugo Ball's *Dada Manifesto* and the opening of the Cabaret Voltaire. The first and only issue of the magazine *Cabaret Voltaire* includes four etchings and a drawing by Picasso.

31 December A banquet in honour of Guillaume Apollinaire is held in the Palais d'Orléans to celebrate his return from the war and the publication of *Le Poète assassiné*. Picasso, who is one of the organizers, is also the inspiration for Apollinaire's 'bird of Benin' in *Le Poète assassiné*.

In May, he shows a work in the 'Advanced Modern Art' exhibition at the McClees Gallery in Philadelphia and in November takes part in the exhibition organized by Cocteau at the Salle Huyghens in Paris.

1917

17 February Sets off with Cocteau for Rome, where he meets up with the Russian impresario Sergei Diaghilev, the Ballets Russes' principal dancer and choreographer Léonide Massine and Igor Stravinsky, the composer of a number of scores for the company. In Rome, where the Ballets Russes is temporarily installed, Picasso works on the costumes and sets for their next project, the ballet *Parade*. Here Picasso gets to know one of the ballerinas, Olga Khokhlova, who subsequently becomes his wife. He stays in Italy for eight weeks, and as well as Rome visits Naples, Pompeii and Florence. The impression made by this trip is evident in his work from 1919.

18 May *Parade* premieres at the Théâtre du Châtelet in Paris. The curtain, sets and costumes are by Picasso, with libretto by Cocteau, music by Satie and choreography by Massine. The term 'Surrealism' appears in print for the first time in Apollinaire's programme notes. The curtain belongs to Picasso's so-called 'classical period', an evident presence in his work as of this year. The scenery and costumes, especially for the Managers (Figs 9 and 10, p. 90; pp. 96–97), remain faithful to Cubism.

June He travels to Madrid and Barcelona with the Diaghilev company on its Spanish tour. The Ballets Russes play the Gran Teatre del Liceu in Barcelona 23–30 June, before

travelling to South America. Picasso and Olga Khokhlova stay in Barcelona.

Mid-November Picasso makes an etching of a Cubist harlequin as an illustration for Max Jacob's book *Le Cornet à dés*.

1918

May Picasso and Vollard are witnesses at the wedding of Apollinaire and Jacqueline Kolb.

12 July Picasso marries Olga Khokhlova. The witnesses are Cocteau, Jacob and Apollinaire.

9 November Guillaume Apollinaire dies of Spanish 'flu.

11 November Signing of the armistice between the Allies and Germany. Picasso etches a Pierrot in the classical style for Max Jacob's book *Le Phanérogame*. In January, the exhibition 'Matisse-Picasso' opens at the Guillaume Paul gallery in Paris.

1919

April Joan Miró visits Picasso in his studio.

May–July In London with the Diaghilev company, which is preparing the ballet *The Three-Cornered Hat*, to work on the design of the curtain, the sets and the costumes. The music is by Manuel de Falla and the choreography by Massine. The premiere is on 22 July at the Alhambra Theatre in London.

August Paints a series of Cubist still lifes in Saint-Raphaël on the French Riviera.

November Max Jacob publishes his book *La Défense de Tartuffe*, illustrated with a Picasso etching from 1916. In October, the Galerie Paul Rosenberg in Paris puts on an exhibition of Picasso drawings and watercolours, including some of the still lifes from the summer. André Salmon writes the catalogue text. In May, the 'Exposició d'Art' opens in the Associació de les Arts i els Artistes in Barcelona with several works by Picasso, including the 1917 *Harlequin*.

1920

15 May Premiere of *Pulcinella* at the Paris Opéra, Picasso's third collaboration with Diaghilev's Ballets Russes, for which he again designs costumes and sets. The choreography is by Massine, who also wrote the libretto with Diaghilev, based on popular Neapolitan tales. The music is by Pergolesi, orchestrated by Stravinsky.
In October, an exhibition of avant-garde French art, with works by Picasso, opens at the Dalmau gallery in Barcelona. He also shows in exhibitions at the Valori Plastici gallery in Rome and the Paul Rosenberg gallery in Paris. The latter includes the preparatory drawings for the costumes for the ballet *The Three-Cornered Hat*.

1921

4 February His son Paulo is born.

April In Munich, Maurice Raynal publishes the first monograph devoted to Picasso.

22 May First performance of Diaghilev's *Cuadro Flamenco*, with music by de Falla and costumes by Picasso, in the Gaîté Lyrique theatre in Paris.

2 July Publication of Paul Valéry's book *La Jeune Parque* with a lithograph by Picasso, *Portrait of the Author*, from a drawing made the previous year.

Summer Spends the summer at Fontainebleau where he paints *The Three Musicians*, in the Synthetic Cubist style, and *Three Women at the Fountain*, in the Classical style.
In January, a Picasso exhibition opens at the Leicester Gallery in London, with works dated between 1902 and 1919. The catalogue text is by the art critic Clive Bell. In September, Picasso shows at the Paul Rosenberg gallery in Paris.

1922

29 March Publication of Pierre Reverdy's *Cravates de Chanvre*, illustrated with three etchings by Picasso.

June–September At Dinard in Brittany, he paints *Two Women Running on the Beach* (MP 78), which he later reworks in 1924 as the curtain for Cocteau's ballet *Le Train Bleu*. Paints several still lifes based on the composition of *Guitar, Clarinet and Bottle on a Pedestal Table* (DR 886).

Autumn Picasso exhibition at the Thannhauser gallery in Munich. In November, he takes part in the show 'Les Inconnus' organized by Kahnweiler at his new Galerie Simon in Paris.

20 December Premiere of Jean Cocteau's adaptation of Sophocles' *Antigone* at the Théâtre de L'Atelier, with stage design by Picasso and Cocteau and costumes by Coco Chanel.

1923

February The Catalan painter Jacinto Salvadó sits for Picasso as the model for a series of *Seated Harlequins* (p. 141), in the classical style timidly commenced in 1915.

19 May The New York magazine *The Arts* publishes the first major interview with Picasso, by Marius de Zayas.

September His output consists for the most part of large still lifes in a style that Alfred Barr describes as 'curvilinear Cubism'.

15 November André Breton's book *Clair de terre* is published in Paris, with a portrait of the poet in drypoint by Picasso, who had met Breton earlier that year.
In November, an exhibition of recent works by Picasso opens at the Paul Rosenberg gallery in Paris, and he also presents sixteen paintings at the Wildenstein Gallery in New York, as well as an exhibition of paintings at the Thannhauser gallery in Munich and a show of his drawings at the Arts Club of Chicago. He also takes part in a collective show at the Galerie Simon in Paris.

1924

April The exhibition 'Picasso. Cent dessins' opens at the Paul Rosenberg gallery in Paris.

18 June The Théâtre de la Cigale stages a programme of avant-garde events, *Les Soirées de Paris*, which includes the premiere of the ballet *Mercure*, produced by Count Étienne de Beaumont and Léonide Massine, with sets and costumes by Picasso, music by Erik Satie and choreography by Massine (pp. 142–51). The ballet is not well received by the public and critics. Picasso is defended by a number of Surrealist artists, including André Breton, who publishes his 'Hommage à Picasso' on 20 June in *Les Soirées de Paris*.
20 June The Théâtre des Champs-Elysées premieres Jean Cocteau's *Le Train Bleu*. The music is by Darius Milhaud, the choreography by Nijinsky, the sets by Henri Laurens and the costumes by Coco Chanel, and the curtain by Picasso is an expanded version of his pastel *Two Women Running on the Beach* (MP 78), done two years before.
Summer In Juan-les-Pins, he fills a sketchbook with some forty pen-and-ink drawings: abstract compositions of constellations and points (pp. 114–15). Two of these are reproduced the following year in *La Révolution surréaliste* and sixteen others illustrate the edition of Balzac's *Le Chef-d'œuvre inconnu* published by Vollard in 1931. During the summer he makes a series of 'curvilinear Cubist' compositions, such as *Mandolin and Guitar* (p. 139).
October Publication of André Breton's *Manifeste du surréalisme*.
December Launch of the magazine *La Révolution surréaliste*, edited by Pierre Naville and Benjamin Péret. The first issue includes a photograph of the tin and wire construction *Guitar* (p. 105) that Picasso had made earlier that year.
Pierre Reverdy's monograph *Pablo Picasso* is published in Paris.

1925

January The exhibition 'From Ingres to Picasso' opens at the Baltimore Museum of Art.

May–June He completes *The Dance* (Fig. 4, p. 46), the antithesis of his classical drawings of dancers of the previous months. The figure in profile on the right is his friend Ramón Pichot, who died a few days previously. *The Dance* marks a break with the classical period begun in 1917.
July Publication of Raymond Radiguet's *Les Joues en feu* with a lithograph portrait of the author by Picasso.
15 July Issue 4 of the magazine *La Révolution surréaliste* includes the first ever reproductions of *Les Demoiselles d'Avignon* and *The Dance*.
Summer In Juan-les-Pins, he paints *Studio with Plaster Head*, using props from his son Paulo's puppet theatre.
November The first Surrealist group exhibition opens at the Galerie Pierre in Paris, with works by Jean Arp, Giorgio de Chirico, Max Ernst, Paul Klee, André Masson, Joan Miró, Man Ray and Picasso.

1926

Spring He creates a series of *Guitars* using the technique of assemblage of found objects – fabric, nails and thread – in a style halfway between Cubism and Surrealism (pp. 178–79).
June Publication of Waldemar George's book *Picasso dessins* with reproductions of sixty-four drawings and the 1925 lithograph *Head of a Woman*. 'Exposition d'œuvres récentes de Picasso' opens at the Paul Rosenberg gallery in Paris, and includes the 1924 *Mandolin and Guitar* (p. 139).
December *Picasso, œuvres 1920–1926* is published in Paris, with an engraving, *Femme*, from 1922–23.
Christian Zervos launches the journal *Cahiers d'Art* in Paris.
Cocteau publishes a collection of texts which includes a piece on Picasso, 'Rappel à l'ordre'.

1927

January He meets Marie-Thérèse Walter.
11 May The painter Juan Gris dies in Paris.
Summer In Cannes, he makes a number of ink drawings of monstrous female bathers. In July, a Picasso exhibition opens at the Paul Rosenberg gallery in Paris. In October, there is a show at the Alfred Flechtheim gallery in Berlin, and another in December at the Galerie Pierre in Paris. He also has a show at the Wildenstein Gallery in New York, and takes part in exhibitions in Barcelona and New York.

1928

January He makes a collage in which the Minotaur appears for the first time – the figure that becomes a kind of alter ego throughout the 1930s.
May Picasso begins his professional collaboration with the sculptor Julio González, from whom he learns the techniques of constructing in metal.
Summer In Dinard, he paints a series of small paintings of bathers, products of the so-called 'Dinard period', in which the position of the figures' limbs and their unnatural proportions result in monstrous forms.
Autumn He carries out various sculptural projects for a monument to Apollinaire, for which he had made several studies during the month of August. The exclusive use of lines marks a return to the abstract compositions of constellations and points of the summer of 1924.
Publication of André Level's book *Picasso*, illustrated with the lithograph *Visage*. *Cahiers d'Art* publishes photographs of the sculpture *The Bather*, made earlier that year, and of other sculptures and constructions.

1929

Spring Salvador Dalí visits Picasso. Works with Julio González in González's studio, making sculptures and constructions from wire, including the large sculpture

Woman in the Garden (1929–30). He also paints an aggressive series of pictures featuring women's heads, such as *Bust of Woman with Self-Portrait* and *Nude in a Red Armchair*.

1930

February Completes *Crucifixion*.

April A special Picasso issue of the magazine *Documents* includes numerous illustrations and articles.

Summer Makes several reliefs using sand in Juan-les-Pins.

September Commences the series of thirty etchings illustrating Ovid's *Les Métamorphoses* commissioned by the young Swiss publisher Albert Skira.

October Prize from the Carnegie Foundation in Pittsburgh for the 1918 *Portrait of Olga in Profile*.

December Eugeni d'Ors publishes his monograph *Pablo Picasso*, with a lithograph by Picasso.

The year sees a number of major exhibitions in the United States: 'Painting in Paris' at the MoMA, with fourteen works by Picasso, opens in January, followed by 'Derain/Picasso' at the Reinhardt Gallery in New York; in March, he has fifteen pictures at the Arts Club of Chicago; in October, he presents drawings and gouaches at the John Becker gallery in New York, and in November he is represented in another show at the Reinhardt Gallery. Louis Aragon writes the catalogue introduction 'La Peinture au défi' for the collective exhibition of collages at the Galerie Goemans in Paris in March, to which Picasso contributes.

1931

In January, the exhibition 'Picasso's Abstractions' opens at the Valentine Gallery in New York. The Harvard Society of Contemporary Art in Cambridge, Mass., exhibits fifteen of his etchings, and in June the exhibition 'Thirty Years of Pablo Picasso' opens at the Lefevre Gallery in London; he also has another show at the Paul Rosenberg gallery in Paris.

1932

January–March Begins the series of works for which Marie-Thérèse is the model. Zervos publishes the first volume of his *catalogue raisonné* of Picasso's works, covering the period from 1895 to 1906. In June, a retrospective of 236 works by Picasso made between 1901 and 1932 and selected by the artist himself opens at the Galerie Georges Petit in Paris. In September, this show is presented in the Kunsthaus in Zurich. On the occasion of this retrospective a special issue of *Cahiers d'Art* is produced and *L'Intransigeant* publishes an interview with Picasso by Tériade.

In June, two drawings by Picasso are included in a collective exhibition at the Pinacoteca de Barcelona, and in November a new Picasso exhibition opens at the Julien Levy Gallery in New York.

1933

January Publication of Tristan Tzara's book *L'Antitête*, illustrated with an etching by Picasso.

Spring In Boisgeloup, he makes more than forty etchings on the theme of the sculptor in his studio, which form part of the *Vollard Suite*.

1 June Publication of the first issue of the magazine *Minotaure*, supervised by Tériade and published by Skira. Picasso makes a collage for the first cover.

October Fernande Olivier publishes her memoir, *Picasso and His Friends*. Various exhibitions in New York include works by Picasso: 'Picasso' at the Valentine Gallery, the A. E. Gallatin collection at the Gallery of Living Art and French painting at the Marie Harriman Gallery.

The first volume of Bernhard Geiser's catalogue of Picasso's work *Picasso, peintre-graveur* is published in Bern, with engravings and lithographs made between 1899 and 1931.

Bibliography

Catalogues raisonnés

BAER, Brigitte; suite aux catalogues de Bernhard GEISER, *Picasso, peintre-graveur: catalogue raisonné de l'œuvre gravé et lithographié et des monotypes*, 7 vols and 1 addendum. Berne, Kornfeld, 1986–96

BERNADAC, Marie-Laure, Michèle RICHET and Hélène KLEIN, *Musée Picasso, catalogue sommaire des collections,* vol. 1: *Peintures, papiers collés, tableaux-reliefs, sculptures, céramiques*. Paris, Réunion des Musées Nationaux, 1985

DAIX, Pierre, and Joan ROSSELET, *Picasso: The Cubist Years, 1907–1916. A Catalogue Raisonné of the Paintings and Related Works*. London, Thames & Hudson, 1979

GLIMCHER, Arnold, and Marc GLIMCHER (eds), *Je suis le cahier: The Sketchbooks of Pablo Picasso*. Boston / New York, Atlantic Monthly Press / Pace Gallery; London, Thames & Hudson, 1986

LÉAL, Brigitte, *Musée Picasso, Carnets: catalogue des dessins*, 2 vols. Paris, Réunion des Musées Nationaux, 1996

PALAU I FABRE, Josep, *Picasso vivo: 1881–1907*. Barcelona, Polígrafa, 1980

——, *Picasso cubismo: 1907–1917*. Barcelona, Polígrafa, 1990

——, *Picasso, de los ballets al drama: 1917–1926*. Barcelona, Polígrafa, 1999

RICHET, Michèle, *Musée Picasso, catalogue sommaire des collections*, vol. 2: *Dessins, aquarelles, gouaches, pastels*. Paris, Réunion des Musées Nationaux, 1987

SPIES, Werner, *Picasso sculpteur*. Paris, Centre Georges Pompidou, 2000

ZERVOS, Christian, *Pablo Picasso*, 33 vols. Paris, Cahiers d'Art, 1932–78

Exhibition catalogues, monographs and articles

ALARCÓ, Paloma, and Malcolm WARNER (eds), *The Mirror and the Mask: Portraiture in the Age of Picasso*. Madrid, Museo Thyssen-Bornemisza; Fort Worth, Kimbell Art Museum, 2007

ALLEY, Ronald, *Picasso: The Three Dancers*. London, Tate Gallery, 1986

APOLLINAIRE, Guillaume, *Œuvres en prose complètes*, Pierre Caizergues and Michel Décaudin (eds), 3 vols. Paris, Gallimard, 1991–93

——, *Œuvres complètes*, Michel Décaudin (ed), 4 vols. Paris, A. Balland et J. Lecat, 1965–66

——, *The Cubist Painters*, trans. by Peter Read in Peter Read, *Apollinaire and Cubism*. Forest Row (East Sussex), Artists Bookworks, 2002

BARR, Alfred H., Jr., *Picasso: Fifty Years of his Art*. 3rd edn. New York, The Museum of Modern Art, 1980

BATAILLE, Georges, 'Soleil pourri', in *Documents*, Paris, 2nd year, no. 3 (1930), pp. 173–74

BERNADAC, Marie-Laure, and Androula MICHAËL (eds), *Picasso, propos sur l'art*. Paris, Gallimard, 1998

BOGGS, Jean Sutherland, *Picasso and Things: The Still Lifes of Picasso*. Cleveland, The Cleveland Museum of Art, 1992

BOIS, Yve-Alain, 'Kahnweiler's lesson', in *Representations*, Berkeley, California, no. 18 (Spring 1987), pp. 33–68

BRETON, André, 'La Beauté sera convulsive', in *Minotaure*, Paris, no. 5 (1934), pp. 8–16

BRIHUEGA, Jaime, *Manifiestos, proclamas, panfletos y textos doctrinales: Las vanguardias artísticas en España, 1910–1931*. Madrid, Cátedra, 1979

CAIZERGUES, Pierre, and Hélène SECKEL (eds), *Picasso Apollinaire*: *Correspondance*. Paris, Gallimard/Réunion des Musées Nationaux, 1992

CLAIR, Jean (ed.), *Picasso. The Italian Journey: 1917–1924*. London, Thames & Hudson, 1998

COWLING, Elizabeth, *Picasso: Style and Meaning*. London, Phaidon, 2002

COOPER, Douglas, *Picasso: Theatre*. London, Weidenfeld & Nicolson, 1968

FOSTER, Hal, *Compulsive Beauty*. Cambridge, Mass., MIT Press, 1993

FRIEDLÄNDER, Max J., *Landscape, Portrait, Still-Life: Their Origin and Development*. Oxford, Cassirer, 1949

GONZÁLEZ GARCÍA, Ángel, CALVO SERRALLER, Francisco, MARCHÁN FIZ, Simón, *Escritos de arte de vanguardia: 1900–1945*. 2nd edn. Madrid, Istmo, 2003 (Fundamentos; 147)

GOWING, Lawrence, 'Director's Report', in *The Tate Gallery Report: 1964–1965*. London, Tate Gallery, 1966

GREEN, Christopher, *Art in France, 1900–1940*. New Haven and London, Yale University Press, 2000

——, *Cubism and its Enemies: Modern Movements and Reaction in French Art 1916–1928*. New Haven and London, Yale University Press, 1987

——, *Juan Gris*. London, Whitechapel Art Gallery / Yale University Press, 1992

——, *Picasso: Architecture and Vertigo*. New Haven and London, Yale University Press, 2006

KAHNWEILER, Daniel-Henry, *Ästhetische Betrachtungen: Beiträge zur Kunst des 20. Jahrhunderts*. Cologne, DuMont Schauberg, 1968

KLEIN, Hélène (ed.), *Les Demoiselles d'Avignon*. Paris, Réunion des Musées Nationaux, 1988

KRAUSS, Rosalind E., *Originality of the Avant Garde and Other Modenist Myths*. Cambridge, Mass., MIT Press, 1999

JACKSON, Rafael, *Picasso y las poéticas surrealistas*. Madrid, Alianza, 2003

LEIGHTEN, Patricia, *Re-ordering the Universe: Picasso and Anarchism, 1897–1914*. Princeton, Princeton University Press, 1989

LOMAS, David, *The Haunted Self: Surrealism, Psychoanalysis, Subjectivity*. New Haven and London, Yale University Press, 2000

McCULLY, Marilyn (ed.), *A Picasso Anthology: Documents, Criticism, Reminiscences*. 3rd edn. Princeton, Princeton University Press, 1997

MADELINE, Laurence, '*On est ce que l'on garde!*', *Les Archives de Picasso*. Paris, Réunion des Musées Nationaux, 2003

PENROSE, Roland, and John GOLDING (eds), *Picasso 1881–1973*. London, Elek, 1973

READ, Peter, *Picasso et Apollinaire: Les Métamorphoses de la mémoire, 1905/1973*. Paris, Jean-Michel Place, 1995

——, *Picasso and Apollinaire: The Persistance of Memory*. Berkeley, Los Angeles and London, University of California Press, 2008

RICHARDSON, John, with the collaboration of Marilyn McCULLY, *A Life of Picasso*, vol. 2: *1907–1917, The Painter of Modern Life*. London, Jonathan Cape, 1996

——, *A Life of Picasso*, vol. 3: *1917–1932, The Triumphant Years*. London, Jonathan Cape, 2007

ROSENBLUM, Robert, 'Picasso and the typography of Cubism', in Roland Penrose and John Golding (eds), *Picasso 1881–1973*. London, Elek, 1973

RUBIN, William, 'From narrative to "iconic" in Picasso: the buried allegory in *Bread and Fruitdish on a Table* and the role of *Les Demoiselles d'Avignon*', in *Art Bulletin*, vol. 65, no. 4 (December 1983), pp. 615–49

RUBIN, William, with additional texts by Elaine L. JOHNSON and Riva CASTLEMAN, *Picasso in the Collection of the Museum of Modern Art*. New York, Museum of Modern Art, 1972

RUBIN, William (ed.), *Pablo Picasso: A Retrospective*. New York, Museum of Modern Art, 1980

—— (ed.), *Picasso and Portraiture: Representation and Transformation*. New York, Museum of the Modern Art, 1996

STEINBERG, Leo, *Other Criteria: Confrontations with Twentieth-Century Art*. New York, Oxford University Press, 1972

WOLLHEIM, Richard, *Art and its Objects: An Introduction to Aesthetics*. New York, Harper & Row, 1968

Picture credits

© Archives de la Fondation Erik Satie, París. Photo Waléry p. 147, p. 149, p. 150; © Archivo Fotográfico Museo Nacional Centro de Arte Reina Sofía, Madrid p. 163; © Art Institute of Chicago/ Giraudon/The Bridgeman Art Library, London p. 44; © Photo CNAC/MNAM, Dist. RMN/ Droits réservés p. 167; © Photo CNAC/MNAM, Dist. RMN/Jean-Claude Planchet p. 69; © Photo CNAC/MNAM, Dist. RMN/Philippe Migeat p. 75; Photo © 1990 The Detroit Institute of Fine Arts p. 77; © Estate Brassaï – RMN p. 92; © Fondation Beyeler, Riehen/Basle: p. 157; © Fundación Almine y Bernard Ruiz-Picasso para el Arte. Photo: Eric Baudouin p. 74, p. 116 (bottom); © Fundación Almine y Bernard Ruiz-Picasso para el Arte. Photo: Marc Domage p. 73; © Fundación Colección Thyssen-Bornemisza, Madrid p. 141; © Courtesy Fundación Mapfre p. 102; © Courtesy Galería Manuel Barbier p. 78 (top); © Galerie Beyeler, Basle p. 58; © Courtesy Galerie Jan Krugier & Cie., Geneva p. 70 (bottom), p. 100, p. 101, p. 119; © Gasull Fotografia p. 78 (bottom), p. 79; © Courtesy Helly Nahmad Gallery p. 118, p. 181; © Courtesy Henie Onstad Art Centre p. 82; © ImageArt – Opio (France) p. 54 (bottom), p. 55 (bottom), p. 72 (bottom), p. 117 (bottom), p. 165, p. 176, p. 177; © IVAM, Institut Valencià d'Art Modern. Generalitat, Spain p. 34; © Courtesy Jan Krugier and Marie-Anne Krugier-Poniatowski p. 179 (bottom); © The Metropolitan Museum of Art. Photo: Malcolm Varon p. 161; © Ramon Muro i Mercader p. 112; Musée d'Art Moderne Lille Metropole © Muriel Anssens p. 175; © Musée des Beaux-Arts de Dijon p. 65; © Musée de Grenoble p. 35; © Musco Picasso Málaga/Rafacl Lobato p. 103, p. 104; © Museu Picasso, Barcelona/ Gasull Fotografia p. 68, p. 85, p. 86, p. 87, p. 153; © Museu Picasso, Barcelona/Ramon Muro p. 168, p. 174; © 2008, digital image, The Museum of Modern Art, New York/Scala, Florence p. 41, p. 61, p. 63; © Courtesy of the Board of Trustees, National Gallery of Art, Washington p. 124; © National Gallery of Ireland. Photo: Roy Hewson p. 83, p. 137; © Opéra National de Paris p. 90; © Orlando photo, Montigny le Bretonneur p. 116 (top); © Philadelphia Museum of Art/Photo: Andrea Núñez p. 133; © Philadelphia Museum of Art/Photo: Graydon Wood p. 117 (top); © Photographe Béatrice Hatala p. 36, p. 114, p. 115, p. 134, p. 136, p. 138, p. 142, p. 144, p. 145, p. 146, p. 148, p. 151, p. 160, p. 178 (top); © Courtesy Richard Gray Gallery, Chicago p. 99; © RMN/Béatrice Hatala p. 19, p. 26, p. 29, p. 31, p. 32; p. 105, p. 129, p. 178 (bottom), p. 179 (top); © RMN/ Christian Jean p. 143 (bottom); © RMN/Daniel Arnaudet p. 143 (a); © RMN/ Droits réservés p. 62; © RMN/Jean-Gilles Berizzi p. 38, p. 170; © RMN/Michèle Bellot p. 55 (top), p. 96 (top); © RMN/René-Gabriel Ojéda p. 173; © RMN/ Thierry Le Mage p. 52, p. 53, p. 57, p. 96 (bottom), p. 97, p. 113, p. 132, p. 164; © 2008 Saint Louis Art Museum p. 171; © Scottish National Gallery of Modern Art, Edinburgh p. 122; © The Solomon R. Guggenheim Foundation p. 139; © Statens Museum for Kunst, Copenhagen p. 81; © Stedelijk Museum, Amsterdam p. 135; © Tate, London 2008 p. 33, p. 46; Credits unknown. All rights reserved p. 54 (top); p. 70 (top), p. 71, p. 72 (top), p. 95, p. 120